W9-CSL-838

Woman as Artist

Papers in Honour of Marsha Hanen

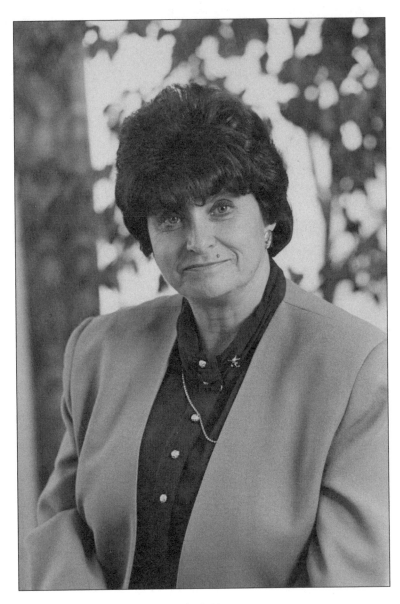

Marsha P. Hanen

Woman as Artist

Papers in Honour of Marsha Hanen

Edited by
Christine Mason Sutherland
and
Beverly Matson Rasporich

University of Calgary Press

University of Calgary Press
2500 University Drive N.W.
Calgary, Alberta, Canada T2N 1N4

Canadian Cataloguing in Publication Data

Main entry under title:

Woman as artist

Includes bibliographical references and index.
ISBN 1-895176-37-9

1. Women artists—Canada. 2. Women authors—Canada.
3. Women—Canada. 4. Arts—Canada. 5. Hanen,
Marsha P., 1936– I. Sutherland, Christine Mason.
II. Rasporich, Beverly Jean. III. Hanen, Marsha P., 1936–
NX164.W65W64 1993 305.437 C93-091929-7

♾This book is printed on acid-free paper.

Contents

Acknowledgements

This volume has been produced as part of the celebration of the tenth anniversary of the Faculty of General Studies and the twenty-fifth anniversary of the University of Calgary. The editors wish to thank all who have contributed to its making, including the University of Calgary Press and its editorial board, the external referees, and the authors themselves. A number of Marsha Hanen's close friends and colleagues are not included here, owing to the constraints of space and theme. We therefore wish to acknowledge that this small tribute represents only a fraction of those she has influenced and befriended, and to thank all those who have contributed by giving us their support and encouragement. We also most particularly wish to thank Jo-Anne Kabeary for her expert help in preparing the text, and Dulcie Foo Fat and the Glenbow Art Gallery for allowing us to use the painting *Chinese Dinner* as a cover image.

The publication of this volume has been made possible by the generous contributions of a number of people. We are most grateful for funds supplied by the Dean of General Studies, the Dean of Social Sciences, the Dean of Humanities, and the Dean of Fine Arts; by the Chairs of the Departments of English, Archaeology, and Philosophy; and by the Associate Vice-President (Student Affairs) from the Special Projects Fund. We also wish to thank President Murray Fraser for his support.

Publication has been assisted by a grant provided by the University of Calgary's General Endowment Fund.

Christine Mason Sutherland
Beverly Matson Rasporich

1

Introduction

CHRISTINE MASON SUTHERLAND

This collection of essays is feminine in a number of ways: it has been made to honour a woman for her achievements on behalf of women; it is by women; it is about women; and it demonstrates, I believe, methods that are typical of women.

The collection honours Marsha Hanen, Dean of the Faculty of General Studies at the University of Calgary from 1986 to 1989, and now President of the University of Winnipeg. Marsha's interest in the arts is characteristic of both her public and her private life. Herself a fine pianist, she has always been a supporter of artistic enterprises, particularly those of women. We therefore hope that by bringing together this collection of essays about women as artists we shall both honour her and give her pleasure.

It is *by* women. Some of the contributors are among her oldest and closest friends. Some of us are women she has nurtured into scholarship by her advice and encouragement, and by her very practical help. All of us have at some time been her colleagues at the University of Calgary, but some are also practising artists, doing creative as well as scholarly work.

It is *about* women. The women discussed in these pages are of all kinds. There are painters, writers, dancers, musicians, teachers, and scholars. Many are Canadian and a fair number Albertan. Some lived in earlier times; others are still with us today. And finally, some are factual and some fictional.

But the work is feminine in quite another way as well. In "Rhetoric in a New Key"[1] Andrea Lunsford argues for the recognition of a new kind of rhetoric, one that is not monologic and hierarchical but dialogic and collaborative. It is multivocal, richly varied rather than being dominated by a single point of view. Such rhetoric, according to Lunsford, is typical of women and should be valued as such, not criticized for failing to meet the standards of traditional patriarchal writing. We like

to think that this collection demonstrates such typically feminine characteristics. Certainly its production has been a joint enterprise from the beginning: one of us suggested a festschrift for Marsha, another provided the idea of using women in the arts as a focus, and a core of contributors met to discuss details and to suggest others who might like to be included.

Since that first meeting we have consulted one another, given and taken advice, and offered encouragement and reassurance. As editors we hope that we have acted as midwives, assisting the creative process of the writers. In doing so, we have enjoyed the full support of the Faculty of General Studies of which Marsha Hanen was once Dean. The project was in fact started in order to celebrate the twenty-fifth anniversary of the University of Calgary and the tenth of the Faculty of General Studies. It is, we feel, a particularly appropriate way of celebrating our achievements, not the least of which has been a sensitivity to the needs and concerns of women—unusual in professional institutions. The editors, both of them founding members of the faculty, bear witness to the respect and consideration shown to women over the years. As befits a volume that celebrates the former Dean of the Faculty of General Studies and the anniversary of that faculty, the collection is interdisciplinary. No fewer than five different faculties at the University of Calgary are represented, and many of the authors take an interdisciplinary approach.

To set the scene for these essays on women in the arts, Margaret Osler has given us a portrait in words of Marsha Hanen herself. Osler's clear account of Marsha Hanen and of her career not only brings her vividly before us, but also explains why the project of giving her a festschrift met with such enthusiasm. As Osler makes apparent, Marsha Hanen's own development as a scholar, teacher, and administrator has been toward just those qualities that Andrea Lunsford identifies as typically feminine.

The essays that follow are divided into three unequal groups. First come four whose subject is Canadian literature. These are followed by two highly interdisciplinary essays that consider not only Canadian literature, but the visual arts as well. The last five essays are contributed by women who are practising artists as well as scholars: they are therefore able to supply insights of a different kind. The Afterword by the co-ordinator of women's studies at the University of Calgary comments on the collection as a whole. Finally, an editorial Postscript draws the various threads together and knits them up.

The first essay, by Diana Relke, introduces one of the most important themes of the collection as a whole: the mentrix. Relke draws upon the

work of contemporary women novelists in Canada to illuminate both the importance of the mentrix and her comparative rarity. For women especially, creative work is a form of collaboration, even if that collaboration is indirect: the idea of the isolated genius solely responsible for his own vision is one that runs counter to the feminine values of connectedness. The mentrix figure is ambivalently portrayed in fiction by Canadian women writers, and this in itself Relke finds significant: mothers of the mind, like biological mothers, are sometimes at odds with their daughters, and are even blamed by them for failing to provide appropriate direction. They are necessary nonetheless.

Tamara Palmer Seiler's essay draws our attention to a quite different body of Canadian literature. Her study of some of our ethnic novels focuses on Winnipeg's North End. She finds that men and women respond differently to the experience of the ghetto: men see it as a combat zone, women as a nurturing space. Seiler's essay thus illustrates in a particularly enlightening way the theories put forward by feminists such as Carol Gilligan[2] and Nel Noddings,[3] and confirmed by the research reported in *Women's Ways of Knowing*[4]: that women see themselves as nurturers, as reconcilers, and are uneasy with confrontation and the struggle for dominance.

Kathleen Martindale's essay on Gail Scott draws upon yet another aspect of Canada's multiculturalism. Scott is an anglophone who has nevertheless chosen to work in the context of French Canada, and issues of language are therefore central to a consideration of her work. Martindale's discussion of language is illuminating. So too is her consideration of the female as melancholic in the work of Gail Scott. As Martindale sees it, negativity—that is, loss, deprivation, non-existence (an important element in Luce Irigaray's critique of Freud)—is at the root of female melancholia.

With Susan Stone-Blackburn's essay we turn from the novel to drama. The play she has chosen to discuss provides another instance of the preference of women for collaborative work: Stone-Blackburn gives us a study of a play written by three Albertan women. *Aphra* is based on the life and work of Aphra Behn, the successful woman playwright of seventeenth-century England. The play was put on twice in one year in Calgary—a measure of its enormous success. Stone-Blackburn uses her study of *Aphra* as an opportunity to consider whether or not the position of women dramatists has improved since the seventeenth century.

Next come two highly interdisciplinary essays, one by Pamela McCallum and the other by Beverly Rasporich. McCallum sees prob-

lems for women arising from the very postmodern theories that might be expected to validate feminist epistemologies. The profound scepticism of the postmodern—the rejection of the notion of absolute truth—can act to disempower the woman's point of view just when it begins to be taken seriously. Midway between total scepticism and the idea of truth as absolute, however, McCallum sees a place for "marked subjectivities." To show how these marked subjectivities operate, she uses the 1991 exhibition at four galleries in Regina, Saskatchewan, "The Regina Work Project," and two short stories by Canadian women writers. Especially memorable is her use of the figure of Saliha, a young immigrant cleaning woman, in the short story "Ajax Là-Bas" by Yeshim Ternar.[5] Saliha's experience demonstrates the truth that "epistemologies of marked subjectivities do not see everything from nowhere but do see some things from somewhere."[6] Such situated knowledges, McCallum believes, can contribute to the empowerment of women.

Beverly Rasporich's interdisciplinary account of the work of two women also deals with issues of power, though in a rather different way. Rasporich uses the work of Mary Pratt and Alice Munro to investigate problems of authenticity and identity faced by women in the arts. She explores the tension created by, on the one hand the culturally accepted view of the woman as passive, as object, and on the other the necessary adoption of a subject stance, an active role, by the practising artist. Following Whitney Chadwick,[7] Rasporich sees Rousseau as an important contributor to this model of the female as merely passive inspirer of works of art—a model that now has to be dismantled. Part of the enterprise of both Pratt and Munro is to do so by legitimizing those feminine activities that have often been seen as too trivial to be used as artistic material.

The last five pieces in the collection are contributed by women who are not only scholars but also practising artists or performers. They draw upon their own experience to illuminate their perceptions of what it is like to be a woman artist in Canada today.

Alice Mansell addresses the particular problems created for women by assumptions and theories grounded in the experience of men. Mansell argues that theories which ostensibly critique the dominant practices arising from traditional patriarchal assumptions in fact reinforce such practices by constant reference to them and "quotation" from them. Compounding the problem of gender is the problem of national culture: most of the theories that act as supertext for current practice are European. The Canadian woman artist is thus doubly marginalized, and is further handicapped by the lack of female role models in art. Mansell draws upon the work of several Canadian artists

to illustrate her points; most valuable and illuminating of all is her citation of her own experience as a Canadian woman painter.

Like Alice Mansell, Marcia Epstein uses her own experience of artistic creation to illustrate her discussion. Epstein deals with the woman as composer. In a way that recalls the method of Luce Irigaray in *Speculum*,[8] Epstein uses the musical form of Theme and Variations to explore a number of approaches to the question of gender and musical composition. Of all the arts, composition has been the one most firmly closed to women; very few women indeed have gained any recognition as writers of music. Epstein discusses why this is so, and considers whether or not contemporary women composers in Canada are still constrained by the gender bias of the past. She has interviewed by mail a number of Canadian women composers whose responses illustrate the various positions currently held on this question.

In the essays of Marilyn Engle and Anne Flynn we turn to the art of performance, and in particular to the teaching of performance. Here the theme of the mentrix returns, not this time in fiction but in fact. Marilyn Engle gives us a vivid and moving account of her own teacher and mentrix, Gladys Egbert. This gifted teacher of the piano, to whom so many Canadian musicians owe so much, is shown as a mentrix *par excellence*. Mrs. Egbert oversaw not only the musical education of her students but their development as human beings as well, and the environment of her house was an important element in the maturing of these young people as artists. She thus demonstrates an ideal of feminine connectedness, of the interaction not just of talents but of whole persons, upon which the success of the artistic enterprise ultimately depends.

In some ways like Marilyn Engle's essay, Anne Flynn's brings before us the work of dedicated women teachers who made their invaluable contributions in an earlier, smaller Calgary where artistic opportunities were few. She pays tribute to three Canadian women who were instrumental in establishing dance in Alberta in the earlier part of this century, recognizing and celebrating their dedication and determination to succeed. Again, particularly worthy of note is the way in which these women used their own homes as centres of creative nurturing. If the male rigorously divides his life into public and private spheres and tries to keep them apart, the female, it is suggested, finds it natural to integrate them.

The theme of negativity which, as we saw earlier, is such an important element in Martindale's essay is brilliantly used by Aritha van Herk as the ironic theme ("Why I am not a writer") upon which she plays variations. This autobiographical piece revisits many of the

issues that have been considered in earlier essays. It also functions as a parable of the creative potential of the very conditions that might appear to inhibit women's development. It balances, therefore, the earlier discussions (in Mansell and McCallum) of theories that do the opposite.

Finally, Eliane Silverman contributes a short meditation in which she invites us all to reflect upon and to participate imaginatively in the experiences of women as they engage in artistic activity. Her call to us, "Make room in your heart and body and head," reminds us that women prefer to work connectedly, holistically. Her piece thus provides an appropriate conclusion. The editorial Postscript highlights some of the concerns, experiences, and perceptions that reappear in one essay after another, giving a genuine, if unplanned, coherence to the whole collection.

This book, then, is offered as a tribute to Marsha Hanen and to the faculty and the university in which she grew to maturity as a teacher, as a scholar, and as an administrator.

Christine Mason Sutherland is Associate Professor in the Faculty of General Studies at the University of Calgary. Educated at Oxford and McGill, she joined the University of Calgary in 1976 as a part-time sessional instructor. From 1978 to 1983 she served as Director of the Effective Writing Programme. Subsequently, she participated in the formation of the communications major in the newly formed Faculty of General Studies, creating courses in rhetoric. Her publications include articles on rhetoric and gender in the seventeenth century. She has made a particular study of the seventeenth-century writer and scholar, Mary Astell. Her association with Marsha Hanen has extended over many years. She is particularly grateful for the help and encouragement Marsha gave her when, rather late in life, she embarked upon an academic career.

Notes

1 Andrea Lunsford, "Rhetoric in a New Key," *Rhetoric Review* 8.2 (Spring 1990): 234–41.

2 Carol Gilligan, *In a Different Voice* (Cambridge, MA: Harvard UP, 1982).

3 Nel Noddings, *Caring: A Feminine Approach to Ethics and Moral Education* (Berkeley: U of California P, 1984).

4 Mary Field Belenky et al., *Women's Ways of Knowing: The Development of Self, Voice, and Mind* (New York: Basic Books, 1986).

5 Yeshim Ternar, "Ajax Là-Bas," *Other Solitudes: Canadian Multicultural Fictions*, ed. Linda Hutcheon and Marion Richmond (Toronto: Oxford, 1990), 321–28.

6 Nancy Hartsock, "Postmodernism and Political Change: Issues for Feminist Theory," *Cultural Critique* 14 (Winter 1989–90): 29.

7 Whitney Chadwick, *Women, Art and Society* (London: Thames and Hudson, 1990).

8 Luce Irigaray, *Speculum de l'autre Femme* (Paris: Minuit, 1977). See chapter 7 in Toril Moi, *Sexual/Textual Politics* (London: Routledge, 1985).

2

Marsha P. Hanen: A Portrait

MARGARET J. OSLER[1]

When Marsha Hanen announced in May 1989 that she was leaving the University of Calgary to become President of the University of Winnipeg, I and many of her other friends and colleagues talked about how she had touched each of us. Close personal friends and ordinary colleagues, we each felt that she had known us in our particularity, had listened to us carefully, and had responded to our needs in creatively individual ways. Our enormous sense of loss at her departure was a direct result of her unique personal, academic, and administrative style.

My own friendship with Marsha is completely intertwined with my academic life at the University of Calgary. Although our paths first crossed when I came to Calgary in 1975, we had unwittingly been following each other around the countryside for a dozen years or more. We had studied with many of the same professors, albeit at different schools and at different times. Our family backgrounds are quite similar. We even established that we had both once been in the audience of a lecture in the spring of 1963. Our commonality of history and interests made it easy to form a strong bond as we worked together on developing interdisciplinary programmes, planning conferences, and becoming close friends. It was only after she left for Winnipeg that I realized just how much my university life was connected to our friendship. In her absence, I keep discovering places where her former presence clarified difficult decisions and guided me along constructive pathways.

Who is Marsha Hanen? And how did she develop into the person who plays such a special role in the lives of so many people? Marsha Hanen was born on September 18, 1936 to Ben and Rowena Pearlman, Jewish immigrants from Russia who had settled in Calgary in the 1920s. Having a strong social conscience and a deep commitment to education, the Pearlmans played an active role in Calgary's small Jewish

community. They were instrumental in founding Calgary's I.L. Peretz School, which was committed to secular Yiddish culture, and where Rowena Pearlman taught for many years. Following the dark years of World War II, they helped refugees from the Nazis come to Canada to establish new lives here. Marsha's own life has come to embody the values underlying these activities: a strong commitment to education and deep concern for community problems. She expresses these values in her devotion to higher education and her commitment to feminism.

Completing high school in Calgary in 1954, Marsha simultaneously qualified as an Associate in Music with the Western Board of Music. Music was always a central part of her life, the one activity she found totally absorbing. Marsha had started playing the piano at age six. As a child she performed in public, and she taught piano while in high school and university. During her high school years she worked as an accompanist for Eileen Higgin, then the foremost singing teacher in Calgary. She also played some chamber music, an activity to which she has returned throughout her life. She continued playing while she was a graduate student, accompanying school choirs in Philadelphia and Boston. Despite the depth of her interest, she decided against a career in music, feeling that she lacked the temperament to be a performer. But she has always had a piano in her home and has even decided where to live on the basis of whether the house provided room for a piano. Her deep involvement with music continues to this day. She currently serves on the board of the Winnipeg Symphony Orchestra.

Marsha went to study at the University of Toronto in 1955. An early marriage to aspiring architect Harold Hanen interrupted her education, which she continued at The Frank Lloyd Wright Foundation, Boston University, and finally Pembroke College of Brown University from which she graduated in 1959 with High Honours in Philosophy. Her experience as an undergraduate was coloured by the fact that she was married and had a child. In the mid-1950s, it was unusual—to say the least—for a married woman to be permitted to pursue her education at almost any private liberal arts college in the United States. Indeed, motherhood raised great practical obstacles in an era before working mothers and day care centres were common. Marsha's characteristic busyness dates from this era. She learned early to pack vast amounts of work into the fragments of time left to her between studies and her domestic responsibilities, a skill that has served her well as she has travelled down the road to academic administration. Given her commitments to career, family, and friends, large blocks of unfettered time are a luxury she has seldom enjoyed. Even so, she has always valued close friends and has managed to find time to devote to

them. When she became Dean of General Studies she continued the tradition of having an almost weekly lunch with me, guaranteeing that we had time to keep in touch both personally and professionally.

Marsha's success as an undergraduate philosophy student prompted her to continue her studies at the graduate level, first at Brown University where she completed her master's degree in 1961, then at the University of Pennsylvania, and finally at Brandeis University where she completed her Ph.D. in 1970, specializing in philosophy of science. Her growth as a philosopher has paralleled developments in philosophy (and other disciplines) during the past thirty years.

In the 1960s philosophy of science in North America was dominated by logical positivism, an approach that emphasized the logical structure and epistemological status of science. Based on the assumption that "science" referred to the same kind of knowledge in all times and places and that it could be readily distinguished from various non-scientific practices, logical positivism presumed that there are simple, atemporal criteria for recognizing scientific explanations, confirmations, and theories. It focused on the articulation of these criteria and on seeking exemplifications of the then unexamined assumption that science is epistemologically privileged. Marsha's graduate training and her doctoral dissertation, "An Examination of Adequacy Conditions for Confirmation," written under the supervision of Nelson Goodman during the late 1960s, embodied this outlook.

As her mentor in graduate school, Nelson Goodman played a formative role in Marsha's development as a philosopher. Her first experience of feeling that she was really *doing* philosophy—as opposed to simply learning it—occurred in Goodman's seminar on the philosophy of art at the University of Pennsylvania. Much of the material from this course was later incorporated into Goodman's book, *Languages of Art*,[2] a project on which Marsha worked as a research assistant. In the seminar, Goodman set weekly papers on questions at the growing edge of the field, questions for which there existed neither a body of literature to consult nor a well-established set of positions with standard arguments on either side. Although his questions were about visual art, Marsha found that her knowledge of music provided a rich source of useful analogies. It was also in this context that she began to develop her own approach to philosophy, one that departed from the arid abstractions of logical positivism by drawing on substantive material from a variety of fields and points of view. Goodman's belief that art is a symbol system, that it is fundamentally cognitive, led Marsha to apply the same kind of epistemological questions to art that she usually applied to science. She came to see painting, literature, and art more

generally as having cognitive functions, as providing a way of learning about the world. Thus, for her, philosophy of art could be understood as part of epistemology more generally. In her later work, she applied the same approach to questions in the philosophy of law and in feminist philosophy.

Marsha's growth beyond logical positivism mirrors similar developments in philosophy of science, in literary theory, and in the humanities and social sciences more generally. These developments are marked by a growing awareness of the strength of interdisciplinary approaches to intellectual problems, an increasing recognition of the contextualization of knowledge, and the consequent erosion of attempts to find universal foundations for both knowledge and practice. Her early papers—in the late 1960s and early 1970s—remained within the traditional positivist framework. They were highly technical discussions of detailed problems in the logic of the confirmation of scientific theories. Written in the adversarial style characteristic of Anglo-American philosophical discourse of that era (and still in vogue among mainstream philosophers), her papers proceeded by arguing against the positions expressed in others' papers on the topic. This approach to philosophical argument has deep historical roots, extending back to the medieval universities in which students exhibited their intellectual prowess by engaging in formal disputations on philosophical topics.

Quickly departing from her apprenticeship in a mode she did not find comfortable, Marsha never wrote in this style again. She adopted in its place an emphasis on intellectual cooperation and the exploration of the consequences of different philosophical positions rather than the antagonistic mode of searching out and destroying all opposing arguments. Marsha's new approach is most commonly practised today by feminist scholars.

Despite her early understanding of the special problems faced by women in higher education, Marsha did not immediately embark on feminist research in philosophy. What she did do—and this is something that was very innovative at the time—was to move to a kind of philosophy that engages deeply and specifically with particular subject matters, rather than simply the abstract logical problems associated with those areas of knowledge. This kind of philosophy requires extensive knowledge of other fields of study and is, therefore, essentially interdisciplinary. Marsha's growing commitment to this approach led to a fifteen-year association with University of Calgary archaeologist, Jane Kelley, and to the product of their union, *Archaeology and the Methodology of Science* (1988). When they first undertook this project in the early 1970s, it was unusual for philosophers of

science to engage so intimately with the subject matter of a substantive discipline, particularly one of the social sciences. Rather than viewing archaeology against the measuring stick of abstract criteria drawn largely from the analysis of physics (the received practice of logical positivists), they examined the theory and practice of archaeology to see how this field might enrich our understanding of the nature of science. The significance of their book can be understood in light of Marsha's increasing recognition of the fact that the philosophical analysis of knowledge must be contextualized and makes sense only within the framework of concrete attempts to generate knowledge.

In a natural development flowing from her work in the philosophy of science, Marsha moved further in the direction of practising philosophy within the context of substantive disciplines by developing her interest in the philosophy of law, particularly the relationship between scientific reasoning and legal reasoning. Her interest in this area was given a big boost when she received the prestigious Fellowship in Law and Philosophy at Harvard University, enabling her to spend the academic year 1977–78 with other mature scholars in the heady environment of Harvard Law School. In subsequent years she wrote a number of papers on the philosophy of law, with a special concentration on contract law and the nature of legal truth.

Once again combining her interests in a fruitful way, Marsha found a natural path into feminist philosophy by examining methodological and legal issues from a feminist perspective. Drawing on insights garnered from feminist critiques of science and epistemology, she applied them to questions in contract law, ethics, and philosophy more generally in a series of papers published in the late 1980s. One result of this work is her ever-strengthening conviction that there is no absolute foundation for knowledge and that philosophical arguments must be understood within the multiple contexts of the philosopher, her audience, and the specific discipline under scrutiny:

> The centrality to feminism of an integrative approach seems to me well documented. But there is still a gap between theory and practice which needs to be closed. We need to be able to see traditionally separate branches of philosophy as informing one another without one being dominant, and philosophy itself as not separate from other disciplines, from lived experience, or from efforts to create a better society.[3]

With her passage into feminist philosophy, Marsha moved completely away from her early logical positivism and toward the commitment to interdisciplinarity that has characterized her approach to education

and administration as well. The clarity that characterizes her speaking and writing, however, is a reminder of her positivist philosophical training.

Marsha's commitment to interdisciplinarity, so clear in her scholarly writing, is also the hallmark of her approach to education and its administration. Shortly after she began teaching in the Department of Philosophy at the University of Calgary in 1966, she became involved in administrative activities that became increasingly central for her. The thrust of her work as administrator has been to create connections between people and among disciplines. Her interdisciplinary vision has had considerable impact, particularly in view of the fact that the more common tendency of universities during the nineteen-seventies and nineteen-eighties has been the drive toward specialization. This tendency has been particularly marked at the University of Calgary.

Until 1975 the University of Calgary had a Faculty of Arts and Sciences that encompassed the academic disciplines making up the humanities, sciences, and social sciences. Within this umbrella faculty, which was the home of the traditional liberal arts at the University of Calgary, there had emerged various interdisciplinary interest areas, which were listed in the university calendar and which suggested clusters of courses students might take in order to pursue interests in areas such as African studies, American studies, and Canada's native people. By 1976, when the Faculty of Arts and Sciences had splintered into four separate faculties (Humanities, Science, and Social Sciences—the Faculty of Fine Arts having attained its autonomy in the late 1960s), two of these interest areas (Latin American Studies and Urban Studies) had become minor programmes, and other such areas (e.g., Women's Studies) had been formed. As Associate Provost of University College, which housed first-year students, Marsha was also responsible for interdisciplinary studies. Her efforts led to the establishment of programmes in Women's Studies, History, and Philosophy of Science within University College, as well as the administration of the interdisciplinary courses taught under its aegis.[4]

In 1981 University College was replaced by the full-fledged Faculty of General Studies, led by Robert G. Weyant, Dean, and Marsha Hanen and David Jenkins, Associate Deans. Together they forged a faculty committed to interdisciplinary methods and general education, both of which had been given short shrift by the increasing specialization within the traditional faculties. This new faculty provided Marsha with an arena in which to act on her interdisciplinary convictions. Along with Bob Weyant (whom she married in 1989), she created a set of integrative programmes in interdisciplinary fields, including Canadian

Studies; Communications Studies; Development Studies; Education Studies; Ethnicity and Folklore; Law and Society; Leisure, Tourism, and Society; Peace and War Studies; Science, Technology, and Society; Urban Studies; and Women's Studies. Students enrolled in these major programmes begin by taking a broad interdisciplinary course on the Western intellectual heritage and conclude with another that attempts to draw together some of the many threads of their education. The curriculum embodies a multicultural component, requiring each student to acquire knowledge of a non-Western world area. Marsha's commitment to this kind of multiculturalism is also expressed in her membership on the board of the Shastri Indo-Canadian Institute.

In 1986 Marsha became Dean of the Faculty of General Studies. Despite the exigencies of limited (and shrinking) resources and limited numbers of faculty members, the Faculty of General Studies is informed by many of Marsha's deepest convictions about the connections among academic disciplines and the importance of interdisciplinary approaches to intellectual problems. When she became President of the University of Winnipeg in 1989, she acquired an expanded domain in which to pursue these educational goals, since that university is one of the few in Canada committed to undergraduate liberal arts education.

As an administrator, Marsha has also emphasized connections— among people as well as among disciplines. Like her academic approach, her administrative style involves seeing issues from a variety of perspectives and taking full account of the individual. Her mode, unusual in the bureaucracy of a large university, is highly personal. She is always willing to talk to people—students, faculty members, other administrators—and to talk at length. She listens carefully to individuals' desires or needs or complaints and helps them think of ways in which to make a constructive outcome possible. Her aim as an educational administrator is to help people fulfil their individual potential within the complexities of the university system. One person may have aspirations as a serious scholar, another as a creator of an interdisciplinary programme, another as an innovative teacher. Marsha can be thought of as an administrative midwife, assisting these individuals to give birth to their academic offspring. Her patience with people and her attentiveness to their particular needs are great, but she has no patience with the devious practices of certain other administrators. And she has nothing but scorn for those who, in her words, "always snatch defeat from the jaws of victory." She can be a tough administrator as well as a sympathetic one. Her astuteness has enabled her to fulfil her academic and institutional vision.

Marsha's success in combining her personal touch, her social concerns, and her administrative talent accounts for the significance of her impact on the individuals and institutions with which she works. Her academic life expresses the development of her values and vision. In these respects she stands as an inspiration to her friends, students, and colleagues.

Margaret J. Osler teaches the history of science at the University of Calgary. Her research has focused on seventeenth-century philosophies of nature and their relationship to medieval theology. With Marsha Hanen, she organized the Science, Technology, and Society major and minor programmes in the Faculty of General Studies. She, Marsha, and Bob Weyant organized the conference and edited the ensuing volume on Science, Pseudo-Science, and Society in 1979. She worked closely with Marsha organizing the 1989 Interdisciplinary Working Conference on Knowledge, Gender, Education, and Work.

Appendix

Selected Bibliography of Marsha P. Hanen's Publications

Dissertation

Marsha P. Hanen. "An Examination of Adequacy Conditions for Confirmation," Ph.D. diss., Brandeis U, 1970.

Book

Jane H. Kelley and Marsha P. Hanen. *Archaeology and the Methodology of Science.* Albuquerque: U of New Mexico P, 1988.

Edited Books

Marsha P. Hanen and Kai Nielsen (eds.). *Science, Morality, and Feminist Theory.* Calgary: U of Calgary P, 1987.

Marsha P. Hanen, Margaret J. Osler, and Robert G. Weyant, eds. *Science, Pseudo-Science, and Society.* Waterloo, ON: Wilfrid Laurier UP, 1980.

Articles in Journals and Books

Marsha P. Hanen. "Goodman, Wallace, and the Equivalence Condition." *Journal of Philosophy* 64 (1967), 271–80.

—————. "Confirmation and Adequacy Conditions." *Philosophy of Science* 36 (1971), 361–68.

—————. "Jewish Education in Canada. Some Personal Observations." *Canadian Zionist* 41.9 (May 1972): 10–12.

—————. "Confirmation, Explanation and Acceptance." *Analysis and Metaphysics.* Ed. Keith Lehrer. Dordrecht: Reidel, 1975. 93–128.

—————. "J. C. Smith's Legal Obligation." *Dialogue* 17 (1978): 371–79.

—————. "Taking Language Rights Seriously." *Philosophers Look at Canadian Confederation/La confédération canadienne: qu'en pensent les philosophes?* Ed. Stanley G. French. Montréal: Canadian Philosophical Association, 1979. 301–10.

—————. "Report of Workshop on Rights." *Philosophers Look at Canadian Confederation/La confédération canadienne: qu'en pensent les philosophes?* Ed. Stanley G. French. Montréal: Canadian Philosophical Association, 1979. 291–95.

—————. "Philosophical Options." *Man and His Environment: Proceedings of Third International Banff Conference.* Ed. M. F. Mohtadi. Elmsford, NY: Pergamon P, 1980.

—————. "Legal Science and Legal Justification." *Science, Pseudo-Science, and Society.* Eds. Marsha P. Hanen, Margaret J. Osler, and Robert G. Weyant. Waterloo, ON: Wilfrid Laurier UP, 1980. 115–42.

—————. "Some Myths of Method." Special issue of *Resources for Feminist Research* 8 (1980), 124–27.

—————. "The Supreme Court Constitutional Decisions. *Canadian Philosophical Reviews* 1.6 (1981): 284–86.

—————. "Justification as Coherence." *Law, Morality and Rights.* Ed. M. A. Stewart. Dordrecht: Reidel, 1983. 67–92.

—————. "Theory Choice and Contract Law." *Theory of Legal Science.* Eds. Aleksander Peczenik, Lars Lindahl, and G. van Roermund. Dordrecht: Reidel, 1984. 441–54.

—————. "Toward Integration." *Science, Morality, and Feminist Theory.* Eds. Marsha P. Hanen and Kai Nielsen. Calgary: U of Calgary P, 1987. 1–21.

—————. "Feminism, Objectivity, and Legal Truth." *Feminist Perspectives: Philosophical Essays on Method and Morals.* Eds. Lorraine Code, Sheila Mullett, and C. Overall. Toronto: U of Toronto P, 1988. 29–45.

—————. "Coherence, Justification, and Feminism." *Justification in Ethics.* Ed. Douglas Odegard. Edmonton: Academic Printing and Publishing, 1988. 39–54.

—————. "Feminism, Reason, and Philosophical Method." *Effects of Feminist Approaches on Research Methodologies.* Ed. Winifred Tomm (Waterloo, ON: Wilfrid Laurier UP, 1989. 31–50.

—————. "Reflections on Contemporary Metaphilosophy." *On the Track of Reason: Essays in Honor of Kai Nielsen.* Eds. Rodger Beehler, David Copp, and Béla Szabados (Boulder: Westview P, 1992), 193–211.

Marsha P. Hanen and Jane H. Kelley. "Social and Philosophical Frameworks for Archaeology." *The Socio-Politics of Archaeology* (Research Reports, no. 23). Eds. Joan J. Gero, David M. Lacy, and Michael L. Blakey. Amherst: U of Massachusetts, Dept. of Anthropology, 1983. 107–17.

Marsha P. Hanen and Jane H. Kelley. "Inference to the Best Explanation in Archaeology." *Critical Traditions in Archaeology: Essays in the History and Socio-Politics of Archaeology.* Eds. Valerie Pinsky and Alison Wylie. Cambridge: Cambridge UP, 1989. 14–17.

Marsha P. Hanen and Jane H. Kelley. "Gender and Archaeological Knowledge." *Metaarchaeology: Reflections by Archaeologists and Philosophers.* Ed. Lester Embree. Dordrecht: Kluwer Academic Publishers, 1992. 105–225.

Notes

1 I am grateful to Diana Relke, Robert G. Weyant, and Marsha P. Hanen, all of whom provided me with information and materials enabling me to write this essay. Pamela McCallum and Pamela Stanton both read an earlier version of the essay and provided useful editorial advice.

2 Nelson Goodman, *Languages of Art: An Approach to a Theory of Symbols,* 2nd ed. (Indianapolis: Hackett, 1976).

3 Marsha Hanen, "Introduction: Toward Integration," *Science, Morality, and Feminist Theory,* eds. Marsha Hanen and Kai Nielsen, *Canadian Journal of Philosophy,* Suppl. Vol. 13 (1987): 20.

4 Much of this information is to be found in Robert G. Weyant and Marsha P. Hanen, "The Faculty of General Studies: General Education in the 80s," unpublished paper, 1988.

3

Models, Muses, and Mothers of the Mind: Mentrix Figures in the Early Lives of Artist-Heroines

Diana M.A. Relke

Dedicated to Marsha P. Hanen, Mentrix *par excellence*

In *Cat's Eye,* Margaret Atwood's artist-heroine Elaine Risely is interviewed by a woman journalist preparing an article on the occasion of a retrospective exhibition of Elaine's paintings:

> "Did you have any female mentors?" she [the journalist] asks.
> "Female what?"
> "Like teachers, or other women painters you admired."
> "Shouldn't that be mentresses?" I say nastily. "There weren't any. My teacher was a man."[1]

Elaine's nastiness is in response to what she perceives as the journalist's desire to impose upon Elaine the new stereotype of the outraged female artist who owes her success in a male-dominated art world exclusively to the women artists who have nurtured her talent, passed on their skills, influenced her style, and sponsored her career. But Elaine resists the reductiveness of the journalist's line of questioning, perhaps because she feels that it threatens to rob her of the uniqueness of her own artistic development, her own particularity. Mentoring, after all, implies some kind of conformity on the part of the mentored to established conventions, while artists generally prefer to be recognized as *sui generis*. Overturning old conventions and initiating new traditions constitute the dream of every creative artist.

Nevertheless, Elaine's insistence that she had no female mentors, no foremothers whose work she admired, and that it has been the men in her life—chiefly her art teacher and, as Elaine says elsewhere in her interview, her husbands—who have supported and sponsored her career drew my attention to the dearth of such female figures in Canadian fiction by women. Hence I became curious about the roles women do play in assisting the development of female artistic creativ-

ity. What I have found is that female artistic development as women writers portray it is largely incompatible with traditional notions of mentoring, but that female characters are often consciously defined by the artist-heroine in terms of behaviours that facilitate and enable the artistic development of the heroine during the early stages of her life. These characters might more usefully be called "mentrix figures."

In a recent paper, feminist psychologist and educator Sandra Pyke traces the concept of mentoring back to its original source. Quoting from a study of mentoring within the academic setting, Pyke writes:

> The concept of mentoring has a long history whose origin derives from Homer's *Odyssey*. King Ulysses' friend, Mentor, was charged with nurturing, protecting and educating Ulysses' son Telemachus. Besides teaching specific skills, "Mentor also introduces Telemachus to other leaders and guides him in assuming his rightful place." Thus, Mentor's instruction transcends a narrow education but rather encompasses personal, professional, and civic development—in essence, the "development of the whole person to full capacity and integration of the person into the existing hierarchy through socialization to its norms and expectations."[2]

This traditional profile of mentoring implies the kind of conformity to "norms and expectations" that is not entirely compatible with artistic creativity. This definition is only minimally useful in identifying the roles played by women in the lives of artist-heroines. But to throw out the term "mentoring" altogether is to lose something vital, namely the functions of "nurturing, protecting and educating." Hence we need a broader definition of mentoring, one that foregrounds those qualities.[3] I am proposing the term "mentrix" not only as a newly coined feminine form of "mentor" but also as a neologism combining "mentor" with the term "matrix," meaning a womb or place in which development is facilitated and enabled.

I have borrowed the terms "facilitating" and "enabling" from Ruth Perry's introduction to *Mothering the Mind: Twelve Studies of Writers and Their Silent Partners* in which she avoids the term "mentor" altogether but radically redefines the concept to include maternal as well as paternal behaviours.[4] "Fathering the mind" would include all of the original Mentor's behaviours that could be described as "insistent, judgmental, and directive" (14). Drawing on psychoanalytic (object relations) theory, Perry uses the mothering of infants as "an informative analogy for 'mothering the mind'" (9). Her formulation is in keeping with the nurturant and protective behaviours of Mentor and involves "providing the conditions, both space and support, for explorations

that simultaneously take the artist inward and outward" (14). In other words, "mothering the mind" includes providing the "preconditions" or "context/matrix" within which "fathering the mind" can take place. It also includes "inspiring" (a Muse function) and "modelling" (as in role model). Perry detects some or all of these behaviours in both women and men: "husbands, wives, friends, aunts, sisters, lovers—and mothers" of the artists examined in her volume (8).

Perry's use of object relations theory, with its insistence upon the centrality of the mother-infant dyad, is particularly appropriate to the mentrix-protégée relationship because the theory posits the process of "introjection" as fundamental to human personality development. Within the mother-child relationship, introjection is the process by which the infant internalizes or incorporates into her own psyche aspects of the mother which then become permanent components of the child's own personality. Moreover, this interaction between mother and infant becomes the blueprint for subsequent relationships in which the growing child continues to internalize others as aspects of her developing self. Here is how Joan Rivière, an associate of Melanie Klein, the founder of object relations theory, describes the results of this process of introjection:

> There is no such thing as a single human being, pure and simple, unmixed with other human beings. Each personality is a world in himself, a company of many. That self, that life of one's own, which is in fact so precious though so casually taken for granted, is a composite structure which has been and is being formed and built up since the day of our birth out of countless never-ending influences and exchanges between ourselves and others.... These other persons are in fact therefore parts of ourselves, not indeed the whole of them but such parts or aspects of them as we had our relation with, and as have thus become parts of us.[5]

Significantly, Rivière illustrates this theory of personality development through literary examples and thereby acknowledges the important relationship of psychoanalytic theory to the theories of literature and the arts. More specific to my purposes here, Rivière's work, like that of Ruth Perry, implicitly questions the value of viewing any single work of art as the product of a lone individual working in isolation. Most important of all, the passage I have quoted begins to explain how objects become subjects and thus helps to illuminate the nature of what I am calling the mentrix-protégée relationship.

To extend Rivière's theory, the process whereby we come to be made up of aspects of others, or "objects," which inhabit our inner "object

world" is not without its complications, for what she calls the "countless never-ending influences and exchanges" may be negative as well as positive. Indeed, our object world is inhabited by "bad objects" as well as "good objects," and the influence of those bad objects can prevent us from realizing our full developmental potential. Within the mentrix-protégée relationship, "projection"—the counterpart of introjection and the process by which aspects of internal objects are imagined to be located in the other—helps to overcome the influence of bad objects. As this splitting of internalizations into good and bad objects implies, the primary mother-infant relationship is not always an appropriate or developmentally positive blueprint for subsequent relationships. But in the more successful of the mentrix-protégée relationships I will be examining, it is the positive aspects of that blueprint which determine the interaction between the two participants.

Each successful relationship between the artist-heroine and her mentrix figure is characterized by intimacy, mutual respect, and caring.[6] It is also characterized by intersubjectivity, where each participant experiences her identity interdependently—that is to say, as a subject-in-relation to the other: each participant internalizes the other and, despite this other's theoretical status as object, experiences her subjectively. In the process of mutual projection and introjection, the protégée projects onto the mentrix the idealized mother of early infancy, while the mentrix responds by projecting onto the protégée the identity of beloved child. That loving mother is in turn introjected by the protégée-child into her object world where, long after the termination of the actual relationship through geographical separation or death, the introject continues to operate as the artist-heroine's guide. In other words, the mentrix is a good object, taken in as a replacement for the inevitable bad objects who undermine self-esteem and thereby hamper artistic development. The timing of introjections and projections is crucial to the psychic development of the heroine, and the intimate connection between the participants, coupled with the mentrix's unique mentoring qualities, makes the mentrix unusually accurate in the timing of her responses and interventions.

Utilizing this broadened definition of mentoring, which incorporates the best qualities of mothering in addition to those of fathering, this paper examines the mentrix figures in four Canadian works of fiction: Margaret Laurence's *A Bird in the House* and *The Diviners*, and Alice Munro's *Lives of Girls and Women* and *Who Do You Think You Are?*[7] What all four works have in common is their autobiographical form. Each work features a mature artist-narrator who is looking back over her life—or, more accurately, recreating her life—in terms of a pattern

of artistic development. Each narrator is either overtly or covertly interested in the degree to which her young self had been conscious of her own artistic proclivities and the degree to which those around her had helped, hindered, or inappropriately defined those proclivities. Among these are a handful of models, muses, and mothers of the mind. Not all of them are women, but those who are, are almost always ambivalently drawn. Their success as mentrixes is always heavily qualified and their influence severely limited. Some of these mentrix figures are presented as succeeding in spite of themselves, while others are depicted as failed mentrixes—mentrixes in potential only. Yet these female figures, along with the male characters who perform similar functions, are interesting for the way in which their efforts are internalized and processed by the artist-heroines.

What Margaret Laurence's two artist-heroines, Vanessa MacLeod (*Bird*) and Morag Gunn (*Diviners*) have in common is their childhood consciousness of the desire to write. Where they differ is in the number and kind of facilitating and enabling relationships they experience as writers. This is, of course, partly because the action of *A Bird in the House* ends when Vanessa is an adolescent, whereas the action of *The Diviners* also includes Morag's adulthood and early middle age. But it is also because of the contrasting cultural milieux in which they spend their childhood and adolescence. In Vanessa's "respectable" middle-class environment, literary art does not play a central role, except in Vanessa's private world, whereas in Morag's world of the Nuisance Grounds, story-telling is a shared activity: primarily Christie but also Jules Tonnerre entertain Morag—Jules with his tales of the Prophet and the various Tonnerre warriors, Christie with his tales of Piper Gunn and his stories about "respectable" folks, which he reconstructs through their garbage. Story-telling is not merely a form of entertainment; it is crucial to the maintenance of cultural identity and personal subjectivity in a world that objectifies and maligns them. Oral art fills up the empty spaces left by the "respectable" middle-class thieves of esteem. Hence the young Morag is far richer in mentors and mentrix figures than is Vanessa.

The only person Vanessa shares her stories with is her Aunt Edna, a kind of second mother who draws Vanessa out on the subject of her art and stimulates her creative evolution.[8] In response to her aunt's question, "How's the poetry?" Vanessa tells her about *The Pillars of the Nation*, a story about pioneers. "You mean—people like Grandfather?" Edna replies. Perhaps it is Edna's intense preoccupation with her difficult father that fuels her curiosity about this pioneer epic and prompts her to ask Vanessa when she finds time to work on the story.

In response to Vanessa's admission that she writes in bed at night with the aid of a flashlight, Edna says:

> "Mercy, what devotion. Do you write some every day?"
> "Yes, every day," I said proudly.
> "Couldn't you spin it out? Make it last longer?"
> "I want to get it finished."
> "Why? What's the rush?"
> I was beginning to feel restless and suspicious.
> "I don't know. I just want to get it done. I like doing it." ...
> "Sure, I know," she said. "But what if you ever wanted to stop, for a change?" (*Bird* 24)

Vanessa has good reason to "feel restless and suspicious" and lose the intersubjective intimacy with her aunt, for while this cryptic exchange may only be a reflection of Edna's private struggle with her own obsessions, it also serves to prefigure the way in which she is instrumental in getting Vanessa "to stop, for a change." Edna's identification of Vanessa's fictional pioneers with the unpleasant reality of Grandfather Connor results in the young author's abandonment of *The Pillars of the Nation*. Vanessa concludes that her "pen would be better employed elsewhere" (*Bird* 67) and begins writing a love story, *The Silver Sphinx*, featuring a "barbaric queen, beautiful and terrible, ... wearing a long robe of leopard skin and one or two heavy gold bracelets, pacing an alabaster courtyard and keening her unrequited love" (*Bird* 64). But Edna, as the vehicle by which reality again impinges upon Vanessa's art, persuades her to abandon this effort as well. Overhearing her aunt bitterly weeping over her lost love, Jimmy Lorimer, Vanessa's immature notions of unrequited love are shattered:

> There arose in my mind, mysteriously, the picture of a barbaric queen, someone who had lived a long time ago. I could not reconcile this image with the known face, nor could I disconnect it. I thought of my aunt, her sturdy laughter, the way she tore into the housework, her hands and feet which she always disparagingly joked about, believing them to be clumsy. I thought of the story in the scribbler at home. I wanted to get home quickly, so I could destroy it. (*Bird* 78)

Edna's effect on Vanessa's literary activities is paradoxical. The huge dislocation between Edna as the real-life heroine of her own desperate existence and beloved Aunt Edna as the inspiration for the exotic heroine of Vanessa's fiction forces a necessary and important change upon the young writer's creative imagination. Hence Edna can be seen as an unwitting facilitator of Vanessa's artistic development, for despite

the humiliation Vanessa suffers upon acknowledgment of that dislocation, her abandonment of this over-romanticized story signifies a step in the direction of artistic maturity.

No more stories are forthcoming from Vanessa's pen, as there is no route to the realm of mature art that does not pass through the purifying fire of everyday experience, and her progress through adolescence seasons her and provides her with the experience she will eventually transform into art. But she needs some distance from that experience first. Hence, in the closing story, Vanessa has need of another kind of sponsor, one who can enable her to escape to a place more conducive to further artistic development. This enabler is her mother, who sells the family heirlooms and canvasses family members for contributions toward Vanessa's university education in Winnipeg. Upon hearing that Grandfather Connor has been coerced into selling some bonds as his contribution, Vanessa resolves not to take "a nickel of his money." However, her mother breaks down that resolve:

> "When I was your age," she said, "I got the highest marks in the province in my last year high school. I guess I never told you that. I wanted to go to college. Your grandfather didn't believe in education for women." (*Bird* 203)

This familiar parental dream—to give one's children the opportunities one has missed oneself—is also a frequent motive behind the desire to mentor. In accepting her mother as an enabler, Vanessa escapes the narrow confines of Manawaka to enter an intellectual environment where the further nurturing of her artistic sensibilities is, if not guaranteed, at least a real possibility. Hence, Vanessa's mother's role as a mentrix is in keeping with the definition of mothering the mind as providing the context within which a fathering of the mind can take place.

The role of women as potential facilitators and enablers is also a theme that runs through the story of Morag Gunn's childhood and adolescence. There are three such characters—all peripheral—who are created exclusively to allude to this theme in *The Diviners*. Morag's conscious search for a mentrix is expressed in her decision to show one of her poems to Mrs. McKee, the Sunday School teacher. "Why, this is just fine, Morag," says Mrs. McKee, "I never knew you wrote poetry." "Sure. I write lots," replies Morag, "I've got more at home. And stories. Would you—" (79). But Morag's intended request for some ongoing mentoring from the teacher is cut off by what Helen Buss describes as Mrs. McKee's "clichéd ideas of artistic form" (69), and Morag is humiliated by the teacher's criticisms of her work. In spite of her

mortification, Morag accepts Mrs. McKee's criticism and revises the poem, but when she resubmits it, her desired mentrix fails her again. Dismissing Morag with an insipid "Much better, dear," she reads out a poem by Hilaire Belloc, which Morag interprets as a reproach to her own work. "How could anybody write anything that good?" Morag thinks, as she burns her own poem while reflecting regretfully upon the fact that she has shown it to Mrs. McKee, "and there is no way she can unshow it" (*Diviners* 81).

This mentrix-protégée relationship fails because there is no intersubjective connection between the two parties. Even through Morag's child-eyes, it is evident that Mrs. McKee is in no way strong enough to connect with Morag's need for nurturing. Shabbily dressed, "tired-looking," and obliged to teach Sunday School because of her status as minister's wife, Mrs. McKee is herself in need of nurturing. Moreover, as Buss implies, Mrs. McKee's preference for Belloc's sentimental verses over Morag's skilful, if childish, ones suggests that she is totally unequipped to function in the role to which Morag wants to appoint her. Were she up to mentoring she might have chosen to read out Morag's poem to the child's Sunday School peers, for that would have been the equivalent of Mentor's task of introducing Telemachus into his appropriate professional venue and assisting him in assuming his rightful place.

Morag has a much more positive experience with a mentrix when she takes a part-time job at Simlow's Ladies' Wear. Millie Christopherson, the senior clerk, takes Morag under her wing and teaches her "Good Taste." Millie provides Morag with the kind of instruction that is crucial to her development and her future as an artist. Morag must "pass" in the world of literary art as she conceives it, and Millie gives her the tools with which to reconstruct herself in those terms. "You catch on quick, dear," Millie tells her. "It's a pleasure to tell you things." In other words, like a good mentrix Millie reinforces Morag's intellectual strengths, and at the same time reveals the gratification she receives as a mentrix. "Morag has never felt such a warmth before. She loves Millie with all her heart" (*Diviners* 112). Helen Buss suggests that this response reveals Morag's desperation for female approval (69), but that is not the whole story. An intersubjective connection, complete with mutual respect and admiration, is being established: Morag becomes conscious of herself as a subject-in-relation, and her identity is thereby strength-ened. She experiences Millie as the idealized mother of early infancy, and Millie responds in maternal fashion to the immediate need she intuits in Morag.

A similar kind of intersubjective relationship develops between Morag and her composition teacher. Indeed, Morag's experience of Miss Melrose as a mentrix operates as a corrective to the failed experience with Mrs. McKee. Morag "worships" Miss Melrose, who gives her advice about her compositions.

> Sometimes after class as well. No one ever before has talked to Morag about what was good and bad in writing, and shown her why. It is amazing. And when you look at the composition again, you can *see* why. Some things work and other things don't work. (*Diviners* 121)

This is as close as Morag gets to a mentor in the traditional sense. Miss Melrose makes herself available "after class as well," and succeeds in refining Morag's literary style by making her *understand*. This creates an intersubjective relationship between teacher and student similar to the one between Morag and Millie. Once again, Morag transfers an idealizing projection onto Miss Melrose, whom she introjects as part of her developing self. But in this case, the self that is being developed is the artistic self—Morag's fledgling sense of her own power and agency as a writer.

Miss Melrose responds to Morag's idealizing projection with a demonstration of positive maternal nurturance: after class the teacher conveys her respect for Morag's originality as a writer and encourages her to submit her essay to the student newspaper. The teacher's criticisms of Morag's work are tough, honest, and kind, and demonstrate her ability to be at once connected and detached: "It's good enough [for the student newspaper].... The story is a little sentimental in places, it seemed to me, but you haven't opted for an easy ending, at least" (*Diviners* 122). But the timing of Miss Melrose's maternal response turns out to be correct only in part, and Morag resists.

Comparing the composition teacher to Mrs. McKee, Helen Buss writes that "the more approving figure of Miss Melrose [is not] enough to bring Morag out into the open as a writer because the teacher's attention is largely of an intellectual nature and takes little heed of the emotional and physical nature of the young girl" (69). Buss is undoubtedly correct, for Morag is torn between her intellectual hunger and the sexual demands of her body—that is, her desire to "get some boy to look at [her]" (*Diviners* 123). However, I believe it is more complex than that. Because of her social and economic status in the community, Morag has outwardly aligned herself with her "outsider" peers against such middle-class institutions as education and art. She fears the scorn of the other students, especially her friend Julie Kaslik, and so she resists

Miss Melrose's suggestion. "I just can't," Morag tells her, "Not right now." Like the ideal mentrix she is, Miss Melrose responds: "Well, then, you must take your own time.... You will" (*Diviners* 122). Miss Melrose is not without desire, yet she is not in this relationship for the inappropriate gratification of her own desires over Morag's. She does not push; she knows that timing is everything.

Morag escapes to the school washroom, locks herself in a cubicle, and weeps, but not because she is sad.

> She has known for some time what she has to do, but never given the knowledge to any other person or thought that any person might suspect. Now it is as though a strong hand has been laid on her shoulders. Strong and friendly. But merciless. (*Diviners* 122)

What Morag now knows as a result of Miss Melrose's firm but caring—and deadly accurate—intervention is that she must get out of Manawaka. Significantly, in the passage that follows the scene with Miss Melrose, Morag finally gets the eyeglasses she has needed for several years. When she looks out her window at a maple tree,

> she can see the leaves. Individually, one at a time, clearly....
> Excited, she looks for a long time. Then thinks for a while about the story that will never see the light of day. "Wild Roses."
> Hm. Sentimental in places? The young teacher not marrying the guy because she couldn't bear to live on a farm—would that really happen? Maybe all that about the wild roses is overdone? Could it be changed? (*Diviners* 124)

Morag has introjected Miss Melrose in place of her own harsh super-ego—or, in object relations terminology, the bad objects who undermine her confidence and self-esteem. Conflicted as she is about publication because of her fear of scorn, that is not what occupies her mind in this passage as she thinks back on the critique of her story and considers the possibility of revision. Significantly, "Wild Roses" is informed by the theme of escape from a situation in which psychic development cannot occur.

In this connection, it is not only leaves that Morag begins to see clearly. She also begins to get a clearer sense of her own destiny, and she even attempts to write herself into existence:

> Morag living in her own apartment in the city a small apartment but lovely deep-pile rug (blue) and a beige chesterfield suite the thick-upholstered kind a large radio in a walnut cabinet lots of bookshelves a fireplace that really works.

> She has just had a story called "Wild Roses" published in the *Free Press Prairie Farmer* and is giving a party to celebrate with all her many friends. (*Diviners* 124)

Morag's introjection of Millie as well as Miss Melrose is apparent in this fantasy. Morag's fantasy apartment is the epitome of Good Taste, and the story that has been published is the one critiqued by Miss Melrose—revised to perfection, no doubt. If Morag's choice of periodicals creates a humorous dislocation, it is almost certainly because Miss Melrose is right: Morag is not quite ready to step into her future, for as she says in a typical adolescent over-reaction to her fantasy, "Shit. Who [am I] trying to kid? Worse than the story. Nothing will happen. Ever" (*Diviners* 124).

Morag's rejection of Miss Melrose's suggestion to publish immediately does not signify the failure of this mentoring relationship. Indeed, the suggestion is a highly successful intervention because it catapults Morag into a point-of-no-return position on her developmental path. Morag herself knows that, as her verbal response to Miss Melrose's suggestion indicates: "I just can't. Not right now," she says, implying that she will publish eventually. When Morag finally does publish her first piece, in the university student newspaper, it is almost certainly in part because she still carries with her, inside her object world, the introject of Miss Melrose. In this way, Miss Melrose succeeds again where Mrs. McKee failed, namely, in the area of introducing Morag into the public arena of her future artistic activities.

In contrast to Margaret Laurence's works, where the university represents a legitimate venue for artistic development, in the fiction of Alice Munro there is a direct and almost hostile opposition between academic and artistic pursuits. Academic work is presented as an obstacle to artistic self-realization rather than a vehicle for achieving it. Hence, although both Del and Rose have possible mentrixes—very strong ones, in fact—those potential mentrix figures impose on the heroines a definition of success as intellectual and academic. This definition cramps the heroines' artistic imaginations; hence it must be resisted. For neither Del nor Rose is there anyone—male or female—who consciously or unconsciously perceives her immediate creative needs or steps in to assist the heroine in reaching the next stage in her artistic development. This is in part because, unlike Laurence's heroines, neither Del nor Rose is anywhere near conscious enough of her creative potential. Each heroine must find her own way, develop a sense of her own creativity, through experiences that nurture the body as well as the mind. Nevertheless, each novel does contain mentrix

figures, although some of them are even more ambivalently drawn than those created by Laurence. Interestingly, the character in each work who is ultimately revealed as the key that unlocks the heroine's artistic creativity is male. Yet these characters, despite their gender, mother rather than father the minds of the heroines, for they do no direct mentoring, but rather perform the task of modelling artistic creativity.

In *Lives of Girls and Women*, Ada Jordan works hard to facilitate her daughter Del's intellectual life. For Mrs. Jordan, education represents Del's only way out of what is perceived as the total ignorance and lack of refinement characteristic of life out on the Flats Road—that is, on the "wrong side of the tracks" in Jubilee. Even among Jubilee's socially and economically more advantaged, general ignorance and lack of refinement are the norm: there are women like "Mrs. Lawyer Coutts" who, according to Mrs. Jordan, is "a stupid woman who [is] uncertain who Julius Caesar was … and who also [makes] mistakes in grammar" (*Lives* 61). Among these intolerable provincials Ada Jordan, a well-read woman with a high school education, stands out as an exotic alien.

Mrs. Jordan's ambitions for Del are in the realm of the purely intellectual: "There is a change coming I think in the lives of girls and women," she tells Del, "but it is up to us to make it come."

> All women have had up till now has been their connection with men. All we have had. No more lives of our own, really, than domestic animals….
>
> "But I hope you will—use your brains. Use your brains. Don't be distracted, over a man, your life will never be your own. You will get the burden, a woman always does." (*Lives* 147)

Mrs. Jordan's implied sexual abstinence, together with the vicissitudes characteristic of mother-daughter relationships, promotes Del's reaction against Mrs. Jordan's role as a facilitator of her daughter's intellectual life. The clamour of Del's sexual and emotional needs, like that of Morag Gunn, is in conflict with what Del perceives as the sterility of her mother's intellectualism. Identified with Tennyson's protofeminist intellectual Princess Ida, Ada Jordan is the champion of the academy over the life of emotional and sexual experience.

Perhaps because she is still so unconscious of her literary proclivities, Del even resists her mother's modelling of the writing life; indeed, Del cringes with embarrassment at the creative pieces her mother publishes in the local newspaper. Mrs. Jordan's articles

> appeared on a page in the city paper given over to lady correspondents, and for them she used the nom de plume *Princess Ida*, taken from a character in Tennyson whom she admired. They were full of long

decorative descriptions of the countryside from which she had fled *(This morning a marvellous silver frost enraptures the eye on every twig and telephone wire and makes the world a veritable fairyland—)* and even contained references to Owen and me *(my daughter, soon-to-be-no-longer-a-child, forgets her new-found dignity to frolic in the snow)* that made the roots of my teeth ache with shame. *(Lives* 68)

Mrs. Jordan may be a potential literary role-model but her style militates against it. More important, her text entraps Del, silences her, and defines her in its author's terms. Del's developmental task at this point is to escape this objectification of her self so that she can eventually establish her own subject position in her own texts.

Mrs. Jordan has come by her passion for intellectual pursuits quite honestly, for her mother had been a schoolteacher "before marriage and religion overtook her" *(Lives* 65). But when young Addie Morrison had "wanted to go to high school in town ... her father said no, she was to stay home and keep house until she got married" *(Lives* 65). But Addie runs away from her uncouth father and brothers and eventually gets her coveted high school diploma, thanks to two women who take the place of her failed parents. Grandma Seeley, the owner of a boarding house, agrees to give Addie room and board in exchange for housework. Like the original Mentor, Grandma Seeley is a protector in that she conceals Addie from her pursuing father until he loses interest. She also gives the impoverished farm girl "a plaid dress, scratchy wool, too long, which she wore to school that first morning when she stood up in front of a class all two years younger than she was and read Latin, pronouncing it just the way she had taught herself, at home. Naturally, they all laughed" *(Lives* 65). The implication here is that while Grandma Seeley attends to Addie's basic needs—quite literally, food, shelter, and clothing—something more is needed.

That something more is provided by Miss Rush, a teacher and another of Grandma Seeley's lodgers, who is both nurturing and educating in the sense that those qualities existed in the original Mentor. Miss Rush fulfils more complex cravings in Addie than can Grandma Seeley's gifts. As Del relates,

> Miss Rush taught my mother to sew, gave her some beautiful merino wool for a dress, gave her a yellow fringed scarf, ... gave her some eau de cologne. My mother loved Miss Rush; she cleaned Miss Rush's room and saved the hair from her tray, gleanings from her comb, and when she had enough she made a little twist of hair which she looped from a string, to wear around her neck. That was how she loved her. Miss Rush taught her how to read music and play on Miss Rush's own piano, kept in Grandma

Seeley's front room, those songs she could play yet, though she hardly
ever did. "Drink to Me Only with Thine Eyes" and "The Harp that Once
through Tara's Halls" and "Bonny Mary of Argyle." (*Lives* 66)

It is hardly surprising that Addie projects onto Miss Rush the idealized
mother of infancy, for she is the ideal facilitator-mother/mentrix in that
she nurtures the whole of her protégée: her gifts to Addie are both
spiritual and material—and traditionally feminine. Most important,
she feeds Addie's hunger for a degree of personal refinement that would
bring her more into line with her ego ideal; in this way Miss Rush
resembles Millie in *The Diviners*. Addie's hunger for refinement is even
more gnawing than her need for the basics provided by Grandma
Seeley: the merely functional plaid dress which, together with Addie's
Latin recitation, earns her the derision of her classmates cannot
compare with a luxurious garment made of "beautiful merino wool" and
set off by a "yellow fringed scarf." The implication is that book-
knowledge alone is not enough. The pendant of hair Addie wears
around her neck signifies her possession of Miss Rush—that is, her
introjection of her as the "good object."

Death robs Addie of both her sponsors—a particular tragedy in the
case of Grandma Seeley, who had planned to lend the girl the money
to attend Normal School (*Lives* 66)—and Addie goes on to repeat in
important ways her mother's life. That is to say, she marries a man and
raises a son, both of whom are as indifferent to education and
refinement as were her father and brothers. Hence she is determined
that her daughter not make the same mistake; in this way she recalls
Vanessa's mother in her determination to provide her daughter with
the opportunities of which she herself had been deprived. But beneath
Mrs. Jordan's conscious rationalization of her ambitions for Del lies a
desire to experience her unlived life vicariously through her daughter.
Because of this, her interpretation of the potential of Del's intelligence,
phenomenal memory, and love of books is narrow in the extreme. Mrs.
Jordan misses what these qualities say about Del as a potential literary
artist and can envision her only in terms of a budding scholar
conforming to the norms and conventions of academe. She offers Del
the story of her own life as a *cautionary* tale in the hope that Del will
succeed where her mother had failed to fulfil her own promise.
However, Del accepts her mother's story as a cautionary *tale*, a story
of "struggle, disappointment, more struggle, godmothers and villains"
(*Lives* 67), a story that can be dramatically embroidered and embel-
lished in Del's retelling of it.

Mrs. Jordan's misperceptions of her daughter's latent talents are
perhaps understandable, given that she and Del share a huge appetite

for knowledge. However, their appetites are not identical. Mrs. Jordan has a passion for the facts of history and a love of the abstractions contained in the encyclopedia she sells, whereas Del loves the concrete materiality of the volumes and the photographic reproductions, which seem to recreate the violence and the passion, rather than merely the ideas, of the past (*Lives* 55).

These contrasting preferences go to the heart of the difference between Mrs. Jordan and Del: the celibate life of intellectual pursuit versus the life of the body *and* the mind together. "I did not want to be like my mother," says Del, "with her virginal brusqueness, her innocence. I wanted men to love me, *and* I wanted to think of the universe when I looked at the moon" (*Lives* 150). But there are no models in Jubilee for this kind of integration; hence, like the young Morag, Del finds her intellectual and sexual desires in conflict. Her all-consuming affair with Garnet French undermines her performance in her scholarship exams, but even in the throes of a broken heart she finds that she can objectify her suffering, manipulate it, render it "literary":

> I was amazed to think that the person suffering was me, for it was not me at all; I was watching. I was watching, I was suffering. I said into the mirror a line from Tennyson, from my mother's *Complete Tennyson* that was a present from her old teacher, Miss Rush. I said it with absolute sincerity, absolute irony. *He cometh not, she said.* (*Lives* 200)

Here, Del creates her own text and her subject position within it. Her invocation of Miss Rush at this point in her narrative is significant, for Miss Rush, whose sensuousness and artistic inclinations had been expressed in her gifts to Addie—fine-textured fabrics, music, cologne, poetry—is a far more appropriate model for Del than is her austere mother.

But in this penultimate chapter, Del is more or less unconscious of the gift she has received from Miss Rush through her own literary adaptation of Mrs. Jordan's story of her young self, a story that is Mrs. Jordan's most important gift to her daughter. Indeed, in the final chapter, where we get a stronger sense than ever before of an adult writer-narrator looking back on her adolescence, we are told just how oblivious the young Del had been to those who had modelled artistic/literary creativity for her. Recalling the afternoon she sat on the porch with the supposedly fragile Bobby Sherriff, newly released from the mental hospital, the narrator says:

> It did not occur to me then that one day I would be so greedy for Jubilee. Voracious and misguided as Uncle Craig out at Jenkin's Bend, writing

his history, I would want to write things down....

Then he [Bobby Sherriff] did the only special thing he ever did for me. With those things in his hands, he rose on his toes like a dancer, like a plump ballerina. This action, accompanied by his delicate smile, appeared to be a joke not shared with me so much as displayed for me, and it seemed also to have a concise meaning, a stylized meaning—to be a letter, or a whole word, in an alphabet I did not know.

People's wishes, and their other offerings, were what I took then naturally, a bit distractedly, as if they were never anything more than my due.

"Yes," I said, instead of thank you. (*Lives* 210–11)

To the adult narrator of these closing paragraphs of the novel, even Uncle Craig, whose recording of dry historical fact had prevented him from becoming a viable model for Del, can now be seen as modelling at least the *desire* "to write things down." More important, she sees that it had been Bobby Sherriff's fantastic gesture—a gesture of self-transformation in terms of the art of dance—that should have opened her consciousness to her creative potential. But that gesture, that gift, had been a letter, a word, in a language Del did not yet know. The linguistic metaphor is significant, for if this is not a creative awakening for the young Del, it certainly is for the adult narrator. Seen in contrast to their ambivalently drawn female counterparts, Bobby Sherriff and Uncle Craig exert a degree of influence upon Del's artistic development that is out of all proportion to their active investment in it.

Who Do You Think You Are? repeats the pattern I have traced in *Lives of Girls and Women*. Rose, who eventually finds her creative identity as an actress, experiences a childhood similar to that of Del Jordan in that she grows up in a semi-rural, lower-middle-class Ontario community, where higher education and cultural refinement are looked upon with suspicion. But unlike Del, the determined Rose wins her university scholarship and hence her escape from Hanratty. As a scholarship girl, she is chosen by Dr. Henshawe, a retired English professor, to be her protégée and live in Dr. Henshawe's quiet and tastefully furnished house, where Rose must submit to being told that she is "a scholar" (and hence uninterested in sex) and is instructed on how she is to conduct herself as such:

[Rose] could not really decide how much she liked being at Dr. Henshawe's. At times she felt discouraged, sitting in the dining room with a linen napkin on her knee, eating from fine white plates on blue placemats. For one thing, there was never enough to eat, and she had taken to buying doughnuts and chocolate bars and hiding them in her room. The canary swung on its perch in the dining room window and Dr. Henshawe

directed conversation. She talked about politics, about writers. She mentioned Frank Scott and Dorothy Livesay. She said Rose must read them. Rose must read this, she must read that. Rose became sullenly determined not to. (*Lives* 69)

Rose identifies with the canary in its cage, here in this house where there is "never enough to eat" in more ways than one. She does not get the kind of nourishment/nurturing she needs. Like Del Jordan, she experiences her sexual and emotional needs as more urgent than intellectual hunger, and she finds Dr. Henshawe's style of life as sterile as Del does her mother's.

Rose is unclear about what kind of nurturing she wants. She studies the photographs of former scholarship girls who have completed their university degrees as protégées of Dr. Henshawe. Most of these women had enjoyed professional careers before becoming wives and mothers, but "Rose [does] not care for the look of them, for their soft-focused meekly smiling gratitude, their large teeth and maidenly rolls of hair...."

There were no actresses among them, no brassy magazine journalists; none of them had latched on to the sort of life Rose wanted for herself. She wanted to perform in public. She thought she wanted to be an actress but she never tried to act, was afraid to go near the college drama productions. She knew she couldn't sing or dance. She would really have liked to play the harp, but she had no ear for music. She wanted to be known and envied, slim and clever. She told Dr. Henshawe that if she had been a man she would have wanted to be a foreign correspondent. (*Who* 71)

The photographs of Rose's predecessors at Dr. Henshawe's seem to bear the stamp of conformity and sterility which Munro implicitly identifies with academic life. Significantly, Rose does not share her dream of acting with her self-appointed mentrix. Yet there is reason to suspect that Dr. Henshawe just might have been willing to assist Rose in fulfilling that dream, for in response to Rose's seeming interest in a career as a foreign correspondent, Dr. Henshawe alarms her by saying, "Then you must be one." Echoing Ada Jordan, she continues: "The future will be wide open, for women. You must concentrate on languages. You must take courses in political science. And economics. Perhaps you could get a job on the paper for the summer. I have friends there" (*Lives* 71). But Rose rejects the notion that education is the route to fulfilment, and like Del Jordan, whose affair with Garnet French undermines her studies, Rose abandons university in favour of marriage to Peter Blatchford, Dr. Henshawe's acknowledged adversary. Via a long and circuitous route through marriage, motherhood,

divorce, and several unsatisfying temporary jobs—all of which ambiva-
lent experiences turn out to be exactly what her artistic development
had required all along—Rose finally achieves her dream of becoming an
actress.

Dr. Henshawe should not, however, be seen as a total failure in her
role as facilitator. Besides using her influence to get Rose a job in the
university library, through her confrontations on the subject of Peter
she also gets Rose to articulate her ambivalence about marriage, which
helps Rose to confront Peter in turn. More important, Dr. Henshawe
introduces Rose into a style of life she has never experienced and hence
provides her with a transitional space in which to observe and practise
the manners and mores of upper-middle-class life, which serves her
well in Peter's world. In this way, Dr. Henshawe resembles Millie
Christopherson, Morag's mentrix. An interesting metaphor conveys
this introjection of Dr. Henshawe: she loans Rose her stylish raincoat
for Rose's trip to Peter's parents' home on Vancouver Island. "It was a
bit long, but otherwise all right, due to Dr. Henshawe's classically
youthful tastes." This garment compensates for Rose's somewhat less
stylish wardrobe, particularly the "fuzzy angora sweater, peach-
coloured, which was extremely messy and looked like a small-town
girl's idea of dressing up" (*Who* 85). The raincoat recalls the pendant of
Miss Rush's hair that Addie Morrison wears around her neck.

As in *Lives of Girls and Women*, a new male character is introduced
into the narrative in the closing chapter and identified as responsible
for an important turning point in the heroine's life. Like Bobby Sherriff,
this character from Rose's adolescence is seen by the adult narrator as
having been instrumental in bringing her young self closer to an
awareness of her own creative desires. In high school Ralph Gillespie
had entertained Rose and his other schoolmates with his imitation of
Milton Homer, the "village idiot":

> Rose never quite got over a comradely sort of apprehension on his behalf.
> She had another feeling as well, not envy but a shaky sort of longing. She
> wanted to do the same. Not Milton Homer; she did not want to do Milton
> Homer. She wanted to fill up in that magical, releasing way, transform
> herself; she wanted the courage and the power. (*Who* 204)

Looking back on her adolescence in the closing chapter, the narrator
recognizes the importance of Ralph Gillespie in the awakening of her
creative desire, just as the narrator of *Lives* acknowledges Bobby
Sherriff's gift. "What could she say about herself and Ralph Gillespie,"

reads the closing sentence in the novel, "except that she felt his life, close, closer than the lives of men she'd loved, one slot over from her own?" (*Who* 210). As in *Lives of Girls and Women*, it is a male figure who achieves the most influence for the least amount of mentoring and modelling energy expended.

Margaret Atwood's Elaine Risely may be correct when she says there were no female artists-mentors. For she, like the artist-heroines of Margaret Laurence and Alice Munro, grew up in an era in which women artists in large numbers were prevented from achieving the status required for official mentoring. Yet as I hope this examination of mentrix figures has suggested, women writers are on some level aware that the context within which *official* mentoring—fathering of the mind—takes place is often provided by figures of ostensibly lesser importance who *unofficially* mother the mind, and that these mothers of the mind are, more often than not, women. If their ambivalent portraiture raises the spectre of female victimization in a culture that questions the legitimacy of their influence, it also suggests that despite the often limited extent of that influence and even their outright failure, the women writers who create them are aware of the need for mentrix figures in the lives of developing female artists.

However ambivalently expressed, the presence of characters who may be construed as models, muses, and mothers of the mind helps us to focus on the nature of artistic creativity. At the very least these characters remind us—in the words of Joan Rivière—that "there is no such thing as a single human being, pure and simple, unmixed with other human beings," and that the self "is a composite structure which has been and is being formed and built up since the day of our birth out of countless never-ending influences and exchanges between ourselves and others." At best, these mentrix figures help "to illustrate the principle that creation is more collaborative than we have been taught to think," for their presence is a reminder that "in this day and age," as Ruth Perry has written, "we can no longer afford the mythology of the individual genius toiling alone to realize his solitary vision, oblivious to the rest of the world. It is time to reinstate the value of connectedness—of the artist to his or her family, to personal history, and to the person or persons who supported the work and encouraged its free expression" (21–22). In a sense, Laurence's and Munro's texts, autobiographical in form if not always in content, covertly and some-times overtly acknowledge the support of individuals who make artistic achievement possible.

Diana M.A. Relke is Associate Professor and Director of Women's and Gender Studies at the University of Saskatchewan. Her research interests include Canadian cultural history, British and Canadian literature by women, metapsychology, and feminist theory. Her current scholarly project is a series of biographies of prominent Canadian feminist academics, which features a biography of Marsha Hanen, whom Relke credits as the most significant influence in her development as an interdisciplinarian.

Notes

1 Margaret Atwood, *Cat's Eye* (Toronto: McClelland-Bantam, 1988) 94.

2 Sandra W. Pyke, "Gender Issues in Graduate Education," unpublished paper, 1991, 11.

3 On the insurmountable difficulty of pinning down the concepts of role model, mentor, sponsor, and the like, see Jeanne J. Speizer, "Role Models, Mentors, and Sponsors: The Elusive Concepts," *Signs* 6.4 (1981): 692–712; and Bernice Fisher, "Wandering in the Wilderness: The Search for Women Role Models," *Signs* 13.2 (1988): 211–33.

4 Ruth Perry, "Introduction," *Mothering the Mind: Twelve Studies of Writers and Their Silent Partners*, eds. Ruth Perry and Martine Watson Brownley. (New York: Holmes and Meier, 1984) 3–14.

5 Joan Rivière, "The Unconscious Phantasy of an Inner World Reflected in Examples from Literature," *New Directions in Psychoanalysis*, eds. Melanie Klein, Paula Heimann, and R.E. Money-Kyrle (New York: Basic Books, 1955) 358–59.

6 For a further discussion of the way in which these concepts operate in the educational—that is, the mentoring—context see Pyke and, in addition, Carol Gilligan, *In a Different Voice: Psychological Theory and Women's Development* (Cambridge, MA: Harvard UP, 1982); Mary Field Belenky, et al., *Women's Ways of Knowing: The Development of Self, Voice, and Mind* (New York: Basic Books, 1986); and Nel Noddings, *Caring: A Feminine Approach to Ethics and Moral Education* (Berkeley, CA: U of California P, 1984).

7 Margaret Laurence, *A Bird in the House* (1963; Toronto: McClelland and Stewart, 1974); Margaret Laurence, *The Diviners* (1974; Toronto: Bantam Books, 1975); Alice Munro, *Lives of Girls and Women* (1971; Toronto: New American Library of Canada, 1974); Alice Munro, *Who Do You Think You Are?* (1978; Toronto: Signet, 1979).

8 For an analysis of the mother figures in Vanessa's life who help her develop her feminine identity, rather than merely her artistic identity, see Helen Buss, *Mother and Daughter Relationships in the Manawaka Works of Margaret Laurence* (Victoria, BC: U of Victoria/English Literary Studies Monograph No. 24, 1985) 54–64.

References

Atwood, Margaret. *Cat's Eye*. Toronto: McClelland-Bantam, 1988.

Belenky, Mary Field, Blythe McVicker Clinchy, Nancy Rule Goldberger, and Jill Mattuck Tarule. *Women's Ways of Knowing: The Development of Self, Voice, and Mind*. New York: Basic Books, 1986.

Buckley, P., ed. *Essential Papers on Object Relations*. New York: New York UP, 1986.

Buss, Helen M. *Mother and Daughter Relationships in the Manawaka Works of Margaret Laurence*. Victoria, B.C.: University of Victoria/ English Literary Studies Monograph No. 34, 1985.

Esman, A. H., ed. *Essential Papers on Transference*. New York: New York UP, 1990.

Fisher, Bernice. "Wandering in the Wilderness: The Search for Women Role Models." *Signs* 13:2 (1988): 211–33.

Gilligan, Carol. *In a Different Voice: Psychological Theory and Women's Development*. Cambridge, Mass.: Harvard UP, 1982.

Laurence, Margaret. *A Bird in the House*. 1963; rpt. Toronto: McClelland and Stewart, 1974.

Laurence, Margaret. *The Diviners*. 1974; rpt. Toronto: Bantam Books, 1975.

Munro, Alice. *Lives of Girls and Women*. 1971; rpt. Toronto: New American Library of Canada, 1974.

Munro, Alice. *Who Do You Think You Are?* 1978; rpt. Toronto: Signet, 1979.

Noddings, Nel. *Caring: A Feminine Approach to Ethics and Moral Education*. Berkeley, CA: U of California P, 1984.

Perry, Ruth. Introduction, *Mothering the Mind: Twelve Studies of Writers and their Silent Partners*. Ruth Perry and Martine Watson Brownley, eds. New York: Holmes and Meier, 1984: 3–14.

Pyke, Sandra W. "Gender Issues in Graduate Education," unpublished paper, 1991.

Silverman, Helen W., and Judith F. Lasky. *Love: Psychoanalytic Perspectives*. New York: New York UP, 1988.

Speizer, Jeanne J. "Role Models, Mentors, and Sponsors: The Elusive Concepts." *Signs* 6:4 (1981): 629–712.

Wolstein, B., ed. *Essential Paper on Countertransference*. New York: New York UP, 1988.

4

Images of Winnipeg's North End: Fictionalizing Space for the Ethnic and Female "Other"

TAMARA PALMER SEILER

Among the contributions that fiction writers have made to our imaginations, both individual and collective, are a number of evocations of place so compelling that they have, paradoxically, become more real to people as fictional landscapes than as actual ones. Thomas Hardy's Wessex country, Mark Twain's Hannibal, William Faulkner's Yoknapatowpha County are such places for readers of English and American literature. Readers of Canadian literature would certainly add others to a list of "real" fictional places, such as Stephen Leacock's Mariposa, Margaret Laurence's Manawaka and Mordecai Richler's St. Urbain Street. And, although not a great deal has been written about its depiction in fiction, these readers might also add to such a list Winnipeg's "North End" prior to World War II, not so much because of its re-creation in the work of one writer, but because it emerges from the work of a number of Canadian writers, particularly those interested in fictionalizing immigrant and ethnic experience.

While it is perilous to draw firm general conclusions from limited and complex data, one can see an interesting pattern of difference both among male writers and among female writers and between them with regard to their depiction of the North End ethnic ghetto and of the spaces within it that they carve out for women. Male writers tend to shape the North End into a perpetually dualistic combat zone and women into repositories of either its best or its worst qualities; female writers, to varying degrees, shape it into a warm, nurturant, ultimately powerfully syncretic space wherein limiting and repressive dualities can be creatively shattered thereby making spaces that include rather than exclude those "othered" by rigid concepts of ethnicity and/or gender.[1]

Indeed, one might see the North End as a very significant spot in the Canadian literary landscape, a kind of archetypal place in a "land of invisible ghettos,"[2] its various depictions the imaginative products of inevitable tensions in a new and multi-ethnic society. Upon a closer

look, some of these fictions can also be seen as attempts to deny or to create legitimate space for newcomers within the nation's cultural imagination as well as its economy and society.[3] Interestingly, many of them also interrelate legitimizing the immigrant and ethnic "other" with engendering space for the female "other."

It is perhaps not surprising that Winnipeg's North End would emerge as a kind of symbolic backdrop for the portrayal of immigrant and ethnic life in Canada and of inter-ethnic tensions. Strategically located in the middle of the continent, Winnipeg early became an important centre in the fur trade, and later a railroad centre and gateway to westward expansion. Developing at the heart of Canada's railway and immigration boom, Winnipeg itself boomed, experiencing a period of growth and prosperity between the 1890s and 1914 "unequalled in Canadian urban development."[4] Attracting a substantial number of the many immigrants who came to Canada during this formative period in the history of the Canadian West, Winnipeg was a microcosm of Canada's development in the first half of the twentieth century, of both its potential and its problems.

One of the most serious of these problems "was the conflict of values between the charter groups and the immigrants, many of whom were Slavs and Jews who did not fit into the Anglo-Canadian mould and as a result experienced overt discrimination." This conflict was concretely expressed in the city's urban landscape, which "was divided ... in two: the 'North End' was the home of most of the city's Slavs and Jews; the prosperous and politically dominant Anglo-Saxons were concentrated in the W(est) and S(outh)" (Artibise, 1951).

The connections between this socio-historical reality and the depiction of the North End in the work of ethnic writers are complex and indirect, all the more so when one appreciates that so-called "realism" in literature is an artificial literary mode, that language does not simply reflect reality but creates it, and that ethnicity itself can be viewed as an invention, created in part by literature. At the same time, socio-historical forces exercise an indirect influence on fictionalized ethnicity. They implicitly inform the ways in which Winnipeg's North End is portrayed in the several fictions under study here as a central vehicle for both reflecting and projecting binary structural and thematic patterns that recur frequently, and indeed underlie fiction dealing with immigrant and ethnic experience in Canada.[5] Together, these fictions and the binary patterns they employ make of the ghetto a paradoxical symbol of both confinement and possibility in the struggle of "the other," both ethnic and female, to find a place in Canadian society and culture.

As a fictional creation, the North End has been rendered in a variety of seemingly contradictory ways as a vehicle for various kinds of social criticism and as a means of both closing off and opening up new psychic and cultural spaces. Such is the case with one of the earliest versions of the North End, that provided by Ralph Connor (Charles Gordon) in his novel, *The Foreigner* (1909). Though a moderate voice in his day, Connor very definitely speaks from within the discourse of the Anglo-Canadian nativist male mainstream, creating from that position a North End that is dark, seamy, violent, primitive—very much a Social Problem in need of the ministrations of the enlightened Anglo-Saxon race.[6] Connor describes a "Galician" wedding to suggest the vast gulf that separates the ethnic North from the non-ethnic (that is, Anglo-Saxon) South Winnipeg.

> Meantime, while respectable Winnipeg lay snugly asleep under snow-covered roofs and smoking chimneys, while belated revellers and travellers were making their way through white, silent streets and avenues of snow-laden trees to homes where reigned love and peace and virtue, in the North End and in the foreign colony the festivities in connection with Anka's wedding were drawing to a close in sordid drunken dance and song and in sanguinary fighting ... foul and fetid men stood packed close, drinking while they could.[7]

In this and in similar evocations of the depravity contained within the boundaries of the ethnic ghetto, Connor conjures up a North End that both symbolizes and helps to create the vast distance he believes separate the Slav and the Anglo-Saxon, between whose "points of view stretched generations of moral development" (87). Connor's North End is clearly the product of a dualistic mind-set and in this regard, despite the Anglo-centrism of his dualism, is a precursor of the later depictions by male ethnic writers. But, in emphasizing distance, negative difference, and potential threat, Connor's depiction of the North End, more than later ones by ethnic writers, becomes a rhetorical device—a way of vividly laying out a problem in such a way as to call for a particular solution. He does this through his missionary character, Mr. Brown, when the latter asserts that "these people here (i.e., in the North End) exist as an undigested foreign mass. They must be taught our ways of thinking and living, or it will be a mighty bad thing for us in Western Canada" (255).

Connor also does this by depicting the old world of his ethnic characters as wholly negative, something whose traces must be completely stamped out. Ironically, their new lives are to be built upon the supposedly superior old-world inheritance of the Anglo-Saxon

characters, as symbolized at the end of *The Foreigner* by Kalman's marriage to a Scottish heiress. Such marriages, common in a variety of forms in Canada's Fiction of Ethnicity[8] will, in Connor's fictional landscape, ultimately eliminate ethnicity and the problematic ghetto that embodies it.[9] Thus,Connor's North End is a vehicle for social commentary, and a means of barring non-Anglo-Saxon ethnicity from the psychic and cultural spaces of full legitimacy. By defining success for immigrants as denunciation and rebirth, Connor attempts to control the space they can occupy: their past selves must disintegrate and be forgotten. They must assume a new identity, the superior "Anglo-Saxon" one.

Writing many years later and from perspectives very different from Connor's, a number of second-generation ethnic writers have also fashioned the North End into a fictional vehicle for social criticism and a means of making a space for themselves in the Canadian cultural landscape. In so doing, they have together, as apologists for their respective groups, made the North End a kind of emblem of their displacement, marginality, and ambivalence.[10]

In the work of such ethnic writers as John Marlyn, Adele Wiseman, Maara Haas, and Ed Kleiman, evocations of the North End and its place in the lives of their characters are among the chief means of developing the fundamentally binary pattern that underlies their fiction and that of Canada's Fiction of Ethnicity as a whole.[11] Their fictional ghettos, though rendered with differing degrees of literary skill, locate and make concrete the interplay of tensions inherent in the polarities between old world/new world, success/failure, identity/disintegration, revelation/concealment, forgetting/remembering, illusion/reality, and integration/resistance, that to varying degrees shape and animate their narratives.

One can see the interplay of these polarities in John Marlyn's *Under the Ribs of Death*, in which the reader finds at least two contrasting versions of the North End. The version that seems at first to dominate is that of the main character, Sandor Hunyadi, who, as the son of Hungarian immigrants and a child of the North End, sees it as a blighted wasteland. The oppressive significance that Sandor attaches to the neighbourhood is suggested in the very first image the reader encounters, that of a lonely young Sandor unhappily enmeshed in the sights, sounds, and smells of deprivation:

> The streets were quiet now. His footsteps beat a lonely tattoo on the wooden sidewalk. The wind behind him ruffled his hair. Above him the lights went on, and over the face of Henry Avenue, half-hidden the

moment before by soft, fraudulent shadows, there sprang into view an endless grey expanse of mouldering ruin.[12]

The reader also learns almost immediately that the young Sandor already views his neighborhood in the negative light cast on it by more desirable sections of the city when, to assuage his disappointment over the thought of the humble supper awaiting him, he imagines himself "the way he would be when he was a man sitting in the lobby of the Hotel, bright button shoes on his feet, his hat and cane on a table nearby—rich and well fed and at ease there in one of the great leather chairs" (17).

That Sandor views the gulf between these sharply contrasting spaces in terms of both ethnicity and wealth is also very clear. As if a deliberate mirror image of Connor's urban geography in *The Foreigner*, Sandor's North End has taught him about the connection between wealth and ethnicity,[13] a painful lesson that induces him to beg his father to change their name so that they can be like the "English ... the only people who count.... Their fathers got all the best jobs. They're the only ones nobody ever calls foreigners" (24). The North End also engenders in him a passionate desire to escape from "the dirty clutter of the street he lived on, ... crawling with pale, spindly kids ... and the battered houses with the scabrous walls and the shingles dropping and the walls dirt-stained and rain-streaked" (24) into the world of the "English" far away in another part of the city. When he does travel there to mow lawns in a world of beauty, wealth, and ease, Sandor explains his journey as being one "into a picture in one of his childhood books, past the painted margin to a land that lay smiling under a friendly spell, where the sun always shone and the clean-washed tint of sky and child and garden would never fade; where one could walk but on tip-toe, and look and look but never touch, and never speak to break the enchanted hush" (64).

The pastoral imagery Sandor uses to describe the South End of the city, where he imagines everyone he sees is "rich, English and happy" contrasts sharply with the disease imagery that permeates his descriptions of the North End, whose buildings seem to him "like a silent herd of monstrous beasts stricken with some unnameable disease, slowly dying as they stood there, their members rotting and falling from them" (74). Given this profoundly bifurcated sense of his surroundings, and his relationship to them, it is not surprising that Sandor should be "seized" by "something stronger than envy" (66)—an overwhelming desire that fuels his intense determination to "grow up and leave all this ... leave it behind him forever" (17).

But there is yet another dichotomy in Sandor's sense of place: his own positive feelings, however muted, about his family and friends occasionally colour his vision of the North End in more roseate hues. Perhaps the most striking example of this is his reaction to the party his family holds in honour of his Uncle Janos's arrival from Hungary. Sandor looks on "in astonishment" at the ways in which the drab Hunyadi home has been transformed by the Hunyadi geranium, whose "blood-red blossoms gave an air of festivity to the room"; "the strains of an accordian"; the people of all ages from the neighborhood talking, laughing, and obviously enjoying themselves; the dancing of his uncle and his parents who "did not merely dance" but seemed to fly, "their feet [hardly touching] the ground"; and by the food, "savoury and varied and as spicy as an adventure, rich with the treasured cooking-lore of the whole of Europe" (87–89). This positive image of the North End, one in which the ethnic ghetto is not a decaying prison, but a warm, communal home, a repository of genuinely creative human forces, is represented in large measure by Sandor's mother, and later his wife, Mary, and by the humanism of his father. Sandor, who regards the latter as ineffectual, perhaps effeminate, glimpses this North End only fleetingly. Marlyn uses Sandor's blindness to create the chief vehicle for his social commentary: dramatic irony that allows the reader to see what Sandor is usually incapable of seeing, making the South End a negative counterpoint, a symbol of all that is phoney and ultimately destructive.

Thus, *Under the Ribs of Death* embodies two visions of the North End, thereby suggesting, as John Roberts has pointed out, that the novel is concerned with portraying an ethnic sensibility as one that must grapple with competing versions of reality. And, as Roberts also argues, Marlyn's use of irony is appropriate, perhaps inevitable, since "irony is intrinsic to a problematic reality" like that of the displaced immigrant.[14] One could see female experience as similarly problematic since it could be argued that to be female is to be "othered" by male-centred social structures and institutions, including language itself. Kay Schaffer, for example, suggests that Western culture (and its languages) places man in the centre and woman on the margins as "other": "The assumption that the masculine (man, Empire, Civilization) has an unquestioned God-given right to subdue or cultivate the feminine (woman, Earth, Nature) and appropriate the feminine to masculine domination is a constant structuring principle of Western discourse."[15] While it would be difficult, if not impossible, to argue conclusively that this profound othering of the female is related to the othering of the immigrant, it seems clear that the processes involved are similar and that language

and storytelling and their power to create the worlds in which we move as individuals and as groups, is central to both.

Also intrinsic to the immigrant's—and perhaps the female's—experience of "competing realities" is a kind of dual vision, the inevitable outgrowth of a sensibility shaped by awareness of a gap between there and here, past and present self, language and meaning. Out of this dual vision come the recurring polarities that shape fictions of ethnicity; portrayals of the ethnic ghetto are closely linked to the interplay of these polarities. The gap between the positive and negative versions of the North End ghetto provides the basis for the male *bildungsroman* structure of the novel, thereby combining the male coming-of-age story with the characteristic binary structure of ethnic fiction.[16] Sandor comes of age in the perhaps too obviously bi-polar space between competing versions of old and new worlds. The measure of his maturity at the end of the novel is the degree to which he can see the communal aspects of the ethnic ghetto in a positive light: the degree to which he is able to remember his past, using it to integrate his own personal identity and to transform the overly materialistic, and therefore imbalanced, new world in which he lives.

Although he does not develop the idea or the characters that project it fully, Marlyn also suggests that this coming of age for Sandor (and perhaps for the new nation of Canada), involving as it does the integration of the polarities warring within him, must ultimately balance the aggressively male, darwinian vision embedded in the capitalist society wherein he longs to find a niche, with a more cooperative, nurturant, female vision. Imaged as both a scabrous inferno and a warm refuge, the North End becomes a central symbol of both the need for this resolution and the difficulty, particularly for the second-generation male, of effecting it.

In the ironic twist at the end of the novel, when the world that Sandor has aspired to is in ruins and the only positive things in his life are those represented by family and community, one can see that Marlyn has used the contrasting versions of the ghetto to critique the prevailing North American mythology of immigration and ethnicity, turning topsy-turvy the twin assumptions that success in North American terms is worth the price it exacts from the immigrant in concealment and loss, and that the new world has much more to offer than the old. This comment would have been made more forcefully had Marlyn's female characters been fashioned with more clarity; neither Mrs. Hunyadi nor Mary emerges as a fully realized character. Nevertheless, Sandor's ultimate failure, Marlyn suggests, does not lie in his inability to leave the North End, to achieve a seamless assimilation, but rather

in his inability to resist the forces pressuring him to do so because he cannot discriminate between the real and the illusory.

Another version of the North End emerges from Ed Kleiman's *The Immortals*. Though it is a cycle of interconnected short stories rather than a novel, and it suffers somewhat from being infused with an overdose of macho nostalgia for lost youth, *The Immortals*, like *Under the Ribs of Death*, is a kind of *bildungsroman*, chronicling the development of not just one male character, but of a whole generation of North Enders, and of the North End itself. Although one can read in his portrayal of the North End the ambivalence toward both his group and the world outside that is characteristic of the second-generation ethnic writer (Sollors, 658), Kleiman does not use the ethnic ghetto to the same extent that Marlyn does as a vehicle for social criticism. Rather, he uses it to explore the personal impact of the complex relationship between individual and community, both dissecting and celebrating the dynamic interaction between individual and collective identities, while at the same time lamenting their transience. Paradoxically, in so doing, he suggests, albeit at times in a tone that some readers would find overly sentimental, the enduring influence of the North End on the lives of his characters.

The North End portrayed in *The Immortals*, like Sandor Hunyadi's, is a world of struggle and poverty engendering in its inhabitants a profound need and determination to "succeed"; unlike Sandor's ghetto, it also engenders a fierce pride, and is a place much more loved than hated. This affection and loyalty for the neighbourhood is apparent in a number of Kleiman's stories, particularly "A Sunday Afternoon with the North End Buccaneers" and "The Immortals."

The former, which begins the collection, tells of the youthful exploits of a gang of bar mitzvah-aged boyhood friends, who spend their free hours either playing Monopoly or exploring the neighbourhood, attempting to assert their supremacy over the south side Henderson gang. The narrator notes that this gang "may have been the toughest in the city, but we were from the North End, and for sheer cheek, we were the city's masters."[17] Its underlying ethos a masculine one of battle and conquest, the story is imbued with a sharp sense of the North End as a distinct entity locked in struggle with the South Side. The highlight of the afternoon for the "buccaneers" is defeating the Henderson gang on the latter's own territory, a victory the narrator Michael savours as a glowing reminder of carefree days, coming of age, and rare triumph:

> It had been a grand excursion, a splendid afternoon, one of the most
> victorious forays into enemy territory we'd ever undertaken. With oars

pulling steadily we moved triumphantly back up the river. While behind us, as we sailed off into glory, we left our enemies, not only licking their sores, but wailing and gnashing their teeth too. (19)

However, that the triumph is short lived is suggested, not in the story's plot, since the Henderson gang remain defeated in the story, but in its mock epic tone, evident in Michael's comment about the buccaneers' invulnerability:

As we rowed back toward the dockyard, the trees on either bank seemed to bow down and the sun was a golden crown in the heavens. So invulnerable did we feel that when Gordie marched from the prow of the boat to the stern ... we almost expected to see him go marching off across the surface of the water. (19)

The transience of their victory is also suggested in the story's conclusion. The boys end their glorious afternoon playing Monopoly once again, dreaming "of one day entering the grown-up world of time clocks, lunch boxes and secondhand furniture, the no-nonsense business world where the arithmetic of feet and inches and dollars and cents was in deadly earnest, where properties were traded and rents raised in cutthroat competition" (23). In this description of the rather tawdry, circumscribed nature of their dreams, which suggests the limitations of a North End victory, Kleiman comes as close as he ever does to criticizing the larger dynamics that produced the ethnic ghetto.

The title story, "The Immortals," presents an even more explicit description of the gap between the two poles of the city, and in so doing, explores the interrelated polarities of success/failure, integration/ resistance, and remembering/forgetting that undergird Kleiman's fiction. The story focuses these tensions on the mock battleground of a football field. Though just an exhibition game, it was one that mattered because it "was a contest between the North and South Ends of the city. And that was no small matter" (49). The ethnic, class, and political dimensions of this contest are clearly delineated:

The North End consisted mainly of immigrants from Eastern Europe, labouring classes, small foreign-language newspapers, watch-repair shops, a Jewish theatrical company, a Ukrainian dance troupe, small choirs, tap-dancing schools, orchestral groups, chess clubs and more radical political thinkers per square block than Soviet Russia had known before the Revolution. The South End—or River Heights, as it is more fashionably called—was basically what that revolution had been against. The mayor, most of the aldermen, the chairman of the school board and many of the civic employees—not the street sweepers, of course—lived in River Heights. (50)

Also apparent in the narrator's description is a palpable contempt for River Heights as an embodiment of all that is superficial, illusory, pretentious. In fact, his description can be read as a startling revision of Sandor's rendering of the North End as inferno, the South End as paradise:

> Another way of distinguishing between the two parts of the city is by looking at the street names. In the North End, you'll find such names as Selkirk Avenue, Euclid Street, Aberdeen, Dufferin—names steeped in history, names which suggest the realm of human endeavor, anguish, accomplishment. But if you look at the street names in River Heights, what you'll find, with few exceptions, are such names as Ash Street, Elm, Oak, Willow. Vast expanses of velvet lawns, well-treed boulevards—the area looks like a garden, a retreat from the toil and anguish everywhere visible in the North End. The two cultures meet downtown, where the South End gentry immediately head for the managerial offices, and the North End rabble file past the company clocks with their time cards. After work countless numbers of expensive cars sweep grandly across the Maryland Bridge back into Eden, while street cars and buses pass northward beneath the C.P.R. subway into a grim bleak underworld of steel fences, concrete walls, locked doors, and savage dogs that seem capable of looking in three directions at once. (50)

As well as being a vehicle for social criticism, this description sets up the basic *carnivale* framework of the story, one based on a reversal of roles. As suggested by the references to classical mythology in the story's title, in the image of Cerberus, the three-headed dog who guards the gates of the underworld, and in the narrator's confession that he is in the midst of writing an epic poem on the night of the contest (51), the game is presented as an attempt to subvert mythology, both classical and national, by reversing, if only briefly, the positions of gods and mortals, of the River Heights Anglo elite and the North End ethnic rabble. Osborne Stadium becomes the mythological arena where this reversal can be effected. "There, on Friday nights, the North End may once more experience the heady hours of triumph it knew during the 1919 Strike, when it seemed the World Revolution might begin right here in Winnipeg" (50). This reversal seems a clear example of what Eli Mandel refers to when he notes that "in ethnic writing there is often an attempt at healing by the rewriting of myths" (61); Linda Hutcheon and others have similarly suggested that female writers re-write and subvert mythology as a means of placing themselves within the conceptual world that casts them as somehow outside of it, "other."[18]

Using this subversion of the received story, Kleiman infuses "The Immortals" with moments of near triumph, when the masculine ethnic

fantasy of long-awaited victory is nearly fulfilled:

> our players charged down the field as if they'd been transformed. In the fading sunlight, their town uniforms looked like golden armour, ablaze with precious stones; their helmets shone with emeralds and sapphires; and they moved with a grace and power that was electrifying. That two hundred pound River Heights fullback ... caught the ball and was promptly hit by Sidney Cohen in the hardest flying tackle any of us had ever seen. (55)

The North End fans cheer on their heroes "...with enough energy to split the stadium apart and bring the walls of that Philistine temple down upon our enemies' heads", while about them "the city shone as if made of molten glass—aflame in the radiance of the setting sun—gates garnished with pearl and gold and all manner of precious stones" (57, 58). However, in "The Immortals," as in "The North End Buccaneers," the futility of the attempt to achieve final victory and the accompanying irony of the title becomes apparent as the North End goes down to defeat, both as a team, and ultimately, as a neighbourhood:

> With the passage of time, the North End, too, has changed. So final has its defeat become that it has even had thrust upon it a suburb with such street names as Bluebell, Marigold, Primrose and Cherryhill. Over the years, that two hundred pound fullback has managed to race clear across the city to score a touchdown right here in our home territory. Now we also have our false Eden. (59)

The story does succeed in subverting the success/failure mythology by reversing the success/failure paradigm. This reversal turns success into valiant resistance against all odds, a definition that makes the North End players into heroes, at least for as long as the community lives in the memories of those who watched the game; it also turns the narrator's ultimate resistance of the South End's hegemony, which he describes in the final paragraphs, into a satisfyingly rebellious act (59).

Although the major thrust of resistance in these two stories is against the Anglo-Canadian majority, as symbolized by River Heights, in a number of stories the characters resist forces *within* the ethnic ghetto. In so doing, they exhibit the ambivalence so common in second-generation ethnic fiction toward both the ethnic community and the larger society, illustrating the ways in which the polarities of integration/resistance and remembering/forgetting become complex, internal struggles as well as external ones. Interestingly, the forces that are resisted in Kleiman's fictional ghetto are the female forces of domestic-

ity. Kleiman's narrator repeatedly casts his female characters as repositories of an oppressive cultural background. For example, in "A Sunday Afternoon with the North End Buccaneers" one of the first images is that of Mr. Bloomberg escaping a suffocating domesticity, symbolized by his wife and the smell of her chicken soup:

> Any excuse would serve to escape the house. Mrs. Bloomberg and her kitchen, and a floor slippery with boiled over chicken soup.... Who wouldn't retreat to the delicatessen for some pastrami sandwiches, cold cokes and a few games of 'Twenty-One or Bust' with those other expatriate husbands who had also fled kitchens that perpetually smelt of burnt toast and stale chicken soup? (13, 14)

A similar fear of being suffocated by females is expressed later by the narrator, when he describes Gordie Bloomberg's teenaged sisters:

> We were aware that the girls' concern with us wasn't totally impartial. A few more years and who knows? The boys playing Monopoly might become prospective suitors for those unwanted girls. We were already uncomfortably aware of Marsha, her boobs bulging inside her tight woolen sweater in a brassiere several sizes too small. However, I suspected even then, just let her get married, even engaged, and the event would be taken as a licence to remove all restraints. She'd be as huge as a barrel in less than a month. (14)

As if serving as a kind of symbol of the negative, smothering aspects of the ethnic community, and a scapegoat for the frustrations they engender, Kleiman's female characters are again and again the cause of a male character's downfall, the obstacle between him and his dreams. A particularly graphic and humorous example of this occurs in "The Handicap," in which a salami that Michael's mother insists his brother take with him to summer camp so that he won't "starve to death on all that goy food" symbolizes the suffocating ethnocentricism of his family life—an ethnocentricism that threatens to become a lifetime obstacle to freedom and self-fulfilment.

Less humorous and more negative depictions of female characters occur in "My Mercurial Aunt," in which the main character is revealed to be ruthless, self-interested, and destructive of those around her; in "Harry the Starman," in which Harry Silverman's dreams of becoming an astronomer are thwarted by the conniving Sue Cramer, who eventually traps him into marrying her, thereby dooming him to the life of a minor accountant in his father-in-law's factory; and in "Greenspan's Studio," which reveals the tragedy of Sam Greenspan's life: that his wife, Hester, doesn't love him despite his generous, affectionate

qualities and that she will ultimately do anything to leave him, including escaping into insanity.

Thus, women often symbolize the problematic aspects of the immigrant and ethnic experience in Kleiman's fiction, preventing the male protagonists from achieving a successful balance among the various polarities intrinsic to that experience. The women often impede true success, provide an overdose of ethnic culture, which must be resisted along with the assimilative forces of the South End, and threaten the integrity of the protagonist's fragile new identity. Ironically, they move him toward disintegration by not allowing him his own selective version of his past or the freedom to live as an individual beyond the restraints of family and community.

Kleiman's North End, then, contrasts interestingly with Marlyn's. Though both reveal a profound cleavage in the ethnic and class geography of their fictional Winnipegs, Kleiman's is a symbol of community and resistance, albeit with some ambivalent features, while Marlyn's is used to show the tragedy of not resisting those forces that would obliterate the cultural and familial memories of its inhabitants. While in some ways their social commentary is similar—that the dreams and power embodied in River Heights are illusory—and their urban geographies are at times infused with a similar masculine model of combat, they differ in the degree to which they challenge this model, and in the nature of their thematic focus. Marlyn focuses on the susceptibility of the immigrant and his children to being seduced by the illusion at the heart of North American life, Kleiman on human failure and on the ultimate illusion of either individual or collective immortality. Both imbed their binary visions in the physical and social geography of Winnipeg's North End.

Like Kleiman, Jack Ludwig in his novel *Above Ground* shapes the North End into a landscape of masculine fantasy that serves as the point of departure for a male *bildungsroman*; however, his protagonist's fantasy as he grows up on the eve and in the midst of World War II is much more explicitly that of a Don Juan rather than a gladiator or soldier. Although created in a much less direct, much less realistic mode than that of Marlyn or Kleiman, Ludwig's northern ghetto occasionally emerges as a place that would be familiar to Sandor or Michael: a cacophonous world where "politics shrilled ... [amidst] the Salvation Army, pawnshops, beerjoints, a bank, a fourth-run moviehouse, a commercial hotel, three fleabag flops, ... pushers of *Pravda, Der Sturmer*, dope, nuns who were mendicants, riot-helmeted policemen, Chinese cooks, Negro barbecuers, Italian barbers, Jewish secondhandclothiers, toughs, hoods, ... schoolkids."[19]

Although he achieves considerably more depth and complexity, Ludwig, like Kleiman, infuses this landscape with mythological significance by frequently tapping into a variety of literary texts, as he does in the above passage by adding to the list "nymphs, Don Giovannis, Faustuses, Medeas, Cyranos, Tartuffes, Clytemnestras" (49). This technique lends significance to a place otherwise vulnerable to being seen as both negative and unimportant. It also lends significance to the protagonist's struggles to free himself from his imperfections, symbolized by his sickly childhood and his crippled leg, and to find love. The latter quest is embodied in the narrator's Don Juan fantasy that his fate is to pursue and be pursued by a world full of beautiful women. Making no secret of the significance of women to his protagonist's development, Ludwig, like Marlyn, casts them as saviours, but for Ludwig, who begins his text with a quote by T. S. Eliot, "so all women are one woman" (frontispiece), their role and power is always sexual, defined solely by masculine need and desire. Although constructing or deconstructing ethnicity is not the major focus of Ludwig's text, one might well read his chronicle of a North End Don Juan as a very recognizable projection of a wounded, marginal sensibility, one irrevocably shaped by the familiar polarities of immigrant experience and the related intense sense of loss, irreconcilability, and need that are recurrent themes in immigrant and/or ethnic fiction.

Several women writers have also used the North End as a setting for fictionalized immigrant and ethnic experience. Among these are three novels: Vera Lysenko's *Yellow Boots*, Maara Haas's *On the Street Where I Live*, and Adele Wiseman's *Crackpot*. While these fictions are in many ways similar to those discussed above, they differ significantly in that all use female protagonists and are preoccupied with synthesis and paradox as a means of resolving the polarities of immigrant and ethnic experience, and in all the North End is a positive force, overall, in the process of harmonious resolution that undergirds their narratives.

Although much of Vera Lysenko's female *bildungsroman*, *Yellow Boots*, is set in rural Manitoba, Winnipeg's North End plays a significant role in the novel.[20] It is the place where the main character, Lilli Landash, daughter of Ukrainian immigrants, ultimately comes of age, synthesizing the various elements of her life by becoming a modern singer of old songs, making a career for herself as a dressmaker, and marrying another immigrant, an Austrian musician. Lysenko's ghetto thus provides a space for the female second-generation immigrant, seemingly placed in an impossible position by a rejecting yet overpowering mainstream culture and a tyrannical father. It also provides the synergistic dynamics that can begin to break down the dichotomies

and the limitations they impose. Thus, unlike many of the questing characters created by other fictionalizers of immigrant and ethnic experience, Lilli does not have to choose between losing her ethnic identity and losing her individual identity. She is able to find a balance between past and present that allows her to nurture both, while creating a place for herself as ethnic, Canadian, and female in the emergent Canadian prairie culture.

Though only sketchily drawn in *Yellow Boots*, the North End becomes foreground in both *The Street Where I Live* and *Crackpot*. Indeed, it is the apparent subject of Haas's book. Although its collage-style, episodic format makes its structure in some ways innovative, *The Street Where I Live*, like the novels discussed above, is a typical immigrant narrative in that it is profoundly shaped by polarities. As in the above novels, the North End is used to embody these oppositions; however, it goes considerably further than any of them, especially those by male writers, in creating a North End that also embodies their resolution.

Haas's ambivalent position as mediator and apologist, which is typical of the second-generation writer (Sollors), is inscribed in the text in a variety of ways. Even the title can be read as a subtle acknowledgement that home and neighbourhood are potentially problematic, since it suggests that "the street where I live" is somehow noteworthy, different (difficult?). This impression is reinforced in the book's very first sentence: "The street where I live is divided by fences so it seems more crowded than it really is." That the dynamics focused on in the text that follows will be internal to the neighbourhood is established here, as is the predominantly light, humorous tone, which is nevertheless sufficiently ironic to suggest that this mode of telling the story masks a darker competing reality:

> Actually, the lots are huge—25–27 feet. Most of the shanties have a large screened verandah and a master bedroom big enough for a brass bed that sleeps six people easily, with leftover space for a kitchen chair to put your clothes on. Of course the bedroom window is a bit small. A good thing. Because it saves on the heat.[21]

While the contrast between the have and have-not geography of Haas's fictional Winnipeg is the subtext of the above passage, and of the novel as a whole, in sharp contrast with Marlyn's text, this difference is seldom referred to directly. Rather, the overt conflict, the one that embodies most obviously the polarities typical of immigrant fiction, is that among the various groups within the ghetto. Thus, the first scene the reader encounters is one that presents the underlying struggle for

space and pre-eminence between neighbours on the street, Mrs.
Kolosky and Mrs. Weinstein, with Haas relying largely on names,
dialects, and stereotypical symbols and behaviours to signify her
characters' respective ethnic backgrounds. The anxieties engendering
this conflict are closely related to the success/failure polarity; what
irritates Mrs. Kolosky about Mrs. Weinstein's fence is that it is "classier"
than hers.

> Why did it have to be something classy like a galvanized iron fence? Mrs.
> Kolosky's fence didn't pretend to be classy—just ordinary chicken wire
> and sweetpeas laced with white string, the kind that comes from a bobbin
> hanging over the cash register of any grocery store. (1)

Interestingly, what ultimately stops this feud is the arrival in the
neighbourhood of Mrs. Britannia, who seems to both women to be in
need of their (albeit somewhat ethnocentric) nurturance: "Boze, Boze,"
says Mrs. Kolosky (translation: God God):

> More foreigners already English yet. The worst kind. Poor woman, says
> Mrs. Weinstein. You should know from her pasty white face, she is eating
> only English white bread and suet Suet, I use for lighting candles to Our
> Virgin Mary, answers Mrs. Kolosky. But for eating, like you say it, Mrs.
> Weinstein. Oy Vay (no translation available): What the poor orphans are
> crying for is a pot of healthy red borsch. Faah on borsch, says Mrs.
> Weinstein. For curing anything and everything, the chicken soup is
> first.... That was the end of the feud, no harm done. And there they are
> as close as lice: Mrs Weinstein, Mrs. Kolosky and Mrs. Brittannia, sitting
> on Mrs. Kolosky's verandah, spitting sunflower seeds in the friendly
> autumn of old comrades. (4, 5)

This episode could be read not only as a comment on the solidarity
of eastern European ethnicity vis-à-vis "the English," or on the solidar-
ity of the working class, but also as a comment on the power of the
maternal drive to nurture those perceived to be weak or in need, a
parable about how to transform rivalry into harmony, thereby making
space for all. One can read behind the text an anxiety about ethnic
difference and the desire to successfully defuse potential conflict.

The above is typical of Haas's fictional technique and thematic
preoccupation. Shaping a North End out of gentle burlesque, slapstick,
and irony allows her to critique with virtual impunity both the ethnic
North Enders and members of the "mainstream" establishment while
simultaneously making the former more acceptable and less threaten-
ing to the latter, and, it should not be forgotten, to the second
generation. She uses apologist marginality to produce a kind of north

country urban "Dogpatch" peopled with caricatures of stereotypical ethnic characters. Seen through the eyes of the prepubescent female narrator, who is trying to make sense of and find her place in her immediate surroundings as well as in the larger world of Canada in the early 1940s, the North End as humorous ethnic pastiche becomes a vehicle for defusing inter-ethnic tensions within the ghetto as well as for making space for the ethnic "other" within the mainstream imagination.

Haas's apologist's double vision is projected repeatedly through a variety of ironic devices and in the names and descriptions of her characters. A comicstrip landscape peopled with such figures as Herman the Laughing Butcher, Hobarty the Hunchback, Moishe the Manipulator, Harry the Hugger, Oiving Monahan, Oreste the Undertaker, Laspoesky the Druggist, and other comic grotesques, many of them frequenters of the Cockroach Cafe, is one that allows the narrator to distance herself from both the ghetto and ethnicity, while at the same time allowing her to proclaim insider knowledge and loyalty. This ambivalence is clear, for example, in the description of aspiring ethnic politician, Brains Slawchuk, "choirleader, drama director, prospective school trustee and local honey-dipper for outlying outhouses" (46), and in the macaronic humour which plays on a knowledge of both the ethnic language and English, as in the name Shmurkaty Kapusta, which is funny to Anglo-centric readers because of its unfamiliar and "silly" rhythm and sound in English, but is even more so to readers who also understand Ukrainian, and who recognize Kapusta as "cabbage" and Shmurkaty as "runny nose."[22]

The energy in the text toward synthesizing disparate elements is also projected through the narrator. Though she speaks directly in the first person only a handful of times, her sensitivity, coming-of-age vulnerability, and quest for wholeness (all of which seem to be the creation of a retrospective adult narrator, thus adding yet another layer to the telling) project the ambivalence that fuels the narrative. It is she who presents in the guise of comedy the incongruities of her family life: incongruities that stem from being the daughter of Laspoesky the druggist, whose professional practice encompasses the conflicts between old world and new, folk medicine and positivistic science, as, for example, when he must meld the seemingly conflicting discourses of spells and prescriptions, and the narrator must read the result in Ukrainian for the Ancient Grandmother: "Take six steps across the threshold of the barn, spit in a westerly direction and apply the ointment to afflicted parts of lumbago" (164). Indeed, the narrator

presents the drugstore as one of a number of neighbourhood institutions (the Cafe, the hockey rink, the dry goods store, Shevchenko hall) that mediate across these and other polarities, and ultimately synthesize disparate parts into a whole. However, even this synthesis is often presented ambivalently, as, for example, in the nearly oxymoronic combinations embodied in the names of neighbourhood baseball teams, the Virgin Mary Maple Leafs and The Star of David Ukrainian-Canadians ("a Ukrainian Trident on the chest and a Star of David on the sleeve") (199).

The narrator's confusion over whether to remember or forget one's past and how to do either over the nature of one's experience (that is, what is illusion, what reality), and over the possibilities for women in the world she sees around her is projected in a self-reflexive scene where she and her friend, revelling in the freedom of having been left alone to mind the drugstore, experiment with various styles of makeup and discuss their favourite magazines. The two modes of fictionalization discussed, *True Romance* and *True Confession* (the narrator's preference), are both flirted with; however, both are ultimately subverted and rejected by means of the very ironic humour Haas has chosen as the alternative means for fictionalizing ethnic and female spaces. This fictional mode effects a humorous synthesis of inter-ethnic differences and rivalries, while at the same time creating a place for the ethnic female as sturdy Mother Earth figure, as progressive modern woman, and ultimately as synthetic artist—writer/mediator—the role promised for and ultimately played by the coming-of-age female narrator in this female *bildungsroman*.

Like Lysenko's *Yellow Boots* and Haas's *The Street Where I Live*, Adele Wiseman's *Crackpot* presents a version of the ethnic ghetto that contrasts markedly with those presented by either Marlyn or Kleiman. Besides being rendered with more literary depth and subtle artistry than in either *Under the Ribs of Death* or *The Immortals*, the North End that emerges from *Crackpot* is a female space, and one that embodies a more profound, though constructive, critique of Canadian society than that offered by either of the other two novels. Not writing primarily in the mimetic mode, but rather in a metaphoric and mythic one that enables her to fashion larger-than-life characters, Wiseman creates the North End not through an accumulation of physical details, as do Marlyn and Kleiman, but through the feelings and interactions of her characters, particularly her main character, Hoda, and through a web of stories that constitute the shared history of the larger Jewish community, the North End ghetto with its particular events and personalities, and Hoda's family.

Wiseman draws on ancient religio-cultural tradition as well as on the experiences of the European shtetl, expressed primarily in Yiddish, and on North End gossip, the latter often reflecting the tensions inherent in the process of immigrant adjustment and ethnic acculturation to the new world.[23] In so doing, she illuminates the psycho-cultural dynamics of the ethnic ghetto, depicting its contours and boundaries in terms of shared and conflicting sensibilities. She paints a North End that is a comfortable home, despite its faults, and draws on some of the traditions that constitute the cultural inheritance of the Jewish ghetto to delineate the nature of the boundary between it and the other sensibilities that surround and define it. Not surprisingly, she focuses primarily on the boundary between the Jewish ghetto and the Anglo-Canadian mainstream, profoundly critiquing some of the fundamental assumptions of the latter, particularly its privileging of its own history and its related failure to acknowledge the cultural validity of the ethnic "others" —the legitimacy and value of their potential contribution to Canada's evolution.[24]

Unlike Sandor Hunyadi, Wiseman's Hoda, also an immigrant child during the nativistic years of World War I, does not internalize the mainstream ethnic and class hierarchy that devalues both her North End neighbourhood and her cultural origins.[25] Although Hoda, like Sandor, constructs childish fantasies about receiving some sign of acceptance into "the empire," her dream of being singled out as his future queen by the Prince of Wales is based on her own sense of self worth—on her faith in her own special qualities, which he may be discerning enough to recognize.

In this recurring fantasy, as in her interactions throughout the novel, Hoda demonstrates none of Sandor's self-hatred and his accompanying obsession with concealment. Rather, she accepts herself, and assumes her value. In sharp contrast with Sandor, Hoda is obsessed not with concealment, but with revelation. She wants desperately to tell her story, to break the silence about the nature and significance of the personal, familial, and cultural odyssey that has brought her to the new world. As a child, she is sure that telling her story will win her the respect and affection she knows she deserves. "If they only knew! Well, they ought to know.... And Hoda began to wonder whether she shouldn't perhaps tell Miss Flake and the rest of the class how much more there was to it than they could possibly imagine."[26]

Hoda displays a similar confidence when she is visited by a group of ladies from the Protestant church that sponsors the basketweaving courses for the blind attended by her father, Danile. Concerned about Danile's absence, and feeling that "some gesture should be made," the

Protestant ladies "adventured forth into the unknown north-end of town." Hoda invites them in enthusiastically, and tells them about the recent death of her mother. Though she finds them to be "rather odd old ladies, stiff and unfamiliar, who spoke to you with squared-off words, like teachers, and with the foreignness of the majority, a little fearsome in that you could never rely on any balance of its shifting elements of ingratiation, confidence, contempt and what sometimes even felt like fear," she is determined "not to be afraid of them." She even assumes their good intentions. "They must be nice; they had come. Maybe they were hungry" (63, 64). But in fictionalizing a North End Winnipeg that "was the very incubator of conflicting absolutes,"[27] Wiseman creates an Anglo-Canadian sensibility, symbolized by the Protestant visitors, that responds to Hoda's openness and generosity with obdurate incomprehension and rejection. Seeing only "an old shack" and "a grossly fat adolescent" who offers them horrifically uncivilized food as well as inappropriately graphic medical details concerning her mother's illness, spiced with shockingly inappropriate language, the delegation of Protestant ladies, thoroughly dismayed, attempts to leave. But Hoda, who has worked hard to maintain a pleasant home for her father, showing a dedication and ability beyond her years, feels compelled, despite her own relief at the imminent departure of these "ungiving presences," to "draw from them some unequivocal recognition of their value, hers and her daddy's" (65).

Despite this desire and her own self confidence, Hoda is unable to pry this acknowledgement from her reluctant guests. Instead, they send anonymous tracts attempting to convert Hoda and her father to their particular brand of Christianity. Although he is oblivious to it, Danile's attempts at his basketweaving classes to offer something of himself and his culture to the Anglo-Canadian mainstream, as represented by these Protestant ladies of charity, had also been rejected:

> Danile responded well to the music. It was natural to him to sing while he worked, as his father had done before him.... It even occurred to him after awhile, when he had begun to feel more at home in this place, that his companions might like to learn a new tune occasionally. Accordingly, he waited politely one day for a break in the organ music, and when he felt the appropriate time had come, he obligingly offered them a few Yiddish ditties in his not unpleasant cantorial tenor. His interpolated offerings were at first greeted by a shocked and embarrassed silence on the part of the ladies who ran the guild ... [who were] particularly uneasy about the possibly blasphemous content of the songs, about liltings too suspiciously gay, or complaints too foreign and even too sinister perhaps, to be heard in the basement of a church.... There was an activist faction

among them which responded to his songs as though to a hostile invasion. (62)

Similarly, Hoda's attempt to tell her story to her school class is cut short and thoroughly rejected by her teacher, Miss Boltholmsup, her name suggesting the inadequacy of the values and sensibility she represents. However, Hoda does not internalize that rejection; rather, she is simply astonished and hurt by the stupidity of it (100).

Later, when Hoda has become a kind of parodic embodiment of elemental female capacities, both whore and dutiful Jewish daughter, she continues to value herself and to act confidently despite her amplified, almost larger-than-life marginality: as a poor Jewish fat woman and a prostitute, she is vulnerable to being seen as an outsider in a number of ways. Despite this, she confidently assumes her place within the Jewish community, attending every wedding, and later in her life every funeral, gradually earning a kind of place, not only at the wedding table, where eventually "to be expected is to be invited" (124), but also in the stories and gossip that Wiseman uses to create and sustain the North End Jewish community. While as a prostitute, she of course often figures negatively in that lore, over time she earns a sort of grudging respect and a definite place, suggested in the phrase Wiseman uses repeatedly, "legend has it" (168). By the time World War II breaks out, she has even become "good old mamma Hoda" (270).

Nor does Hoda want to flee the ghetto, either physically or psychologically. While Kleiman's narrator recalls the ghetto in primarily positive tones, his viewpoint being a retrospective one that creates a North End out of the roseate hues of nostalgia, turning it into a thing of the past synonymous with lost youth, Wiseman's Hoda remains there, attempting to reconcile past, present, and future within it. Reversing Sandor Hunyadi's naive equation of the downtown hotels and River Heights with being "rich, English and happy," Hoda equates happiness, safety, and her own sense of self worth with her private and communal home in the North End. As a child, "Hoda was rather proud of her tumble up and down porch and the tree that was giving it a ride.... She showed it off to her friends" (26). Much later, Hoda takes pride in the way she and Danile, with his basketweaving artistry, have been able to "turn the inside of a shack into such a pretty home." She even asks her customers confidently, "You like the decor?" (215). When, as a sexually precocious adolescent, she is encouraged to leave the ghetto to work the downtown by Seraphina, an old school friend who has also become a prostitute, she does so reluctantly just one time. Unlike Sandor, who is constantly deceived by surfaces and consequently

thinks that concealing his true origins behind a new English name will
overcome the ethno-cultural barriers to the material success he craves,
Hoda is aware that the makeup she puts on under Seraphina's
encouraging eye hides nothing and is contrary to her own personal style
and forthright nature. For her, the landscape beyond the North End is
hardly a paradise, as it is for Sandor. The grand hotels that she had
envisioned are not the ones to which her customers take her. She also
quickly learns of the disadvantages and dangers of plying her trade in
unfamiliar territory, beyond the protective communal boundaries.

> If they caught you, the guy got sent to jail ... and you could get sent to
> reform school.... Hoda didn't think it was worthwhile going downtown if
> that was going to happen to you. What if the cops caught her, and
> suppose she didn't remember to start hollering "rape" on time, or they
> didn't believe her.... What would happen to Daddy? (133).

After a few encounters with customers, Hoda compares the experi-
ence unfavourably with her business in the North End. "It was like what
she was used to, only she didn't feel the same about it; she didn't feel
she really knew what he was like, the way she felt when she did it even
with total strangers, in her own part of town. He hardly said anything
and she didn't really even know what he looked like. It wasn't as though
they were having fun together at all, or sharing a good secret, or
anything" (133). Hoda misses the sense of community that she feels,
even as a prostitute, in the ethnic ghetto, and decides that "it would be
a long time before she tried to work downtown again" (135).

Although Hoda is generous, both sexually and otherwise, she insists
on protecting her home and her "Daddy" from anyone who might harm
them. She requires her customers to play along with her father's
assumptions about her work: that she is a tutor and they are her pupils.
Later, she takes measures to protect her home from city authorities
who she fears might condemn it, particularly since the growth of the
tree in the front yard has finally ripped the verandah completely off.
"That's what they did when they got the chance," Hoda worries, "chase
you out of your own home" (216). Significantly, she uses *words* in her
battle with the city to protect her space, placing a sign declaring
"Danger. Verandah Under Repair" in front of her house to deter
fastidious inspectors. She develops a similar strategy with the public
health officials at city hall, where she goes periodically to be checked
for venereal disease. Resenting being treated there like "something at
the other end of a long stick," she "developed over the years, a kind of
sophistication, a public attitude, a way of outfacing whoever faced her"
(209, 210). This strategy involves using words skilfully (much as

Wiseman herself does) to undermine through parody and irony the false sense of superiority of those in power. She declares loudly that she too "is a citizen and she had her rights and they ought to be glad she had a sense of responsibility" (203).

Through her verbal aggressiveness and her storytelling skills, Hoda is able to make a place for herself and her old friend Hymie (the "on the make" character in the novel who achieves wealth and a kind of sleazy success as a bootlegger) in the heart of the city, as embodied in its motto: "Commerce, Prudence and Industry." Regaling her waiting room audience with her stories, Hoda asks:

> Have you ever noticed that motto up front? ... You know, like, our city motto. You don't even know your own city motto? What kind of citizen are you? I know it all right. I ought to. It says, "Commerce, Prudence, Industry." That's my motto too, in fact. I figure if it's good enough for my home town, it's good enough for me. Commerce? Any time you like. Prudence? What do you think I'm doing here with the bottle? Industry? Hell, I ain't had no complaints yet. I figure I'm a model citizen.... Instead of those pictures they have of the sheaf of wheat and the buffalo and stuff, they should pay me to go sit up there, just like I am now, or maybe in my bareskin on a bench.... People would look then all right. (211, 212)

Similarly, she imbeds Hymie's story within the city's motto, suggesting that his somewhat shady activities and dedication to material success are actually very congruent with the subtext of the motto, if not with its outwardly decorous tone:

> And now Hymie's moved down East, and he's gone into industry, and he's a millionaire today. How do you like that.... So don't you ever be ashamed of your city motto.... You can take those three words, plus a little bit of this and a little bit of that, and you can end up where you won't ever have to worry about commerce, prudence and industry again because when you're up there that high, anything you do or don't do is all right by everyone all over. And I'm the dumb bunny who tried to tell him it wasn't honest.... Come to think of it, maybe they should change our motto up there altogether. Instead of those three words and those pictures, they should have a picture of a big, naked arse, and underneath it just two words, RISK IT! (213)

As if sensing a kind of invasion in Hoda's words, just as many years before Miss Boltholmsup had feared Hoda's story and Hoda herself as a representative of a growing number of immigrants (particularly Jewish ones), "fat presences with demanding eyes" (96), the school teachers who have been the audience for Hoda's commentary on the city motto react with a "momentary flutter of guilty smiles that were not

smiles really, but the involuntary expression of their astonishment. At times one's own dear familiar country can suddenly seem so foreign" (213).

It is clear from these and other instances that reveal Hoda's combined sense of pride in her origins, belief in her own worth, and ability to see beneath surface realities, that she is determined to carve out a physical, psychic and cultural space for herself in Canada. She is quite willing to be assertive in doing so, as, for example, during the Winnipeg General Strike when she attacks a mounted policeman who is threatening Mr. Polonick, her radical friend and former teacher from her days in Yiddish school. However, Hoda's vision of Winnipeg's urban geography is not the male vision of Sandor Hunyadi or of Kleiman's thinly veiled autobiographical narrator, Michael Buchalter. She does not see the North and South Ends of the city in either the imagery of paradise/inferno or of battle. Rather, the metaphor that is expressed through Hoda and informs the entire structure of *Crackpot*, one taken from Lurianic Kabbalism, a strand of Jewish mysticism, asserts not dichotomies, but the paradoxical union of opposites, not aggressive force or rationality as the key to transformative power, but experience of the transcendent, particularly love.[28]

Thus, while all three of the fictions I have discussed portray the North End ethnic ghetto as a space that encompasses and symbolizes the tensions that inevitably arise out of the process of immigrant adjustment to Canadian society, tensions that are characteristically expressed in ethnic fictions in the polarities of success/failure, identity/disintegration, revelation/concealment, forgetting/remembering, and integration/resistance, only Wiseman uses her protagonist's version of it to *fully* claim the space denied to the ethnic immigrant in Ralph Connor's version of the North End and in his view of the desirable evolution of Canadian society. While Haas also recasts the North End ghetto in a way that transforms it from the battleground that it is in the work of the male writers I have discussed, and makes of it a synthetic force, she does not go as far as Wiseman in suggesting an eventual resolution of the contradictions that undergird her characters' lives. Using the profoundly marginal character of Hoda, and drawing deeply on Jewish tradition and on the North American mythology of immigration—a mythology that assumes the inevitability and rightness of the immigrant's losing her past to acquire the history and sensibility of the majority—Wiseman reshapes both, thoroughly undermining the paradigm that equates immigrant/ethnic and ghetto with social problem.[29] Through parody, metaphor, and allusion, she retells the immigrant story from a female ethnic perspective in a way that re-defines success,

asserts cultural identity, and reveals the wealth of new world possibilities within the old world culture and the need for them in the new world.

Wiseman does this through the novel's characters, themes, and structure, all of which are based on the notion of a paradoxical union of opposites. For example, Hoda's father, Danile, is a wise fool, a blind seer who can look beneath surface appearances to underlying realities; Hoda's mother is a cripple who can carry her family on her deformed shoulders; Hoda herself is both a prostitute and the most dutiful of Jewish daughters, an embodiment of seemingly contradictory female principles. Their family's myth of origin, which preoccupies both Danile and Hoda, is one that begins in a graveyard, and Hoda traces both her birth and her family's journey to the new world back to death and calamity. And, even though once in the new world they are abandoned by their rich uncle and live in poverty, they feel in some way lucky. As Danile puts it, "You wouldn't believe our luck, for on the surface, aren't we the unluckiest people in the world? But study things, study and you'll see. God only seems to punish.... God blinded me for reasons of his own, and the loss is nothing to the gain. For if I had not been blind and your mother had not been a little crooked many wonderful things would not have happened and you would probably never have been born. Shouldn't I call that luck?" (9, 10).

This paradoxical union of opposites is expressed most intensely in the inscription at the beginning of *Crackpot*:

> He stored the Divine Light in a Vessel, but the Vessel, unable to contain the Holy Radiance, burst, and its shards, permeated with sparks of the Divine scattered through the Universe.

Drawn from the work of Rabbi Isaac Luria, "whose speculations gave birth to modern Kabbalism," (Ponce, 79) or Jewish mysticism, the quote, which is taken from a Kabbalistic legend of creation, provides both the novel's title and the metaphor on which it is structured. Although the metaphor embodies a mystical doctrine too complex to explore fully here, it captures the inseparability of good and evil, suggesting that a cracked pot is not just a useless piece of pottery but a vessel whose bursting allowed the divine to permeate the universe, rendering dichotomies meaningless and erasing boundaries between inside and outside. Hoda is just such a vessel and she and her story are profoundly subversive of the dualistic sensibility that confines the immigrant both from without and from within.

By remembering and resisting in a new way, *Crackpot* unites the polarities inherent in immigrant experience and also provides a far-reaching critique of the aggressive masculine ethos that shaped the

new world in its own image and attempted to control the spaces available within it. Wiseman fictionalizes the female immigrant dream of finding a legitimate space—a home—in the new world, but not through a dichotomous, ironic fictional world where to find a space for themselves, immigrants and their children can only disintegrate into the unyielding majority in hopes of achieving an elusive material success. Nor does she accomplish this through a dream of conquering the hegemonic Anglo-Canadian "other" through fantasies of heroic prowess and invincibility. Rather, she fictionalizes the ethnic ghetto into a place, not just of endings (either happy or sad), but of beginnings, a starting point from which her characters can assert the paradoxical power of a love that can unite opposites, and the power of an artistry that can draw on its unique past and present circumstances to create an illuminating synthesis, one that envisions new spaces and challenging possibilities.

Tamara Palmer Seiler has published two books and a number of articles in the fields of western Canadian history, ethnic studies and Canadian literature, and is currently Director of the Canadian Studies Programme at the University of Calgary. She has been a member of the Faculty of General Studies since its inception in 1981, so she was privileged to work with Marsha Hanen both when the latter was Associate Dean and, later, when she was Dean of the faculty. Dr. Hanen had a significant impact on Professor Seiler: as a role model, as an administrator who provided encouragement and opportunity, and most especially as an intellectually stimulating and emotionally supportive colleague and friend.

Notes

1 See Elaine Showalter, *A Literature of Their Own: British Women Novelists from Bronte to Lessing* (Princeton, NJ: Princeton UP, 1977), particularly chapter 11, "Beyond the Female Aesthetic," for an enlightening discussion of the problem inevitably raised by focusing on "an aesthetic that champion[s] the feminine consciousness and assert[s] its superiority to the public, rationalist masculine world. At the same time that it promised women an alternative source of experience and self-esteem, however, the female aesthetic uncannily legitimized ... old stereotypes" (298). See also Bronwen Levy, "Women Experiment Down Under: Reading the Difference," *Kunapipi* 7.2–3 (1985): 171. Mary Eagleton discusses similar issues in *Feminist Literary Theory: A Reader* (Oxford: Basic Blackwell, 1986). While acknowledging the problem these critics highlight, I read the female depiction of the North End, particularly that of Adele Wiseman in *Crackpot*, not as one that illustrates old stereotypes about female writing,

but one that challenges them by asserting the positive power and legitimacy of a female vision at a profound, metaphysical level.

2 George Woodcock, *Mordecai Richler* (Toronto: McLelland & Stewart, 1970) 23–24.

3 Tamara J. Palmer, "Mythologizing the Journey to and from Otherness: Some Features of the Ethnic Voice in Canadian Literature," ed. Valeria Lerda, *From "Melting Pot" to Multiculturalism: The Evolution of Ethnic Relations in the United States and Canada* (Rome: Bulzoni Editore, 1990) 65–74.

4 Alan F. J. Artibise, "Winnipeg," *The Canadian Encyclopedia* (Edmonton: Hurtig Publishers, 1985) 1951.

5 Robert Kroetsch, "The Grammar of Silence: Narrative Patterns in Ethnic Writing," *Canadian Literature* 106 (Fall, 1985):65–74, and Eli Mandel, "Ethnic Voice in Canadian Writing," ed. Wsevold Isajiw, *Identities: The Impact of Ethnicity on Canadian Society* (Toronto: Peter Martin Associates, 1977): 57–68.

6 Morris K. Mott, "The Foreign Peril: Nativism in Winnipeg, 1916–1923," M.A. thesis, U of Manitoba, 1970; Howard Palmer, *Patterns of Prejudice: A History of Nativism in Alberta* (Toronto: McLelland & Stewart, 1982); and Terrence Craig, *Racial Attitudes in English-Canadian Fiction, 1905–1980* (Waterloo, ON: Wilfrid Laurier UP, 1987) 32–46.

7 Ralph Connor, *The Foreigner* (Toronto: Westminster Press, 1909) 87.

8 I have elsewhere defined the Fiction of Ethnicity as "a set of structural, thematic and stylistic conventions that constitute a tradition or genre, a cultural artifact ... that reflects in some way the nature of ethnic experience in Canada and at the same time predisposes Canadians to perceive that experience in terms of these conventions." Perhaps not surprisingly, the marriage of an ethnic character to an Anglo-Canadian is a common event in this Fiction, a rite of passage symbolizing the ethnic character's having finally suffered sufficiently and been sufficiently divested of ethnicity to be granted a legitimate place.

9 The notion of ethnicity implied here is one that defines it as "other," heathen, rather than as simply embodying a sense of peoplehood. The latter definition would, of course, make the Anglo-centre as ethnic as the Slavs that Gordon looks down upon.

10 See Werner Sollors, "Literature and Ethnicity," ed. Stephan Thernstrom, *Harvard Encyclopedia of American Ethnic Groups* (Cambridge, MA: Harvard UP, 1980) 647–55, for a discussion of the second-generation writer as group apologist.

11 See Kroetsch; also Mandel 58.

12 John Marlyn, *Under the Ribs of Death* (Toronto: McLelland & Stewart, 1957) 17.

13 For the classic discussion of this connection, see John Porter, *The Vertical Mosaic: An Analysis of Social Class and Power in Canada* (Toronto: U of Toronto P, 1965). See also Wallace Clement, *Class, Power and Property: Essays on Canadian Society* (Toronto: Methuen, 1983); David H. Flaherty, "Who Rules Canada?" *Daedalus*, 117.4 (Fall 1988): 99–128; and T. J. Palmer, "The Fictionalization of the Vertical Mosaic: The Immigrant, Success and National Mythology," *Canadian Review of Comparative Literature* spec. issue (Sept./Dec. 1989): 619–55.

14 John Roberts, "John Marlyn's *Under the Ribs of Death*: Irony in an Immigrant Novel," *Canadian Ethnic Studies* 14.1 (1982): 41.

15 Kay Schaffer, *Women and the Bush: Forces of Desire in the Australian Cultural Tradition* (Cambridge: Cambridge UP, 1988) 82. For the ground-breaking discussion of woman as "other," see Simone de Beauvoir, *The Second Sex* (New York: Alfred A. Knopf, 1953).

16 W. H. New, *A History of Canadian Literature* (London: Macmillan, 1989) 242.

17 Ed Kleiman, *The Immortals* (Edmonton: NeWest, 1980).

18 See Linda Hutcheon, *The Canadian Postmodern: A Study of Contemporary English-Canadian Fiction* (Toronto: Oxford UP, 1988) 111, and Samaro Kamboureli, "Dialogue with the Other: The Use of Myth in Canadian Women's Poetry," *The Feminine: Women and Words*, eds. Ann Dybikowski et al. (Edmonton: Longspoon Press, 1983) 107, 108.

19 Jack Ludwig, *Above Ground* (Boston: Little, 1968) 49.

20 See Beverly Rasporich, "Retelling Vera Lysenko: A Feminist and Ethnic Writer," *Canadian Ethnic Studies* 21.2 (1989): 48–52.

21 Maara Haas, *The Street Where I Live* (Toronto: McGraw Hill Ryerson, 1976) 1.

22 Robert B. Klymasz, "Macaronicism in Ukrainian-Canadian Literature," *Literatures of Lesser Diffusion*, spec. issue of *Canadian Review of Comparative Literature* (Sept./Dec. 1989): 764 and 766.

23 Michael Greenstein, *Adele Wiseman and Her Works* (Toronto: ECW Press, 1984) 5.

24 For a thought-provoking discussion of ethnicity as boundary, see Werner Sollors, *Beyond Ethnicity, Consent and Descent in American Culture* (New York: Oxford UP, 1986). In chapter 1, Sollors discusses Frederik Barth's view that "the essence of ethnicity [is] in such mental, cultural, social, moral, aesthetic, and not necessarily territorial boundary-constructing processes which function as cultural markers between groups. For Barth it is the ethnic boundary that defines the group, not the cultural stuff that it encloses" (27).

25 In his pioneering American study, *Strangers in the Land: Patterns of American Nativism, 1860–1925* (New York: Atheneum, 1965), John

Higham defines nativism as opposition to an internal minority on the grounds of its foreign connections. Howard Palmer (*Patterns of Prejudice*) adapted the concept to the Canadian context.

26 Adele Wiseman, *Crackpot* (Toronto: McLelland & Stewart, 1974) 59.

27 Quoted in Roslyn Belkin, "The Consciousness of a Jewish Artist: An Interview with Adele Wiseman," *Journal of Canadian Fiction* (1981): 148–76.

28 Charles Ponce, *Kabbalah* (San Francisco: Straight Arrow Books, 1973). Two of the most interesting aspects of this tradition, which Wiseman taps into through the central metaphor of the cracked vessels drawn from a Kabbalistic myth of creation and in other ways through the novel, is its insistence that good and evil are inseparable, and that there is a female as well as a male principle at the heart of the forces of creation.

29 See Hutcheon, especially chapter 6, "Shape Shifters," for a discussion of the techniques, particularly paradox, used by Canadian women writers to reshape traditions and rewrite myths.

5

"The Unfeminist Figure of Melancholy":
Gail Scott's HEROINE

KATHLEEN MARTINDALE

A BRIEF HISTORY OF MELANCHOLY

Gail Scott's recent novel, *Heroine* (1987), is an unflinching yet lyrical attempt to imagine what she calls in her companion essay, "A Feminist at the Carnival," "the unfeminist figure of melancholy."[1] Why is melancholy unfeminist? Is it because or in spite of the fact that in the artistic tradition melancholy is typically figured as female, whereas in the medical and philosophical literature melancholy is assumed to be a male condition? Melancholy has been regarded as something men have but women merely represent. The Western philosophical, artistic, literary, and medical tradition has displayed a profound ambivalence toward what the *Oxford Dictionary* now defines as "mental depression, lack of cheerfulness; tendency to low spirits and brooding; depressing influence of a place" and toward its gendered representation.

While the earliest discussions of melancholy, the black bile, present it as much feared and hated, later authors treat it as indicative *in men* of the presence of learning, even genius, unfortunately burdened by the ability to think but not to act. In the earlier literature, men suffer from melancholia but women are its emblems. Perhaps the most well-known "figuring" of melancholy is Dürer's engraving "Melancolia I," who is depicted, not as she had been previously, as a "sluggish housewife ... [but as] a superior being—superior, not only by virtue of her wings but also by virtue of her intelligence and imagination—surrounded by the tools and symbols of creative endeavour and scientific research."[2]

Freud, in his 1917 essay, "Mourning and Melancholia," advances our understanding by offering a theory of melancholy as a pathological form of mourning for an introjected lost object which is both loved and hated. While both mourning and melancholia display the same features—a "profoundly painful dejection, cessation of interest in the outside world, loss of capacity to love, inhibition of all activity"— melancholia marks itself as pathological by the melancholiac's self-

reproaches.[3] Melancholia differs from mourning primarily because the sufferer's self-esteem decreases significantly (254–56). Although the mourner idealizes the lost object, his or her ambivalence toward the object gives rise to melancholy, which can be a response not just to a loss by death, but to any situation of disappointment, emotional wounding, or abandonment. What Freud does not say and is not interested in in his analysis of mourning and melancholy are what interest me most. His real concern is with the pathology of melancholia, but he maintains the silences and confusions of earlier accounts about its gendered aspects. During normal mourning, the mourner is exclusively devoted to his or her mourning, but eventually "respect for reality gains the day" (253). Though Freud does not hold out the possibility that anyone can attain "normalcy," he does imply that gradually mourning will cease and life will continue as before.

My question to Freud, then, is similar to that of one of the most important contemporary feminist revisionists of Freud, psychoanalyst Luce Irigaray, who contends that the structures of melancholy and femininity are nearly identical: is "normalcy" ever possible for those gendered female in Western culture—that is, for those who are constructed and trained from birth to be self-reviling and manifestly, if so unfortunately, offer evidence of disturbances of self-regard—let alone for melancholic malcontents of the female variety, also known as feminists? For surely becoming a feminist entails a process of rejection of mainstream culture and women's place in it which gives rise to feelings both of anger and grief. Irigaray's parodic reading of Freud's article on mourning and melancholy takes off from the familiar Freudian narrative about the dire sequence of psychic events following upon the little girl's catastrophic discovery of her own castration; but Irigaray insists on following Freud's logic to its conclusion: that becoming feminine, becoming a successfully heterosexual woman, means becoming a melancholiac.

Both the melancholiac and the feminine woman manifest the same shared traits: profoundly painful dejection, including a loss of interest in masturbation; abrogation of interest in the outside world; loss of the capacity for love; inhibition of all activity; and a fall in self-esteem.[4] The feminine woman is not entirely worthy of the name of melancholiac, because she hasn't enough narcissism to produce the syndrome fully. Like Gail Scott's heroine, who has enough narcissism left to masturbate but not enough to get herself out of the tub and into the world, Irigaray's melancholy woman also seems to complain, "Oh, Mamma, why did you put this hole in me?"[5]

In Irigaray's controversial analysis, which clearly uses Freud in the

service of a feminist analysis of women's exclusion from representation, the feminine and therefore melancholy woman cannot be entirely melancholy, nor can she work that affliction through into mourning. Indeed, she cannot figure or represent herself at all.

> She functions as a hole ... in the elaboration of imaginary and symbolic processes. But this fault, this deficiency, this 'hole,' inevitably affords woman too few figurations, images, or representations by which to represent herself. It is not that she lacks some 'master signifier' or that none is imposed upon her, but rather that access to a signifying economy, to the coining of signifiers, is difficult or even impossible for her because she remains an outsider, herself (a) subject to their norms. She borrows signifiers but cannot make her mark, or re-mark upon them. (71)

In comparison with Irigaray's wickedly irreverent but nonetheless fully informed reading of the gendered implications of melancholy, Julia Kristeva's poetic Lacanian account is worshipful of her masters and therefore merely conventional. Nonetheless, just as Irigaray has read Freud against Freud, so Kristeva can be read for feminist purposes against Kristeva and her post-feminist disciples. A detailed example of how to do this can be found in Judith Butler's *Gender Trouble: Feminism and the Subversion of Identity* where she uses "Mourning and Melancholia" and *The Ego and the Id* to clarify what is missing not only there but also in Kristeva.[6]

Compared with the clearly feminist interpretations of Freud offered by both Irigaray and Butler, Julia Kristeva's poetic effusions are not only depoliticized but oddly enough unilluminating, given that she is now a practising psychoanalyst who provides clinical examples from her work on depressed female patients. In *Black Sun: Depression and Melancholia*, Kristeva explains the greater ease with which women fall into melancholy as a consequence of their greater difficulty in achieving autonomy from their mothers without loss of their love.

In her chapter on "Motherhood According to Bellini," in *Desire in Language*,[7] Kristeva first linked motherhood and melancholy. In her later work, particularly the chapter in *Black Sun* on the novelist Marguerite Duras, Kristeva claims that maternal abandonment is the trauma underlying all Duras's writing. This assertion fuels Kristeva's argument that political events are internalized and measured only by the human pain they induce; thereby suggesting how dangerous it is to take uncritically Kristeva's reductions of the political meanings of women's lives to their psychological significance. For some theorists, Kristeva's work easily exemplifies the limitations of psychoanalytical feminism. This is not my claim, but I will acknowledge it here.[8]

For Kristeva, love and melancholia are opposites. Where love is a striving for union with an idealized object, melancholia is an archaic denial of separation from the mother which takes the sufferer back so early into psychic life that no relation is as yet possible, prior to the entry into the symbolic order of language. In the case of melancholia, sadness becomes the object, or what Kristeva calls "the Thing", an unnameable, non-symbolizable something, which she likens to the metaphor of a black sun or a light without representation.[9] The melancholiac mourns for a loss which is denied and cannot be symbolized—hence her silences, which amount to a denial of representation.

No matter what the disciplinary terms of reference, whether it be art historical, psychoanalytical, literary, or political, melancholy is figured as linking together contradictory feelings—elation and despair; love and hate; plenitude and loss—as well as requirements for perform-ance—theoretical insight and activity—and notions of adequacy and inadequacy, which, in Panofsky's words, make melancholiacs con-scious of a "sphere beyond their reach which makes them suffer from feelings of confinement and insufficiency" (168). If, following Kristeva's suggestion, we consider melancholy as a discourse, then reading it offers ways of linking the feeling of melancholy with its gendered representations and the ensuing fears, present from the beginning of its ideation in Western culture, that the melancholiac is related to the political malcontent.

What, then, is the relationship between the woman who mourns, perhaps excessively, and the woman who is militant? Most forms of feminism deny the relationship or, more likely, find it one of inversion. Melancholy is unfeminist because it is passive or even impassive, self-indulgent, and pessimistic. In this article I will challenge the claim of some feminists whose opposition to postmodernist feminist literary practices, such as we find in Gail Scott's *Heroine*, suggests that "real feminists" don't feel pessimistic and melancholy. Then I will argue that Scott's novel allows for a much more profound understanding of both feminism and the relationship between femininity and melancholy. Finally, I will suggest that what is in contention between Scott and her feminist critics is nothing less than the narrative of feminism and the feminist narrative.

FEMINIST CRITIQUES OF THE HEROINE

One of the earliest binary oppositions to have been thoroughly destabilized by feminist literary critics was that between the hero/ victim or the heroic/the ordinary. Though the critiques keep being elaborated, one still useful review of the contestations of the concept of the hero or heroine as examined in feminist literature up until 1982 can

be found in Rachel Brownstein's *Becoming a Heroine: Reading about Women in Novels*.[10] Nothing has remained sacred for feminist critics, not even the hero's/heroine's name. Some reject "heroine", the female diminutive of "hero," outright, because of the "-ine" ending, which not only feminizes the word in English, but, they argue, diminishes her accomplishments. Gail Scott herself uses the word, but in "A Feminist at the Carnival" she re-visions its etymology to connect it with a cyclical narrative structure (123–24). One critic prefers "hera," thereby alluding to the goddess; still, alas, wife of....[11] Rachel Blau DuPlessis, in *Writing Beyond the Ending: Narrative Strategies of Twentieth-Century Women Writers*, investigates the relationship between narrative forms and possibilities for communal quest beyond the endings of the nineteenth-century traditional heroine's plot of marriage or death. Like Brownstein and Munt, DuPlessis reserves her most thoughtful discussion of the issue for her note on the terms she uses. She distinguishes "heroine" as the object of male attention or rescue and declines to use it for her project of textual and societal change. Instead, she suggests "female hero," "a central character whose activities, growth, and insight are given much narrative attention and much authorial interest."[12] Though the reasons given for the different usages vary and are in themselves interesting, Brownstein, Munt, and DuPlessis's arguments about which term to use indicate the general direction in which feminist critique of the hero and the heroic has proceeded, away from the romance plot with its supposed passive maintenance of the female status quo and toward the dynamism of character and social change more readily found in sub-genres of the novel, such as the picaresque, the detective story, or speculative fiction, including science fiction, utopian narratives, and fantasy.

Many feminist critics argue that certain genres and modes of literature, such as the romance or marriage plot, the bourgeois novel, or realism altogether should be treated with extreme suspicion or entirely given up.[13] In the strongest of these critiques, these narrative conventions and structures are said to be lethal to feminists and/or to women. The feminist with a taste for trashy novels or soap operas, accordingly, is complicit in her own textual/societal victimization, succumbing to the less than innocent pleasures of (hetero)sexist erotic subjugation which isolate and paralyze women, thereby helping to prevent textual/sexual change from occurring.[14]

In the face of the non- or anti-feminist prescriptions for the heroine encoded into eighteenth-, nineteenth- and even twentieth-century fiction, feminist theoretical and fictional texts have put forward their own prescriptions about romantic heterosexual love, marriage, and the

narratives which make them seem credible and favourable outcomes in life and art. Inspired by the resurgence in Europe and North America in the late 1960s of a chiefly liberal and then radical feminism, feminist writers and critics wrote theoretical treatises and manifestos against romance and fictional texts for personal autonomy, especially of the sexual kind.

The 1970s bore witness to the popular feminist fiction, the bestseller that changed women's lives, influenced a whole generation, and made millions of dollars in profits, usually for established publishing houses. Women's studies programmes, themselves newly established, made novels such as Erica Jong's *Fear of Flying*, Margaret Atwood's *The Edible Woman*, Rita Mae Brown's *Ruby Fruit Jungle*, Marilyn French's *The Women's Room*, and Lisa Alther's *Kinflicks* required reading in their enormously popular "Images of Women in Literature" classes. It was not only the bored, mousy housewife who was banished; the governess and the executive secretary who used to pine away for the unrequited love of a mysterious, brutal, rich, but uncommunicative older man now had to tell him to hit the road and then do it herself, whether leaving to "find herself" meant going toward the big city, a brilliant career, feminist activism, or the arms of another woman. Out with the female victim, and in with the strong woman, the positive image, the role model.

Such writing was prescriptive, sometimes ridiculously so, in its own ways. Its oppositional aesthetic sometimes placed such a great strain on the heroine's/hera's/female hero's progress by demanding a progressive narrative that the structure became not only predictable but laughable. For example, in Alice Walker's novel *The Color Purple*, her heroine Celie overcomes her history of exploitation and abuse by becoming an independent entrepreneur, a maker of colourful pants.[15] In Lisa Alther's novel *Kinflicks*, her comic heroine Ginnie finally grows up when she rejects suicide, incorporates her dead mother into her feminist sense of herself, and is brave enough to make her way through life alone and self-reliant: "She wrapped her mother's clock in her faded Sisterhood Is Powerful T-shirt.... She left the cabin, to go where she had no idea."[16] Furthermore, in this writing's tendency to efface the contradictions within its conceptions of its central character and her relationship to her textual and social world, the endings in particular suggested just the opposite of what on the surface they claimed to assert: that strong women always win out and that women who win are always the strong ones.

According to DuPlessis, feminist fictions about the development of the writer/artist should annul aesthetic distance, be life-like, and end

in human change (103). These characteristics are conspicuously absent from _Heroine_. Gail _the narrator_ parrots some of the clichés of the sectarian left revolutionaries and later, of the feminists she models herself after: that the revolution cannot afford sentimentality or discouragement, and that feminists should cut the melodrama and turn hurt into anger. However, Gail Scott _the author_ undercuts the clichés, in part simply by putting them in the mouth of her uninspiring, anti-heroic, and anti-romantic heroine. By contrast, feminist prescriptive fiction, such as Walker's and Alther's among many others, is suspicious of irony and ambiguity.

Instead, the more that fictional endings proclaim that the feminist heroine and her revolution will succeed, the more the reader might reasonably enough remain unconvinced. Doris Lessing's _The Golden Notebook_, first published in 1962, became a feminist bible, apparently with some misgivings on the part of the author, in the early 1970s, and is in many ways a "straight" version of Scott's _Heroine_.[17] Lessing's polyvocal fiction, which includes texts from the narrator's colour-coded notebooks ranging from non-fiction to para-fiction to anti-fiction and meta-fiction, is a complex and contradictory text. It can, nonetheless, be read, because of Anna Wulf's progress through a breakdown into a successful text which writes her more than she writes it, as the original text of a feminist heroine-as-writer. Brownstein might be correct in claiming that the "structure of the novel makes the point that traditional realistic narrative is inadequate to the truth about the lives of modern women." However, when she asserts that a "fragmented, unstable, ineffectual self can centre on a heroine only ironically" (29), she fails to see that a narrative structure of "truth to life" is still a problematic prescription.

Brownstein rightly observes that Lessing keeps the traditional identification of the heroine with interiority, as in the feminine convention of journalkeeping. Scott, on the other hand, makes even journal keeping suspect. _Heroine_ has Gail the narrator using her diary to escape revolutionary duties and the task of writing the novel. "Paragraphs Blowing on a Line," Gail Scott's superb critical commentary on the novel, is named by the author a fake diary, thereby sending up the form itself.[18]

Unlike feminist critics such as Miller and DuPlessis, who want to change the ending of the narrative, Scott resists the conventions of narrative itself. Part of her challenge requires questioning the definition of the heroine herself and the way she is written into and is written by her text. This far more ambitious critique can be found in and around the novel, that is, in her collection of essays, _Spaces Like Stairs_, which

has an unusually close relationship with the novel, so much so as to occupy a space within the borders of the text itself. Indeed, the notion of spaces and gaps which refuse to be bridges or to be bridged are crucial concepts in Scott's re-figuration of the unfeminist figure of melancholy.

Scott's rethinking of the word "heroine" connects her with the ascension ceremony at Delphi, or feast of the heroine, which, according to Robert Graves, "represented Persephone's cyclical rise from Hades, not to 'heaven,' but to wander about on the earth with Demeter [her mother] until the time came for her to return to the Underworld."[19] Circularity appeals to Scott because Persephone's movement is cyclical and not that of the patriarchal model of linear ascent to climax. Though the essentialist claim about masculine/feminine and about feminist narrative structures is not useful, the appeal to Scott of the cyclical over the linear, of the structure allowing for contradiction without shame, is crucial for understanding what differentiates her fictional-theoretical practice from that of feminist prescriptivists.

Scott's choice of Persephone, who desires to "grasp in language the mother as a woman" ("A Feminist at the Carnival," 127), but must mourn for her, split off as she is from the maternal object for half the year, suggests how *Heroine* marks an ambiguous, open-ended movement between melancholy, or denial denied, and mourning, or denial admitted into consciousness and speech. It also suggests another courageous refusal on Scott's part: the refusal to move her heroine, whom she insists on seeing as a subject-in-process rather than as a finished product, "all the way" into a lesbian and utopian narrative in which the loss of the maternal object is fully recovered in a sexual relationship with another woman.[20]

Scott's theoretical and cultural relationship to her mother tongue and to potential and competing feminist symbolic creative mothers also marks *Heroine* as a melancholy text and suggests why she rejects common Anglo-Canadian and American notions of the positive feminist heroine. In an astonishing short piece in three parts called "A Story Between Two Chairs," whose preface and afterword are longer and more discursive than the poetic "text" itself, Scott suggests why being an anglophone writer in Quebec puts her in a situation, culturally and politically speaking, that resembles melancholia.[21] Though fluently bilingual and a voluntary exile from her rural English Protestant bourgeois culture she, like a melancholiac, berates herself for shouldering a history which diminishes the self-image of the politically sensitive person:

When you find yourself in this historical conundrum, and at the same time you feel a tremendous solidarity with what has been going on in the way of [Québécoise] national affirmation in the past twenty years, the positive, upbeat image often expected of feminist fiction seems oversimplified. (63)

Scott, like her heroine, came to "la cité" to transgress the limits not only of patriarchy, but of feminist prescriptions for writing, which offered the fostering and legitimizing power of a/the feminist community, but in return demanded restrictions on the play of imagination, desire, and language. Refusing to go to heaven, but insisting on remaining on earth, Scott rejects a maternal lineage of Anglo-Canadian fictional mothers such as Atwood, Laurence, Munro, and Audrey Thomas, for whom the feminist revolution is centred on content and meaning rather than structure, form, and language. Instead, she has taken up the legacy of the Québécoise feminist writers Louky Bersianik, France Theoret, Louise Cotnoir, and Nicole Brossard, linguistic and structural revolutionaries who, together with Scott, make up a Sunday writing group whose work has been collected in *La Theorie, un dimanche.*[22]

Still not content to allow her text to be monovocal in the sense of monolingual, Scott practices a bilinguality or confluence of French and English in her text which marks her culturally and linguistically as a colonizer, but also lets the voices of the colonized appear untranslated in her text. Like the melancholiac who insists that nothing is lost, Scott keeps her English culture and language while admonishing herself for being English and fixating on the culture and language of the loved Other. She even brings inside her critical text the externalized voice of an Anglo-Canadian feminist critic who has attacked her novel:

"Your work isn't positive enough to be feminist," says a feminist writer from English Canada. "It doesn't show an upbeat enough image of solidarity." "But," I reply, at first feebly, then angrily, "It's about the relationship between thinking and feeling; about the struggle between her feminist consciousness—in both its greatness and its limitations— and social constructs, memory, dreams, nightmares." ("A Feminist at the Carnival," 131)

Scott's final rebuttal of her critic is based on a defence of respect for the historical situation in which they both live, that is, of melancholy post-modernism. In language oddly resembling Kristeva's in *Black Sun,* Scott defends her writing of the unfeminist figure of melancholy in terms of the *zeitgeist.* She imagines melancholy as

that permeating contemporary melancholy of this decadent end-of-century which has to do with the seemingly hopeless destruction of Mother Earth. Whom we (at least white society) have treated as we often do our biological mothers: narcissistically, exploitatively. ("A Feminist at the Carnival," 116)

Though Anglo-feminist critics and writers might doubt, along with Kristeva, whether melancholy postmodernism is the breakthrough that had been hoped for, Scott insists that her work is actually more in touch with the spirit of the age, and therefore, she would argue, more, not less, politically responsible than theirs. Even here, though, where her argument is seemingly most conventional, Scott indulges in a playful gap. Following the last line quoted above, there is a space in the text and in the argument. The last sentence, which begins with the conjunction "for" is set apart, a conclusion without a stated premise: "For, a writer may do as she pleases with her epoch. Except ignore it." Such is her defense that she is more responsible than they are, for all their insistence on upbeat heroines and narratives of triumph.

MELANCHOLY LANGUAGE

The most memorable thing Julia Kristeva says about melancholy is that it operates like a language, a language focused on failure and the denial of loss. This language's characteristics include the following: inhibition, sometimes to the point that lengthy and frequent silences or spasmodic crying replace speech; asymbolia, or the loss of meaning, alternating with manic elation; frequent and repetitious complaining by the speaker which conceals a hatred for the lost object; speech patterns displaying monotonous melodies and repetitive rhythms, sometimes assuming the form of obsessive litanies of self-recrimination and sometimes producing a poetic form in which signs decompose and recompose; emotionally deadened speech; the manifestation of a cognitive hyperlucidity about the speaker's own self-inspection; and finally, the inability to finish sentences or follow their logic to a conclusion (*Black Sun*, 9, 14, 33, 41, 48, 51, 59).

While the interior monologues of Gail Scott's heroine manifest all of these semantic traits, the fact that they do might interest readers for rather different reasons. For example, their presence might fascinate psychologists and others because Scott's novel seems to add textual evidence to Kristeva's linguistic argument. Anti-feminist readers and those who reject postmodernist culture or art, which includes some feminists, might be persuaded by Kristeva's polemic against postmodernist feminist texts such as those by Marguerite Duras: an awkwardness of style and a failure to provide readers with catharsis,

which might even endanger them psychologically. "Confining itself to baring the malady ... such a literature encounters, recognizes, but also spreads the pain that summons it. It is the reverse of clinical discourse." (*Black Sun*, 226, 228–29).

My fascination is otherwise. I find Kristeva's arguments about the specifics of melancholy language useful because she sheds light on how Scott over-writes, rather than avoids, melancholy. By choosing to rework melodramatic and even boring narrative forms, such as that of a woman who loved too much, Scott produces a text of great poetic originality and beauty. She takes many risks, some but not all of them political, in doing so. She works not in the manner of a painter producing a palimpsest, but by writing over and "over the top", in which nothing is lost or effaced. Truly, *Heroine* is a melancholy text, in Kristeva's sense, "maintain[ing its] omnipotence over a hell that is not to be lost" (*Black Sun* 45).

Like Doris Lessing's blocked writer, Anna Wulf, in *The Golden Notebook*, who keeps various diaries to voice different aspects of her fragmented, anguished self, the heroine uses a black diary to record her hidden pain after she attempts to reconcile with her left leader lover. In one brilliant diary entry, written under what the narrator calls her line of pain on March 8, 1980, International Women's Day, Gail recounts how she tried to flirt with another man, a doctoral candidate in semiotics, no less, in order to give herself more power in her relationship. What happens as she and the semiotician talk about postmodernism (Gail, operating as does the author in a French milieu, uses the French term, "la modernité", so what she calls modernism would be termed by anglophones postmodernism) could have come straight from Kristeva, except that the passage is written with a sardonic sense of humour and concludes with a send-up of psychiatry:

> So, we're sitting in a Spanish restaurant on Park Ave. talking about how the French modernist scene is different from the English, etc. Smoking cigarettes and drinking Sangria. When suddenly I can't remember how to get to the end of a sentence. Each time I start, it's as if the memory of the past (the noun, the sentence's beginning) wipes out the present (verb). So I can no longer move forward in the words. This is so scary I run out of there around the corner to the shrink at McGill. She says (sitting in her wicker chair): Gail, the problem is you've lost your boundaries.... Caught as you are between wanting to be your own self AND the object of his affection.
>
> I say that's obvious. But how to define those boundaries yet have love too? She wouldn't or couldn't answer, which really made me laugh. (175–76)

Unlike Kristeva, who is the heroine of her text because she offers her patients a love which bridges them back to normalcy, Gail's psychiatrist, who offers sound if pedestrian advice, is mocked because she speaks in clichés and inhabits the hated bourgeois world of anglophone McGill University. Gail turns to her for answers, just as she has to Jon and Marie who seem to offer her the revolution, culture, and feminism to fill the void within her, the subject of one melancholy refrain: "Oh, Momma, why'd you put this hole in me?"

When Marie tells Gail the narrator that the responsibility of feminists is writing (113), this is just one more obligation laid on the heroine from the outside. Indeed, the very language in which Marie offers this advice is itself prescriptive and therefore contradicts the openness or questioning of language, politics, and culture that Gail Scott, fiction theorist, in her essay "A Story Between Two Chairs," tells us she seeks:

> She was also starting to feel uncomfortable with the restrictive way "feminism" sometimes gets applied to writing practice: the rigid attitudes prevailing in certain milieus about what a "feminist heroine" is, for example, have progressed little beyond the social [sic] realism of the 20s and 30s. If writing is the act of always seeking more understanding, more lucidity, prescriptive directives have no place in our trajectory towards the uncanny edge of language (62). [Itself a prescriptive!]

While refusing to take the prescribed Anglo-Canadian and Anglo-American feminist journey from victim to triumphant heroine, Scott inevitably prescribes another sort of anti-heroic journey, from the slogans and certainties of Marxism or feminism to "the uncanny edge of language." This journey requires that, like other budding artists, she make the transgressive passage from the country to the city, but in her particular case that means going, not to Toronto, centre of Anglo-Canadian culture and commerce, but to "la cité," Montreal, and its culture of otherness, where she very often is "la seule anglaise," totally fluent in French but an outsider nonetheless.

Becoming, as Kristeva remarks, a foreigner in her maternal tongue, her speech like an alien skin (*Black Sun* 51), is necessary to making that journey to the edge, partially because it gives her insights into her own language and culture she could not otherwise have had and also because it makes her hyper-aware of the play and materiality of language itself. As Gail Scott's essay works like a commentary, an intertext with her fiction, so Kristeva creates an intertext within her text. Therein, she reports in italic print from her notes about the analysis of a severely depressed intellectual named Anne who frequently withdraws to her bed. Kristeva interprets Anne's conflictual

relationship with her mother (tongue) and how she had:

> _effected a true swallowing of the hated maternal object thus preserved_
> _deep within herself and changed into a source of rage against herself and_
> _of a feeling of inner emptiness ... Anne confirmed me in that impression:_
> _"I speak, she would often say, "as if at the edge of words, and I have the_
> _feeling of being at the edge of my skin, but the bottom of my sorrow remains_
> _unreachable." (Black Sun 56)_

Anne's remark about the depth of her sorrow illustrates the para-
doxical pride of melancholiacs in their misery, and also indicates that,
being still in the grips of her masochistic triumph over her mother, she
is not yet capable of releasing herself into mourning. Anne's insightful
response to Kristeva's interpretation is not only poetic but also provides
a metacommentary on her own relationship to language, rather than
a mere instance of the boring, broken rhythms of melancholy speech
itself. Kristeva's reporting of Anne's doubling-over of language suggests
what work Scott has done to create the poetry and the musicality of
embodied speech in the novel. While the melodramatic plot and the
novelistic necessity of telling a story push the narrator into conven-
tional relationships with language and privilege meaning, Scott pushes
the story in the other direction, toward poetry and a paradoxical
beauty.[23] Kristeva is undoubtedly right that "naming suffering, exalting
it, dissecting it ... is a way to curb mourning" (_Black Sun_ 97), but the
narrator's obsession with doing this in her diary is undercut and
ironized by the author's working of this raw, very raw, material into a
collage, her use of repetitions with differences, and her playing with the
distance between herself and the narrator, Gail.

USING NARRATIVE AGAINST NARRATIVE

Unlike the other feminist theorists who have critiqued the heroine's
plot, classic realist fiction, or even narrative itself, attending primarily
to the relationship in narrative between what comes at or after the
ending, Gail Scott's concern is with writing _before_ the ending. Whereas
a critic like DuPlessis will claim that the formal project of Lessing's
Golden Notebook is "to surpass meretricious, abandoned or incomplete
stories, sometimes love plots ... to achieve a dialectical amalgam and
to articulate a more dynamic statement about history, political and
personal relationships" (101), Scott's fascination is with where the
narrative starts, and with how to get her heroine into the story, but
most specifically, with where the misery comes from.

In "Paragraphs Blowing on a Line," Scott playfully offers several
models of the novel's structure, none of which is the "real" one because

following the threads of the heroine's love obsession doesn't make the bathetic plot conform to any particular pattern. Scott doesn't completely "give in" to the pull of melodrama, doesn't simply trace "The Three Stages of Love," doesn't make her heroine choose between heterosexuality and lesbianism after the affair is over. Moreover, she decides not to arrange her novel in the orderly plan she also imagines, in which seven neat chapters lead up to the breakdown/breakthrough of writing under the line of pain (82–83, 93). Averring that the pain was in her before the love story began puts a new construction both on the melodrama—because in that case the stage Before Love is still not the beginning—and on the feminist critique of romantic love—because the heroine can give up her heroin, get out of the tub, and prepare to start her novel, but still remain melancholy.

At the level of structure, *Heroine* represents another refusal to choose between poetry, theory, and narrative. Scott uses the approach of what is called "fiction/theory" in Quebec: that is, not theoretical analysis of fiction, but a blurring of genres in which fiction and theory write over and over each other, like the collage on the cover of the text. She produces a novel form which behaves like a hysteric[24]—that is, the text acts out what it cannot narrate. Whenever the heroine tries to move the plot forward, to get out of her tub and into her novel, the text shatters and works over the past in which it and the heroine appear to be entombed and the action stops. She returns to her womb-like tub where she bathes in the fluids, and achieves a masturbatory bliss which returns her symbolically to her original condition of fusion with her mother.

Perhaps the most essential convention of the novel as a form is its agreement to show characters moving in action through time. Because Scott refuses to agree to this convention, her novel seems to have the same relationship to time as does the melancholiac who, in Kristeva's evocative language, is not ruled by the before/after notion, is not directed toward a goal, but contradictorily insists that the past has not passed and that it was the best and only time (*Black Sun* 60). Refusing to move either toward the traditional heroine's plot of nineteenth-century realism or the Amazon utopian future proposed by a feminist like Nicole Brossard, Scott plays expectations about narrative off against poetic and musical structures such as the song, the lyric. While these forms do have a driving movement or pulsation, they tend to be more spiral-like and repetitive than the one-directional movement required by narrative.

Obviously, such a break with conventional narrative requires more work on the part of the reader, who must struggle to make sense of what

is happening in a more active way than the reader of realism who merely reads to find out what happens next. Nonetheless, while playing with narrative conventions, especially stopping, elongating, or otherwise interrupting expectations about the passage of time, is older than literary modernism, and is now familiar to readers of twentieth-century fiction, Scott isn't merely reworking the conventions of modernism, but parodying those conventions and asking how the heroine gets into them and what might happen to her, textually and sexually, should she be able to get out of them. When, in "Paragraphs Blowing on a Line," Scott remarks that "a heroine locked in time could be the ruination of a novel" (132), her remark could be taken more than one way: that is, with a sigh of relief, and a feminist gleefulness about the novel's demise, rather than merely with an anguished wringing of hands.

As a reading experience, however, _Heroine_ is not all that difficult. In "Paragraphs," Scott provides a guide to the novel's doubly framed narrative structure which merely confirms what patient and careful readers find out who make it past the first and perhaps maddest section, "Sepia". At the empty centre of the narrative is the lovelorn heroine in her bathtub, obsessively protecting her nostalgia, a fake emotion which inevitably inscribes itself in a fake narrative form. Around that fakery is the narrative of her interior monologues, with the various parts of herself, as well as with her mother, whose name is capitalized as "Her," with a sort of muse of memory named Sepia, with Jon, the very shadowy left leader and philanderer, and with Marie, the Québécoise feminist writer whose voice of reason, control, and detachment represents for the heroine the feminist discourse to which she aspires, Jon's revolutionary one having proven a false step forward into a glorious future.

Yet another narrative frame surrounds that one, leading out to the unnamed Black tourist, who, like a filmmaker, scans the city from his viewpoint at the telescope on Mount Royal. If Sepia represents the medium of photography which arrests time in separate and unchanging pictures, then the Black tourist suggests the medium of film which works like a narrative, moving through time. At a possible further narrative remove is the also unnamed grey woman and the city itself. These marginalized "narrators" or watchers do not know or see Gail the heroine, but their viewpoints are also taken up by the novel. By including them, Scott broadens her angle of vision and makes it more poetic and mysterious. She also suggests that the novel as a whole exists somewhere beyond the significatory powers of her heroine. The novel then is a melancholy event which cannot completely signify itself (Kristeva in _Black Sun_ defines melancholy as "merely an abyssal

suffering that does not succeed in signifying itself" 189).

<div align="center">A MELANCHOLY CONCLUSION</div>

In both form and content, *Heroine* poses challenges to many feminist
sensibilities, particularly perhaps those who came to feminism during
the 1970s and believed that sisterhood was (already) powerful and that
"the personal is political" was an uncomplicated and obvious equation
that meant just what it said. If taken together, it was then thought, and
still is by some privileged feminists, feminism would have a coherent
and complete guide, not just for personal and political transformation,
but for revolutionary artistic expression too. By focusing on the petty
and silly jealousies of our heroine, her cliché-ridden and ridiculous
revolutionary lover, and the other malcontents, *Heroine* undercuts
with bitter ironies the early period of feminist optimism about radical
change. This story is not a new one, nor does Scott add anything
original to what has been written about the trajectory of a generation
of women who moved from the New Left, to disillusionment with the
sexism they found there, to feminist activism, and then to political
withdrawal when they figured out the cost/benefits ratio of living a form
of oppositional politics and culture in societies dedicated to conformity,
consumerism, and corporatism.

Moreover, *Heroine* suggests that no ideology, whether Marxism,
nationalist struggle as in Quebec, or feminism, has all the answers for
human miseries. To conservatives who insist that this is a postideological
age, that suggestion is reassuring. Even Marie, the voice of order and
reason, becomes a feminist bureaucrat in power clothes who asserts
that her primary responsibility, after looking out for number one, is to
her writing. This claim is an affront to many feminist activists. When
the heroine bitterly proposes an eighties toast to Jon and the green-
eyed girl, who represent the new man and the new feminist woman, she
seems resigned to the fact that "now ... the couple seems back for good.
I was the sucker to think it ever left" (95). Cynicism about the failed
revolutions that swept western Europe and North America in the late
1960s is a popular response to the age of reaction that has marked the
Reagan–Bush, Thatcher, and Mulroney years. As one of the constant
refrains in *Heroine* reminds readers, the times are indeed "growing
colder."

We may admit all of these things about the novel, and about the
postmodern condition it seems so well to describe, which the philoso-
pher Lyotard sees as incredulity towards all metanarratives, especially
narratives of liberation. But is there nothing affirmative in it for
feminists, not only those who have grown weary of the fake consola-

tions offered by utopian and speculative fantasies where the righteous prosper and justice prevails, but also for those who are suspicious of New Age mystifications and other private and usually expensive personal solutions to collective miseries?

There is, and, believably, it is something small. In "Paragraphs," Scott claims that the triumph in the novel is that the obsession grows smaller and the melodrama is reduced. "She will just integrate it in all its beauty and pain, like an oyster integrates a pearl" (92). The action by which she does this is slow and modest, like the course of psychoanalysis itself, which Freud claimed could reduce the agony of the neurotic to normal human misery. Such is the project too by which melancholia is worked through and becomes mourning for the mother and the union with her that is permanently lost and forever unattainable. Only by recognizing that loss can the melancholiac be released into mourning, and then, perhaps, into militancy.

Kathleen Martindale is Associate Professor of English at York University, where she teaches feminist literary and cultural theory. Her publications address questions of exclusivity/inclusivity in feminist theory, autobiography, and pedagogy. Previously, she was coordinator of women's studies at the University of Calgary, where she had the pleasure of working with Dean Marsha Hanen. Marsha remains her ideal of wisdom, innovation, and leadership in education.

Notes

1 Gail Scott, "A Feminist at the Carnival," *Spaces Like Stairs* (Toronto: The Women's Press, 1989) 116.
2 Erwin Panofsky, *The Life and Art of Albrecht Dürer* (Princeton: Princeton UP, 1955) 160.
3 Sigmund Freud, "Mourning and Melancholia," *On Metapsychology: The Theory of Psychoanalysis*, trans. James Strachey (London: Penguin, 1984) 11: 252.
4 Luce Irigaray, *Speculum of the Other Woman*, trans. Gillian C. Gill (Ithaca: Cornell UP, 1985) 66–67.
5 Gail Scott, *Heroine* (Toronto: The Coach House Press, 1987) 31, 34, 125.
6 Judith Butler, *Gender Trouble: Feminism and the Subversion of Identity* (New York: Routledge, 1990) 61.
7 Julia Kristeva, *Desire in Language*, trans. Leon S. Roudiez (New York: Columbia UP, 1977).
8 See, among many others, Marianne Hirsch, *The Mother/Daughter Plot: Narrative, Psychoanalysis, Feminism* (Bloomington, IN: Indiana UP, 1989) 152.

9 Julia Kristeva, *Black Sun: Depression and Melancholia*, trans. Leon S. Roudiez (New York: Columbia UP, 1989) 13.

10 Rachel Brownstein, *Becoming a Heroine: Reading About Women in Novels* (Harmondworth: Penguin, 1982); see in particular her lengthy and amusing notes to the introduction, 297–300.

11 Sally Munt, "The Investigators: Lesbian Crime Fiction," *Sweet Dreams: Sexuality Gender and Popular Fiction*, ed. Susannah Radstone (London: Lawrence & Wishart, 1988) 116.

12 Rachel Blau DuPlessis, *Writing Beyond the Ending: Narrative Strategies of Twentieth-Century Women Writers* (Bloomington, Indiana: Indiana UP, 1985) note 22, 200.

13 Catherine Belsey, *Critical Practice* (London: Methuen, 1980); Joanna Russ, *How to Suppress Women's Writing* (Austin: U of Texas Press, 1983).

14 Not all feminist critics of popular culture agree; see, among others, Janice Radway, *Reading the Romance: Women, Patriarchy and Popular Culture* (Chapel Hill: U of North Carolina P, 1984).

15 Alice Walker, *The Colour Purple* (New York: Pocket Books, 1982) 261.

16 Lisa Alther, *Kinflicks* (New York: American Library, 1978) 518.

17 Doris Lessing, *The Golden Notebook* (New York: Simon & Schuster, 1962).

18 Gail Scott, "Paragraphs Blowing on a Line," *Spaces Like Stairs* 79.

19 Graves is quoted by Scott ("A Feminist at the Carnival," 124), but the passage is not identified.

20 Compare the utopian fiction by Daphne Marlatt, *Ana Historic*, which appeared a year later, in 1988.

21 This piece comes from Scott's collection of essays, *Spaces Like Stairs*.

22 Nicole Brossard, Louky Bersianik, Louise Cotnoir, Louise Dupré, Gail Scott and France Theoret, *La Théorie, un dimanche* (Montreal: Les Editions du remue-ménage, 1988).

23 Compare the very different use made of the same melodramatic plot by the American novelist Erica Jong in her recent semi-pornographic potboiler and ad for Twelve Step programmes, *Any Woman's Blues*.

24 Gail Scott, "A Visit To Canada," *Spaces Like Stairs* 47. When DuPlessis calls for a new narrative for feminists in *Writing Beyond the Ending* (102), she is describing what feminists in Quebec have been writing for years now as fiction theory.

6

Aphra Behn and Contemporary Canadian Women Playwrights

SUSAN STONE-BLACKBURN

For the centrepiece of Maenad Productions' 1990–91 season, the three members of its artistic core co-authored *Aphra*, a play about England's first professional woman writer, Aphra Behn. She had seventeen plays produced in major London theatres between 1670 and 1690[1] and she ranked among the foremost playwrights of her day by any measure. Despite her success and her historical significance as the first woman to compete with men in writing for the stage, Behn's name and her plays all but vanished after her death, though those of her male contemporaries lived on in literary histories, anthologies of Restoration plays, and occasional stage revivals.

The choice of Aphra Behn as a subject for their play reflected the contemporary concerns of Maenad members Rose Scollard, Nancy Cullen, and Alexandria Patience, who incorporated their Calgary theatre company in 1989 with the mandate "to promote the feminine vision through exciting and dynamic new works for theatre."[2] Scollard had been writing radio and stage plays for some years; Cullen was just starting as a performance poet and playwright; Patience was a director and actor who had directed Fringe productions of plays by both Scollard and Cullen. They agreed that they were more likely to further their theatrical interests by means of self-production than by looking to mainstream theatre. What they wanted was a theatre that would welcome the theatrical exploration of women's experience, that would foster women's creativity, that would, in other words, feature the work of women writers and directors, actors and designers, working together collectively to create theatre out of women's experience.[3]

There might seem to be little point to a comparison between the Maenads and Aphra Behn. Scollard, Cullen, and Patience created their own small company because they had little hope of finding a place for the kind of work they wanted to do in established theatres, while Behn achieved enormous success writing for one of the two leading London

theatre companies of her time. The Maenads' *Aphra*, however, spot-lights not Behn's triumphs but her losing battle against the forces of conventional morality that consigned her name and her work to oblivion. It shows that her vitality made her equal to the forces against her during her lifetime, but after her death there was no defence against them. That these forces were sexist, not just "moral," is evident in the play, as it is in commentaries on Behn through the centuries.

My own interest in both the posthumous obliteration of Aphra Behn and the challenges faced by the Maenads and similarly motivated women in contemporary theatre raised some questions for me about what progress has been made by women playwrights in our culture over the past three centuries. Are the same or similar forces at work today against women playwrights? Is progress being made, or are the same battles being fought over and over?

Sheer numbers of women playwrights today would suggest progress—there were only three plays by women known to have been profession-ally produced in England before Behn's first in 1670 (Cotton 15–16). Today there are many plays by women produced. Of course, if we compared the number of women alive today with the number three centuries ago, and especially the number of literate women, much of the impression of progress based on sheer numbers of women's plays produced would vanish. And if one feels assured that women must be making steady progress in theatre, it is sobering to learn that there were more plays by women produced on the London stage in the sixty years between 1660 and 1720 (about one per year) than there were between 1920 and 1980.[4]

Cullen, Patience, and Scollard, working hard to make a specifically woman-centred impression in theatre themselves, were astonished by the discovery that even a very striking mark made by a woman playwright in her day could be so thoroughly erased over time. Cullen had learned just a bit about Aphra Behn in a theatre history class, and neither Scollard nor Patience had heard of her at all.[5] They could find none of Behn's work in Calgary's public library system but did track it down in the University of Calgary's library.[6] *Aphra* depicts the contest between Behn's talent, hard work, and sheer vitality and the voice of "moral opinion" that condemned her for stepping outside her proper role as a woman. The play takes place during her final illness, as she continues to write, and afterwards, during the botched posthumous production of her last play, which points toward her erasure by posterity. At times, the play "is adrift in time and space" (*Aphra* S2), showing Aphra as a child with aspirations that far outreach the limitations on the life of a seventeenth-century woman, as a desperate

woman threatened with prison for debts incurred as a spy in the king's service, as a spirit who is denied burial in the Poets' Corner of Westminster Abbey because of her sex and who comments wryly on her oblivion from the perspective of our own time.

Cullen, Patience, and Scollard's characterization of Behn emphasizes her warmth, her humour, her hard work, and her defiance of the limitations imposed on "proper" women. These characteristics are clear from Behn's writing and well reinforced by George Woodcock's biography, *The Incomparable Aphra*, which the Maenad playwrights read.[7] Behn was second only to Dryden as the most prolific writer of the Restoration era,[8] and she is shown scribbling furiously, even during the last days of her life when "she is cold, hungry, ill, and in considerable pain" (*Aphra* S3). Piles of manuscript littered the stage in the first production.[9] Aphra's warm, outgoing nature is reconciled with her urge to work, as she writes even in the midst of conversation: "I like my friends about me when I work. It's a warmth better than any fire or hot toddy" (S3). She thrives as a writer on the life that surrounds her, reflecting happily during a quarrel between her actress friends, Mary Betterton and Betty Currer, "I find the most inspiration for writing while in their lively midst, taking questions, phrases and disagreements as a lucky chance to move my quill in new directions" (S6).

Necessity, as well as character, drove Behn's prolific writing. "I'm forced to write for bread and not ashamed to own it" (S8), Aphra replies to the assertion that "a woman belongs in the home not in the market place." Part of her battle for freedom from the conventional restrictions imposed on women was for recognition that a woman had the right to work for a living in the public world of men without being scorned for it; she wants "only what is fair/a simple testament to the dignity of my labour" (S11). The few women writers before Behn were ladies whose writing was a leisure activity, whose work was typically circulated in manuscript among friends, not entered into the marketplace. They were expected to be graceful literary amateurs who expressed appropriate modesty and self-effacement in their writing and did not commit the indelicacy of public exhibition by publishing their work.[10] Aphra resists the condemnation she suffers for using her talent like a man: "All I ask, is the privilege for my masculine part the poet in me" (S8).

What chiefly characterizes Aphra is her vitality. It is manifested in the energy with which she writes amid "life and love's gay goings on" (S6), in the joyous celebration of love in her plays and her life, and in her struggle against the bonds of woman's conventionally restricted life. Young Aphra, hearing the life in store for her described as dressing, dining, visiting, theatregoing, walking, and sleeping with her husband

(a description of woman's life taken from Act I of Behn's *Sir Patient Fancy*) protests, "I want to travel to the four corners of the earth. I want to have adventures. To be a sailor or a spy. I want to learn things, to understand the workings of the heavens and all manner of things. I want to learn Greek and Latin and write plays as good as Ben Jonson's," to which her mother replies, "You poor fool. Do you really imagine a woman can do those things?" (S6). But Aphra does manage to attain a degree of learning quite remarkable for a woman of her time, to travel to Surinam in the New World, to act as a spy for the king in the Netherlands, and to write plays notable for the humorous characterization and intrigue and liveliness that characterize Jonson's.

Aphra's feminist passion does not turn her against men—far from it. Among her close friends were many men, and while they are not featured in the play, Aphra speaks of them warmly and acknowledges that male playwrights had difficulties too: "There were many obstacles to playwriting in my day, not the least of which was poverty—Tom Otway, my dear friend and a gifted playwright, died of starvation and Wycherley was in debtor's prison for seven years and never wrote again because of it" (S3). The enemy is not men but "moral opinion," and it is embodied in characters of both sexes whose insistence on womanly modesty in all its forms is pitted against the various expressions of Aphra's vitality. Aphra introduces Morality Man as "decrepit, aged and moribund, clinging to life—like an old husband who would compel you to lie in the wide moth eaten bed his forefathers lived and died in." Morality Woman is "the enemy of all that is natural, original or spontaneous" (S3). Her view is that women "should be seen and not heard," while Morality Man's is that "they should be obscene and not heard" (S6). This pair appears frequently in the play to supply the voice of Aphra's detractors, sometimes in a derisive chant:

> WOMAN: No one equalled this woman in downright nasti-
> ness.
> MAN: She's nasty!
> WOMAN: She's lewd!
> MAN: She's unclean!
> WOMAN: She's bawdy!
> MAN: She's rude!
> WOMAN: She's obscene!
> MAN: She's always dishabille,
> WOMAN: She's ruder than Rabelais,
> BOTH: And she *cracks* like a bawdyhouse queen. (S3)

A taste for bawdiness was characteristic of the Restoration period, and it is manifest in the plays of Behn's male contemporaries as well as her own. Aphra protests such attacks on her work, because bawdiness seems to be "the least and most excusable fault in the men writers to whose plays you all crowd.... But from a woman it is unnatural" (S8). This sense that she was an "unnatural," immoral woman is the chief cause of her eventual oblivion.

Behn went beyond bawdiness in her plays to a defence of love that was also an assault on the arranged, mercenary marriage of the time. Aphra muses humorously on the reception of *The Lucky Chance*: "They tried to censor it of course. But you would find nothing offensive in it, unless you are offended by the idea that marriage is a sham. I'm sure though that it sealed my fate as far as moral opinion was concerned" (S9). Her dramatic campaign against arranged marriage is usually taken to have a biographical basis, though nothing is known of the Mr. Behn she seems to have married except that he must have died not long afterwards—perhaps of the plague in 1665. (Woodcock 28; Cotton 57). Morality Woman's accusation, "You blasphemed the sacred temple of marriage," is met with Aphra's witty rejoinder: "Marriage is as certain a bane to love as lending money is to friendship" (*Aphra* S8). Her life as well as her plays is a battleground between her vitality and her detractors' morality: "Your life is scarcely exemplary. All those lovers," Morality Woman sniffs. "APHRA: I wish only that there had been more. Who can be happy without love?" (S8)

Patience, Scollard, and Cullen credit Aphra Behn as a fourth co-author of *Aphra*. They incorporate her own language into the dialogue frequently, and they also stage two scenes from her final play, *The Widow Ranter*. The title character is a most unconventionally assertive and exuberantly "masculine" woman, the focus of considerable disagreement between Aphra's actress friends about what is acceptable in a female character. Mary Betterton, unusual among actresses of the time in her reputation for virtue, opposes production of the play, despite her friendship with Aphra, because of the widow's manly dress and mannerisms.[11] The problem is that she adopts them not "for reasons of necessity or intrigue" but simply because she wants to (S4). Lively Betty Currer, however, loves Ranter and is eager to play the part.

In the first act of *Aphra*, the three women read the scene in which Ranter makes her first appearance, smoking a pipe, drinking, and expressing herself in a vigorous way that is normally given only to male characters. She shows considerable enthusiasm for handsome gentlemen and no modesty in her plan to pursue one Lieutenant Daring. She

scorns conventional sentiment, particularly when it attaches to an old husband:

> SURELOVE: I have reason, Madam, to be melancholy. I have received a letter from my husband in England who tells me the doctors can do no good on him. I fear I shall see him no more.
> RANTER: Good news! I don't know how you put up with him so long! An old fusty weather beaten skeleton, as dried as stock fish and much of the hue. Come, come. Here's to the next. May he be young, heaven I beseech thee." (S4)

When Aphra and her friends finish reading the scene, they are all laughing, but Mary quickly moves to a defence of her husband for declining to produce the play:

> MARY: It's ... a question of good taste.
> BETTY: Good what? Ah, we're getting back to the widow are we? You don't like her swaggering ways?
> MARY: Well really Betty. All that drinking and smoking.
> BETTY: And all that initiative.
> MARY: Exactly. It's most unseemly.... I just don't think it's proper to have the widow playing suitor.
> BETTY: So a woman putting on britches as an excuse to show her legs is acceptable but putting them on as a show of strength is not.

Betty sums up the problem as Aphra's "refusal to put virtue before zest in her women" (S6). Betty sees no virtue in the motivation for more conventional portrayals of women disguised as men though, a point she reiterates in Act II: "As long as these cross dressing roles can be seen as an exploitation of sexual appeal then they're tolerated but the widow is just too feisty and overbearing" (S10).

Act II of *Aphra* features the scene from *The Widow Ranter* in which Ranter, disguised as a man, challenges Daring to fight over the woman he is courting, though she prefers another.[12] Ranter means "to make it as comical a duel as the best of them" (S10), since she has no wish either to kill him or to die as a martyr to love herself. Daring resigns his claim to the indifferent damsel but responds to Surelove's suggestion that Ranter might be a better choice with "Ranter! Gad, I'd sooner marry a she-bear.... We should be eternally challenging one another to the

field and ten to one she beats me there. Or if I should escape there, she would kill me with drinking" (S10). He reveals eventually that he has become aware of both her identity and her feeling for him and is teasing her: "Give me thy hand, Widow. I am thine, and so entirely, I will never— be drunk outside of thy company" (S11).

This second scene of *The Widow Ranter* is performed in *Aphra* in the context of the posthumous production of *The Widow Ranter*. Betty has her wish to perform the role of the widow, but she knows the play is doomed, because it has been "murdered"—whole scenes cut—and miscast, notably by giving the part of Daring to "a man better suited to play Caliban" (S9).[13] Betty's performance is not enough to save the play, the Moral Woman reports with satisfaction: "It was only fitting that the widow should die a quick and unqualified death.... After all a woman who is hardy, bold, passionate, aggressive is a contradiction in terms" (S11).

This description of the widow is equally a description of Aphra, and the reasons for Ranter's descent into obscurity are also the reasons for Aphra's. She dies, but the Moral Couple lives on. And though they have been hard on male playwrights, they have been harder on Aphra Behn. "They were chopping and changing old Will Shakespeare even in my lifetime," Aphra remembers, "and Otway was mutilated after death in a way I can hardly bear to relate. I myself was consigned to oblivion" (S3). Her reputation as an immoral woman outlived her reputation as an accomplished playwright: "I was forever after seen as that lascivious creature dancing through indecency and uncleanness. And all my stagecraft, all my truthfulness of character, all my cleverness with intrigue and plotting went for nought" (S9).

The Maenad playwrights' portrayal of Aphra Behn and her fate reflects fairly the twentieth-century research on her and critical assessment of her work.[14] The significance of her work as a pioneering woman has been generally acknowledged since 1929 when in *A Room of One's Own* Virginia Woolf credited her with initiating a change that in Woolf's view was more important than the Crusades or the Wars of the Roses.[15] Realizing that it was a credible way to earn money, "the middle-class woman began to write.... All women together ought to let flowers fall upon the tomb of Aphra Behn ... for it was she who earned them the right to speak their minds," Woolf declared (62–63). The question of Behn's theatrical or literary merit is a separate issue. Victoria Sackville-West places her among the "minor dramatists of the Restoration" (75), but most of those who have paid much attention to her work think otherwise.

A chronological sweep through some twentieth-century attempts at

comparative critical assessment starts with Montague Summers's "Memoir of Mrs. Behn," published in his six-volume edition of her plays in 1915: "She is worthy to be ranked with the greatest dramatists of her day, with Vanbrugh and Etheredge; not so strong as Wycherley, less polished than Congreve," with a "rightful claim to a high and honourable place" in English literature.[16] In 1948, George Woodcock asserted that Behn "could outwrite any of them [her fellow playwrights] but Dryden, Wycherley and Otway" (74), and considering her fiction, poetry, plays, and translations, concluded that "by the time she died it was impossible to deny that a woman could write as well as a man, with both learning and style; there was no man, except Dryden, who could show greater versatility or a wider range of literary achievements" (235–36).

In the 1980s, Nancy Cotton in *Women Playwrights in England c. 1363–1750* praised Behn's complex plots, her delightful comedy, and her use of theatrical resources for special effects. That she is often compared unfavourably to contemporary writers of comedy of manners Cotton attributes to Behn's preference for another genre, comedy of intrigue. "Her wit is more often in the plot than in the dialogue," but "she wrote as well as any of her contemporaries except Etheredge, Wycherley and Dryden" (60–61). Tom Lasswell's attempt to compare two of her plays closely with a play of Etheredge's and one of Wycherley's leads him to agree that they are essentially different types of plays and also that much of Behn's strength is theatrical, which causes literary critics to underestimate her. He prefers the emotional warmth of her comedy of intrigue to the cold intellectual quality of Wycherley's comedy of manners but concludes simply that comparison of the four plays proves "she could hold her own with these two giants among her contemporaries in virtually every category where real common ground existed" (176, 180).

Two things seem clear from a survey of the scholarly commentary on Aphra Behn. One is that she never quite reached total oblivion, though certainly her personal notoriety outweighed the impact of her works. Many of the Moral Couple's attacks on Aphra are taken from Woodcock and Summers, who quote various sources ranging from her own day through the eighteenth and nineteenth centuries, culminating in moral condemnation even from people who would not risk the impropriety of first reading her work! (Summers lx; Woodcock 224–25).

The second thing is that in comparison with the work of her male counterparts hers has been and still is unfairly neglected. Though the moral earnestness and prudishness of the centuries following Behn's death have been supplanted by the freer sexuality that makes our own

time more receptive to Restoration comedy, twentieth-century antholo-
gies of Restoration drama still exclude Behn's plays. (In my eleven
anthologies of Restoration and eighteenth-century plays, there is not
one play by a woman.) Scholars like Woodcock keep rediscovering
Aphra Behn, and considerable feminist scholarship on Behn has been
published since the mid-seventies. It has had little impact outside the
relatively new academic field of women's studies, however, so she was
a surprise to the Maenads and to most of *Aphra*'s audience members.

What comparison can we make between Behn and her sister
playwrights of today? How many of the factors that have worked
against Aphra Behn over the centuries still affect the work of women
playwrights? How far have we come toward gender equity in theatre?
Gone is the novelty of a woman playwright that may initially have
worked in Behn's favour, especially at a time when actresses (in place
of boys in women's roles) were a recent and popular innovation.
Woodcock points out that her first play's prologue treats the sex of its
author as an added attraction (49), and Maureen Duffy attributes the
full house opening night to "the kind of curiosity that would go to see
a talking horse" (98). Behn's beauty and personal charm were widely
remarked in her day, which no doubt attracted supporters initially, but
that advantage did not take her far. Woodcock observes that by the time
of her third play,

> with Aphra's earlier success as a playwright, and her rise to literary fame,
> a hostile clique had already begun to form against her. For a woman to
> write one play was perhaps a novelty. For a woman to continue writing
> good and successful plays, and to take her place as an equal competitor
> among the male writers, was intolerable to many of the wits and also to
> some of her fellow playwrights, who perhaps feared that her sex would
> give her an unfair advantage. (73–74)

Though this scenario may not seem unfamiliar to today's women,
certainly what was the main issue for Aphra Behn seems less problem-
atic now. Women playwrights no longer seem much concerned that
what succeeds in theatre may be unfeminine. In interviews with women
playwrights collected by Judith Rudakoff and Rita Much in *Fair Play:
12 Women Speak*[17] and by Kathleen Betsko and Rachel Koenig in
Interviews with Contemporary Women Playwrights women do not
suggest that they feel obliged to choose between success and personal
reputation.[18] Nor is the woman who advocates and practises love
outside of marriage likely to be dismissed as "a mere harlot who danced
through uncleanness" (Dr. Doran, Victorian dramatic historian, cited
in Woodcock 7).

However, suspicion of female sexuality and distaste for deviance from heterosexuality (if not marriage) are still issues. The Maenad playwrights are cautious about explaining their reasons for calling themselves "Maenads." Originally, they say, their mandate was "to promote the orgiastic and visionary concerns of women." And then they start to explain: "orgiastic not just as a sexual term but as a ritualistic one." "And celebratory." "A Maenadic ritual was an orgiastic ritual." "We struck it from our bylaws (because everybody said no one will ever give you funding!) ... but we carry it in our hearts, and I think that is what really affects our work, that kind of celebratory, ritualistic, sexual aspect of ourselves. It doesn't necessarily come out as sexuality is commonly perceived—some of it is the choreography or the lighting— maybe not 'sexual,' but 'sensual' is a better word."[19] The Maenad plays are in fact less overtly sexual than Aphra Behn's, perhaps an indication that Maureen Duffy's assertion in 1977 that "in many ways emancipation hasn't yet completely caught up with her [Behn's] guiltless celebration of the erotic" (291) still holds true.

While the portrayal of female sexuality may be less problematic now than at any time in the three centuries following Behn's death, the issue of how to portray women on stage seems to be more problematic in other respects. The politics of feminism are complex, and it is hard to imagine that any woman writing today is oblivious to them. Maenad Rose Scollard puts it simply: "Some people think we're too feminist. Others think we're not feminist enough" (Maenad). The words "feminine" and "feminist" are problematic; the Maenads chose "feminine," which they saw as broader than and inclusive of "feminist," to avoid the limitations associated with the political implications of "feminist" theatre—but they wonder now if "feminine" might be interpreted as an equally limited opposite of "feminist." "Maybe, in retrospect, we should have said we do 'a woman-centred theatre,'" Nancy Cullen muses (Stone-Blackburn 29).

Like the Maenads, many of the Canadian women interviewed in *Fair Play* explore the matter of how their plays are related to feminist issues without necessarily supporting what they see as a feminist political agenda. Several declare themselves feminists with no hesitation, though none limits her plays to what Banuta Rubess calls "the 'obvious' things like violence against women, date rape, witch hunts" (Rudakoff and Much, 60). Most seem to feel the tension between being judged "not feminist enough" and being limited—or considered to be limited—by a political agenda. Gender roles are no less an issue now than they were in Aphra Behn's time; the terms of the debate are just different.

In her study of early English women playwrights, Nancy Cotton

concludes that a woman could either be womanly and avoid success or she could write like a man and achieve success, but neither permitted "dramatization of peculiarly feminine perceptions" (210). For the most part, Aphra Behn wrote "like a man" to achieve success. She was followed within a few decades by five women who had four or more plays staged professionally in England (Cotton 18–23), and many others had one or two. It is not clear that any further progress has been made, though a few women continue to achieve some success as playwrights. As Michelene Wandor points out in *Carry On, Understudies*, women novelists and poets are hardly anomalous; "as playwrights, however, women scarcely figure on the literary map."[20]

Statistics do not suggest that women have "arrived" as playwrights, only that there is enough diversification in theatre to allow more plays to be produced than in Behn's day. A 1983 survey of English and Welsh theatres showed that only seven percent of the plays being produced were by women—and half of those were Agatha Christie's (Wandor 90, 124). This is exactly the same as the percentage of plays by women for the period 1660–1800 calculated by Ellen Donkin from listings in *The London Stage*.[21] *Canplay* published a survey of 1988–89 Canadian theatre seasons to which sixty theatres responded, including all fifteen of the largest-budget theatres. Though thirty-two percent of the membership of the Playwrights Union of Canada was female then, only seventeen percent of the plays produced were written by women, and only nine percent at the large-budget theatres where a playwright stands to profit most by having plays produced.[22] There are too many differences to allow for a convincing statistical argument about whether women are doing better or worse as playwrights in the late twentieth century than three centuries earlier, but it is clear that they are not doing very well.

Of course, unequal responsibility for children continues to be a factor, as it is in every profession, though less so than in Behn's day. (Behn herself had none.) Many of the most successful women playwrights have managed to work around children, but men's work is still less likely than women's to be impeded by children's needs. Time spent in theatres workshopping plays and monitoring productions is essential for success, and this means time away from children that is not demanded of novelists or poets.

Is success attainable today by dramatizing "peculiarly feminine perceptions?" Or is theatre still so overwhelmingly a male enterprise that women must write like men to succeed? It is doubtful that men go out of their way to keep women's plays out of the theatres now any more than they apparently did in Aphra Behn's day, but those who hold the

decision-making power in theatres do not often find women's drama-
tized experience interesting or important enough to warrant produc-
tion. In Rose Scollard's view, "one of the last great barriers to women
is an imaginative one. If you write on social themes like AIDS or child
battering you probably have the same chance as a man of being
produced. But if women look into their own imaginative lives ... it's a
different story.... A lot of the things women want to write about aren't
seen as stageworthy" (Maenads). Margaret Hollingsworth describes the
search for the inner world as a "very female thing.... That inner world
is an element that makes my plays very female and makes men afraid
of them" (Rudakoff and Much, 157). Whether the barrier is fear or
disinterest, it seems likely to be there when the playwright's voice is
distinctly female.

Success in theatre depends on a collaboration among many people:
the writer needs producers, directors, actors, designers, and critics
who feel no barrier and can share her vision. Further, publication of a
play generally depends on successful production. For success, a writer
needs professional contacts, opportunities for apprenticeship in the
complex art of theatre. As Ann-Marie MacDonald put it, Virginia
Woolf's observation that a woman needs money and a room of her own
to succeed as a writer translates in theatre into a need for "money and
a room and a few friends" (Rubakoff 138).

Though the women whose voices are heard in *Fair Play* often say they
have been lucky or have not felt disadvantaged in getting produced,
many of the same women say that they are likely to get more help from
other women than from men and that they themselves particularly
enjoy other women's work. MacDonald, whose hit *Goodnight Desdemona*
was widely produced in Canada's 1991–92 season, says that working
with women in Nightwood helped her "to become creative, confident
and autonomous so that when I work with men I am not defending
myself all the time or apologizing for my views or approach" (Rubakoff
140). Maenad creates the same sort of opportunity for women working
together to develop confidence in their own voices. These theatres also
provide opportunities for women directors. The need for more women
directors and the lack of any concerted effort to develop them in Canada
is widely remarked among the playwrights interviewed in *Fair Play*.

Apart from choices made about which plays are produced, gaps
between men's and women's theatrical interests are likely to show most
clearly in critical responses to plays—so more female theatre critics
would also contribute to the success of female playwrights. The gender
gap in criticism can be illustrated with two of the few substantial
accounts of *The Widow Ranter* in the literature on Behn. George

Woodcock and Nancy Cotton each give two pages to a description of the play. Woodcock devotes half of one sentence to the widow; the rest is on the politics and battles among the Governor, the Indians, and General Bacon that formed the plotline based on a historical incident in Virginia and on the conventional romance between Bacon and the Indian queen. Cotton (like the Maenads) confines her attention to the Widow Ranter. Cotton and Woodcock have quite different kinds of interest in the play which are easily explicable in terms of gender differences. The phenomenon undoubtedly extends to other critics, as well as to those who choose which plays to produce. As long as most of these people are men, and men's experiences and interests differ from women's, men's plays will continue to have the better chance of success.

This sort of disadvantage to women accumulates over time, so that while a young woman playwright with a bit of luck in contacts may not seem to be disadvantaged by gender initially, she is less likely than a man to fulfill her initial promise over a lifetime and still less to sustain her reputation beyond her lifetime. Sharon Pollock, probably the most firmly established of Canada's women playwrights, observes that "the more successful a woman playwright becomes, the more powerful she is and the more she works within the power structure of theatre, the more obvious to her the sexual discrimination is" (Rudakoff and Much, 214). This was apparently Aphra Behn's experience as well.

Aphra Behn's voice was heard loud and clear during her lifetime but silenced afterwards. Not one of the women playwrights who followed her is remembered today. Choices of critics, editors, publishers, professors of literature, all mostly male, come into play over time. Will the women of our own century fare better? Lillian Hellman was a force in American theatre for three decades after her first play, *The Children's Hour*, was voted outstanding play in the 1934 Pulitzer Prize competition—but she was denied the prize because of its frank treatment of a lesbian theme.[23] Plays by Hellman's male contemporaries Eugene O'Neill, Arthur Miller, and Tennessee Williams are much more frequently revived and anthologized than hers are.

It is hard to determine how much of the silencing of women playwrights today is attributable to overt discrimination and how much to an aesthetic standard that fails to take the female voice into account. How would "peculiarly feminine perceptions" express themselves in a play? Some feminist scholars are beginning to ask whether there is a distinctively female dramatic aesthetic and what it might be. If the quality of a woman's play is measured by a male-standard set of aesthetic expectations and a woman has different aesthetic inclina-

tions, what characteristics of her play might be different from male standard—and so open to being judged inferior?

Character is one of the main ingredients of a play, and women may well see both men and women differently from the way men see them. Women's plays might be expected to show woman as central rather than as she relates to men, as subject rather than as object of male attention. The Maenads' woman's-eye view of Aphra Behn, for instance, celebrates her vitality rather than her beauty. The Maenads portray her friendships with other women, not her love affairs. They show her strength, not a need for men's help. And they spotlight her own most unconventionally robust and assertive female character. In a chapter called "Towards a New Poetics" Sue-Ellen Case speaks of the need for a poetics of drama that would "accommodate the presence of women in the art, support their liberation from the cultural fictions of the female gender and deconstruct the valorisation of the male gender" (114–15). *Aphra* illustrates how this is done.

Actresses readily testify that plays which portray women in any depth are scarce. Alexandria Patience describes the usual experience: "As an actress, there's a potential for boredom in the roles you have to perform—they can be very superficial adjuncts to the story" (Stone-Blackburn 28). The stereotyping of most female characters explains what happens to actresses who do not fit a type, like a talented and committed friend of Nancy Cullen's who "doesn't quite fit into the mainstream theatre image of an actress of her age—not a typical ingenue" and so gets very little work in mainstream theatres (Maenads).

Are women any better at writing men's roles than men are at writing women's? To the suggestion that women don't create convincing male characters, playwright-actress Ann-Marie MacDonald protests,

> Well, *excusez moi!* Let's talk about some of the parts I've had to play ... I've been crucified on the cross of the ingenue one too many times.... If you get a part with teeth in it it's usually negative: the character is a bitch or suicidal.... Any slave class studied its masters a lot more closely than the masters ever studied the slaves. So women probably study men a lot harder than men ever analyze women. I tend to think that the portrayal of men by women is substantially truer to life than the opposite. (Rudakoff and Much, 142)

Gender is likely to affect plot as well as characterization. Feminist theorists question the traditional notion that some form of conflict must be central to plot. Karen Malpede introduces *Women and Theatre: Compassion and Hope* with a description of the ancient origins of theatre as a woman's life-affirming, celebratory rite, followed later by

the patriarchal conception of drama as conflict.[24] Her view is that in women's theatre "the type of dramatic tension created by divisive conflict is replaced by a new, almost unexplored tension of sensual, erotic, and intellectual affinity between characters," and she observes that "the pull together, towards intimacy, is as complex and as fraught with terror and impossibility, as is the drive toward dominance" (13). Even among plots of conflict, some kinds of conflict have been considered more interesting than others. Wandor points out that domestic and interpersonal conflicts, the kind women have most experience with, traditionally rank as less significant than public, epic conflicts (128). The Maenads counted *Aphra* their biggest success when it first appeared, and they attributed this to lack of contentiousness about its aim to retrieve a talented woman from history's garbage. I suspect its success is connected to a more traditionally 'masculine' plot than most of their other plays have.

Aphra's plot concerns a conflict between Aphra and the social force personified by the Moral Couple, in a sense a conflict between the life force of Aphra's vitality and the deathlike force of moral opinion which kills her art if not herself. It has the familiar quality of the tragic struggle between the heroic individual and an unbeatable opposing force. Aphra's playwrights showed remarkable creativity in centring the plot on what happens after Aphra's death while still keeping her vital presence centre-stage, but there is nothing 'feminine' about the plot except that its protagonist is a woman.

Some speculate that gender might have an effect on form as well. Sue-Ellen Case and Banuta Rubess both speak of form in relation to male and female sexual experience, suggesting that, in Rubess's words, "the structure built on conflict and resolution ... where everything gets built up into one screaming point and then everything is suddenly released" is the traditional one, but "women write in waves, repeated climaxes, collages" (Rudakoff and Much 68). Case refers to Luce Irigaray's conception of a feminine form that is constantly weaving itself, that emphasizes process, concerned not with clarity but what is touched upon, fragmentary, ambiguous, and without formal closure (129). Such a departure from the traditional linear form that drives toward resolution can leave critics dissatisfied. *Aphra* is fragmentary and develops in waves, but there is resolution and closure in the double event of *The Widow Ranter*'s failure and Aphra's rejection by the male poets in Westminster Abbey's Poets' Corner.

This discussion of character, plot, and form is meant just to suggest some of the current lines of discussion about women's plays and some of the reasons why a woman's play might encounter resistance. Of

course, each of these subjects has complexities that cannot be explored here. Even if there is a "natural" way to write that differs for women and men—and the question has certainly not been answered conclusively—it is clear that women can learn to write like men. Paradoxically, it is "natural" for them to learn to write like men by imitating successful models or following man-made rules of playwriting. Any departure from the traditional—all experimental theatre, in other words—faces a struggle to gain acceptance. If women want to write in ways that differ from the traditional, they will struggle for acceptance.

I do not pretend to have arrived at a definitive answer to the question of whether any progress has been made for women playwrights since Aphra Behn's time, but I can summarize the results of my investigation. The issues do not seem to have changed much, but thanks to feminist work, our awareness of them has. There was a big gap for Behn between what was successful and what was feminine, and though she chose what was successful, the resulting personal notoriety eroded her success. For women playwrights now the gap appears to be between what is successful and what is the truth of women's experience—or perhaps between what is successful and what seems advisable from a feminist perspective in order to change stereotypical images of women.

The politics of feminism today complicates the tension created in Aphra Behn's day by pressure to be feminine. Behn had to manoeuvre the pitfalls of Restoration politics, and for the most part she did so successfully, but the politics were not gender politics and have not been dealt with here. The politics of gender are significant for any playwright today, but women playwrights are the most likely to get caught in the crossfire between feminists and anti-feminists, because their work is most critically scrutinized by those who are concerned with gender issues. This counters the gain we have made since Behn's time in reducing the difference in expectations for men and women. The ways in which dramatic expression of women's experience departs from the male norm that establishes critical standards remain a constant impediment from Aphra Behn's day to our own.

There are two degrees of silencing to be concerned about, both dealt with in *Aphra*. The first is a silencing of the true voice of women if a successful production is attainable only for plays written to male standards. This shows in *Aphra* in the failure of *The Widow Ranter*. The second is a silencing of any voice of woman over time as Aphra Behn's was silenced even after successful productions, as the result of a series of choices made mostly by men. There is progress on the first front— not in mainstream theatre so much as in smaller theatres and especially experimental women's theatres like the Maenads'. Whether

or not this will lead to a long-range gain has yet to be determined, since it creates the possibility for ghettoizing women's work. Still, in Canada Pollock's woman's-eye view of Lizzie Borden in *Blood Relations* was indisputably a mainstream success, and MacDonald's *Goodnight Desdemona* seems to be crossing over from women's theatre into the mainstream.

As to the chances for survival of a woman's voice over time, it is too soon to say whether they are improving. The best hope lies with the growing numbers of feminist directors, professors, and editors who are less likely than decision-makers of the past to overlook exciting women's plays. There has not been enough in the way of unequivocal gain to allow us to be complacent about progress, but there are enough signs of positive change to give us grounds for hope that a century from now our time will be recognized as an era of importance for women playwrights equal to Aphra Behn's.

Susan Stone-Blackburn is Professor of English at the University of Calgary, where she teaches drama and science fiction. Her publications include a book, *Robertson Davies, Playwright*, and a variety of articles on drama or science fiction. She was Associate Dean of Humanities (1985–89) and the first Advisor to the President on Women's Issues (1989–91). Off-campus she became President of the woman-centred Maenad Theatre Productions in 1991. Susan found a role model and a mentor in Marsha Hanen. Her integrity and dedication, her effectiveness as a champion of undervalued causes on campus, and the combination of competence and caring that characterized Marsha's administration as Dean of General Studies demonstrated what a difference one woman could make in an institution.

Notes

1 Nancy Cotton, *Women Playwrights in England c. 1363–1750* (Associated University Presses, 1980) 16–18. Cotton lists other plays of unknown authorship that may be Behn's, and a final one that was produced several years after her death.

2 Nancy Cullen, Alexandria Patience, and Rose Scollard, with Aphra Behn, "Aphra," *Theatrum* (Sept./Oct. 1991): S1–S2. Aphra Behn's attraction for contemporary women playwrights is underscored by the appearance of a second Canadian play about her at the same time as the Maenads'. Beth Herst's *A Woman's Comedy* was workshopped in Toronto's Tarragon Theatre just after *Aphra* opened in Calgary and published in *Canadian Theatre Review* just a few months after *Aphra* was published in *Theatrum*. The playwrights did not know of each other's work.

3 All information on the Maenads comes from interviews with Rose Scollard February 19 and February 22, 1991, and with Scollard, Alexandria

Patience, and Nancy Cullen on June 11, 1991, unless otherwise documented. A portion of the June 11 interview was published in *Canadian Theatre Review* (see n. 19).

4 Sue-Ellen Case, *Feminism and Theatre* (London: Macmillan, 1988) 38, 39.

5 Scollard, who completed a four-year honours degree in English at the University of Toronto in the 1960s was as dismayed by the omission from her studies as I am at having earned a Ph.D. in English specializing in drama (University of Colorado, 1970) without ever encountering a play by Behn.

6 Martin Morrow, "Playwright is important—and funny," *The Calgary Herald*, 21 Feb. 1991.

7 George Woodcock, *The Incomparable Aphra* (London: T.V. Boardman, 1948).

8 Maureen Duffy, *The Passionate Shepherdess: Aphra Behn, 1640–89* (Great Britain: Jonathan Cape, 1977) 156.

9 At the Calgary Pumphouse's Joyce Doolittle Theatre, February 21–March 9, 1991.

10 Jean Elizabeth Gagen, *The New Woman: Her Emergence in English Drama 1600–1730* (New York: Twayne, 1954) 67.

11 Tom Lasswell, *Two Plays of Aphra Behn: "The Lovers, Part One" and "The Feign's Curtezans." A Theatrical Defense of the Author and the Comedy of Intrigue* (Ann Arbor: University Microfilms, 1982) 103.

12 Both this scene and the earlier one represent *The Widow Ranter* accurately. A few lines and characters are omitted to reduce complication and to keep the number of actors to the three used in *Aphra*, and an occasional line is added for clarification, but essentially the situation and dialogue are Aphra Behn's.

13 Caliban is the savage and deformed slave in Shakespeare's *The Tempest*.

14 In addition to Woodcock's biography and a number of Behn's plays, they read Victoria Sackville-West's brief book on Behn, *Aphra Behn, the Incomparable Astrea* (London: Gerald Howe, 1927); a Ph.D. thesis by Tom Lasswell (1982), which contained useful information about Behn's theatre world, including the actresses she worked with; and Montague Summers's memoir in his 1915 collected edition of her plays.

15 Virginia Woolf, *A Room of One's Own* (London: Grafton Books, 1977).

16 Montague Summers, ed., *The Works of Aphra Behn*, 6 vols. (1915; New York: Phaeton Press, 1967) 3:lxi.

17 Judith Rudakoff and Rita Much, *Fair Play: 12 Women Speak* (Toronto: Simon and Pierre, 1990).

18 Kathleen Betsko and Rachel Koenig, *Interviews with Contemporary Women Playwrights* (New York: Beech Tree, 1987).

19 Susan Stone-Blackburn, "Maenadic Rites on Stage in Calgary," *Canadian*

Theatre Review 69 (Winter 1991): 28–33. This passage is found at 29–30.

20 Michelene Wandor, *Carry On, Understudies* (London: Routledge, 1986) 121.

21 Ellen Donkin, "Caught in the Act," presented at Breaking the Surface: An Interactive Festival/Conference on Women, Theatre and Social Action, hosted by Maenad and the University of Calgary, November 1991. Forthcoming in *Feminist Theatres for Social Change*, eds. S. Bennett, T. Davis, and K. Foreman (London: Routledge, 1993) 2.

22 Dave Carley, "Canadian Content is Up, but Women Lose Out," *Canplay* October 1988: 3, 4.

23 Judith Olauson, *The American Woman Playwright: A View of Criticism and Characterization* (Troy, NY: Whitson, 1981) 27.

24 Karen Malpede, *Women and Theatre: Compassion and Hope* (New York: Drama Book, 1983).

7

Postmodernism, Knowledge, and Gender[1]

PAMELA MCCALLUM

There can be no doubt that the theorizing of those writers who have defined the postmodern movement—Jacques Derrida, Michel Foucault, Jean Baudrillard, Jean-François Lyotard, Richard Rorty, among others—has produced a number of arguments that offer a substantial challenge to the assumptions of traditional Western philosophy. While it would be misleading to suggest that the writings of these critics form a monolithic unity, it is nevertheless possible to point to a number of overlapping themes and motifs in their arguments. The body of work which has become known as postmodern theory is suspicious of Western rationalism's claims that a neutral and objective reason can formulate accurate, unbiased knowledge; it is suspicious of any assumption that human reason is homogeneous and universal, unaffected by the specific experiences of the individual knower; it is suspicious of the presupposition that knowledge is generated from a free play of the intelligence and is not bound up with or implicated in forms of power and systems of domination. To raise such questions is to imply that the goal, purpose, and justification of knowledge can no longer be unreflectively defined as a pursuit of an absolute, timeless truth.

Feminists would readily give assent to many of the central points in postmodernism's critique of the Western rationalist tradition,[2] for Western epistemologies, or so it seemed to many feminist theorists, had spoken about knowledge and knowing with an assumption—sometimes implicit, sometimes explicit—that the investigating mind is male. Feminism and postmodernism appeared to be allied in dismantling similar conceptions about reasoning and the constitution of knowledge. It would not be correct, however, to suggest that feminism appropriates postmodernist theory without reservations. Rita Felski has noted that feminism as an oppositional politics and as a radical critique of existing norms has continued to rely on the categories of truth, value, and ethics which postmodernist thinkers have rejected. As she asks, "How ... is feminism to legitimate and sustain its own

critique of patriarchy, once it recognizes the existence of a more general legitimation crisis which questions the grounding and authority of all forms of knowledge?"[3] A similar and related point is raised by Nancy Hartsock when she wonders why "exactly at the moment when so many of us who have been silenced begin to demand the right to name ourselves, to act as subjects rather than objects of history, ... just then the concept of subjecthood becomes problematic? Just when we are forming our own theories about the world, uncertainty emerges about whether the world can be adequately theorized?"[4]

What motivates the concerns of both Felski and Hartsock is the vexing question of how feminist theories might be able to integrate the insights of postmodernist critique while at the same time insisting on the oppositional political transformation that has characterized the ethical claims of feminist critique. To some critics the answer has seemed to involve a 'politicizing' of postmodernism. If postmodernist thought is to be incorporated into feminist theories of knowledge, Nancy Fraser and Linda Nicholson argue, then it must be supplemented with the politics it currently lacks.[5] What I would like to do in the following discussion is to disentangle some of the issues implicit in these discussions of postmodernism and feminism. I will take as my point of departure some important reflections on these questions by Nancy Hartsock, "Postmodernism and Political Change: Issues for Feminist Theory."[6]

Hartsock has reservations about the argument advanced by Fraser and Nicholson. According to her, the epistemological assumptions that underpin the postmodernist critique of Western rationalism have implications that cannot be easily integrated into a more global theory of feminist politics. In an intricate and dense analysis of Rorty and Foucault, she suggests that their critique of Western Enlightenment rationalism unwittingly reincorporates some of the effects of the theories that they consciously claim to reject. The critique of an objective subject of knowledge, the postmodern insistence that "truth" is only the perspective that has been legitimized by social institutions, has issued into "the conclusion that if one cannot see everything from nowhere, one cannot really see anything at all." (21)

The concerns that Hartsock raises here seem to have their locus in the interrelationship between power and knowledge which takes shape in Foucault's later work. His historical analyses of prisons, hospitals, and asylums (and, by extension, the social institutions of education and work) conceptualized an economy of power circulating throughout political, cultural, and psychological structures. In itself the observation that power is pervasive does not deny or negate the possibility of

resistance, and indeed Foucault sees the two as intimately linked together: "Where there is power, there is resistance." But if this resistance contests forms of power, it does so less as a strategy of transformative praxis than as a "compatriot of power," a necessary counter-term in an overall system.[7] While discrete and local points of resistance continue to develop within Foucault's model, they have ceded any capacity to transform or alter the general circulation of power. The postmodernist awareness that reason is implicated in systems of power has led to a refusal of the possibility of knowledge; the postmodern distrust of transcendence and supersession has produced a political immobility and a reluctance to act, except to chronicle the history of subjugation. Hartsock concludes that postmodernist theories must be seen as "situated knowledges" of a "Euro-American, masculine, and racially as well as economically privileged" group.[8] Indeed, the impotence and powerlessness ascribed to the knower in postmodernist thought can be read as an effort by the institutions of Enlightenment rationalism to negotiate the shifting ground of the mid-to-late twentieth century. We must be careful, Hartsock cautions, not to accept uncritically the situated subjectivity of the frequently playful, but ultimately powerless, postmodern knower as an uncontested universal norm. In its place she suggests that feminist theorizing explore what she designates "epistemologies of marked subjectivities" (24).

Knowledge constructed by and for groups who have suffered "the powerful distortions, inversions and erasures of oppression" (24) will inevitably be marked by the lived experience of oppression. Because of this, epistemologies of marked subjectivities are firmly and unavoidably located in a specific historical and social situation with a conscious awareness of positioning. The knowledges produced by such subjects will be "situated knowledges" which do not so much reject the notions of truth or fact, as see truth as a partial and provisional construction, fact as inescapably caught in historical circumstances. As Hartsock describes it, "epistemologies of marked subjectivities do not see everything from nowhere but they do see some things from somewhere" (29). Whereas Foucauldian theory rejects the notion that a subject adequately represents itself in its conscious reflections, marked subjectivities can be seen to achieve a certain adequacy—admittedly incomplete and open to revision—in the construction of knowledges.

But what is the kind of knowledge produced by these marked subjectivities? What shape and form would these epistemologies take? I would argue that the aesthetic practices of Canadian women writers and artists offer clues to varied and diverse forms in which such knowledges might be constructed. The short story "Ajax Là-Bas" by

Montreal writer Yeshim Ternar dramatizes the workday of a young cleaning woman, Saliha Samson.[9] Taking a brief break while she waits for the wash cycle to finish, Saliha lets her mind wander. This associative wordplay is one of the things that pass through her thoughts:

> Canadians are funny, thinks Saliha. They have detergents and lotions and soaps for everything. Everything has its own cleanser here. And every cleanser has its own name. Like Mr. Clean. But Mr. Clean is also M. Net. Wisk! What a strange way to call your laundry detergent. And Ajax. Particularly Ajax. George, the Greek *dépanneur* at Park Ex, told her Ajax was a Greek hero. Old heroes live on as detergents in Canada. (322)

Saliha's humorous reflections open up multiple ironies that destabilize received ways of knowing. Perhaps the first and most obvious lies in the name of the cleanser: advertising seeks to evoke the Greek hero, legendary for his brute strength (in the stories of the Trojan wars it was Ajax who rose to meet Hector's challenge to single combat) in order to associate that strength with the cleaning product. However, as the situation of the text reveals, this is only a metonymic association; it is not the mythical power of Ajax but the labour power and energy of the immigrant woman worker that cleans the apartment.

In a similar and related context Ajax brings to mind the familiar stories of the *Iliad* and the *Odyssey*, that foundational moment of Western culture which chronicled the victory of a rational, masculinized Greek culture over an oriental, feminized Trojan culture. Because Saliha has immigrated to Canada from Turkey, the modern location of the ancient city of Troy, the reader may be tempted to see her as yet one more "Trojan woman," subjugated to the dreary repetition of domestic work. And yet, while such an interpretation would not be wrong, neither would it recognize the final ironic destabilization of these deceptively simple reflections. In the immigrant world of Montreal the binary opposition of Greek and Trojan is undone: Saliha and the Greek grocer enjoy casual conversation as they attempt to decipher the strange society around them. To say this is not to erase the differences between Saliha and George; rather it is to recognize that the lived experience of a shared situation can help to construct the knowledge from which Saliha's joke takes form. Nor is the experience of housework merely burdensome for Saliha; she has earned enough to support herself, to pay the tuition for her language classes; she feels "tired but life is under control" (328).

Linda Hutcheon notes that a capacity to put difference into play characterizes irony. In her words, "perceived incongruity is one of the

major markers of irony, a trope that, unlike metaphor or allegory, depends on some significant difference: a disparity, contrast, opposition, contradiction, or incompatibility."[10] "Ajax Là-bas," that is, Ajax "down there," in the situated consciousness of a woman domestic worker, also puts into question the reader's received conceptions of Saliha's subjectivity. We do not expect mythological allusions from a cleaning woman, nor do we expect the rich imaginative reflections that unfold throughout the story as Saliha remembers her childhood schooldays in Turkey or muses about the artifacts in the apartment. In this way the reader comes to acknowledge the ironic juxtaposition of an intellectually astute consciousness with the repetitious drudgery of the housework. The significance of the diverse and fascinating subjectivity that is revealed in Ternar's text can be grasped if we look at the conditions under which it has been shaped. Fashioned in the margins of Europe and in the immigrant world of Montreal whose inhabitants struggle with both French and English, Saliha's knowledge is not only inseparable from her contingent lived experience, but also expresses a considerable achievement in the face of oppression.

A parallel set of questions and issues is explored in Cynthia Flood's short story, "A Young Girl-Typist Ran to Smolny: Notes for a Film," which enacts the construction of knowledge in the mind of reader and character.[11] The storyline follows the attempt by a young woman, Kate, to sell an unnamed socialist newspaper door-to-door in the Vancouver suburb of Burnaby. As she walks from door to door, sometimes making a sale, more often not, she tries to visualize the young girl typist of the title, a reference to a sentence in A.J.P. Taylor's introduction to the memoirs of the 1917 Russian Revolution, *Ten Days That Shook the World* by the American journalist, John Reed. Taylor writes that "a young girl-typist ran to Smolny" to inform the Bolshevik leader, Leon Trotsky, that newspaper workers were willing to produce their paper even though it had been banned (65). A woman lost in history, she is accessible to Kate only through the scraps of texts (Taylor's "young girl-typist," Deutscher's "unknown working girl") which briefly mention her message to Trotsky. Nameless and undescribed, her identity is a blank space although she was the one who enabled the male leader to act. Even her traditional female occupation could be misleading; because she works at a press, she might well have been a typesetter, who has been rewritten into the more appropriately "female" job of typist. In her efforts to envision the young girl-typist, Kate must not only attempt to give concrete density to the sparse references of male historians, but also to break through the over-familiar and conventionalized images of "Russia" and "eastern Europe" that crowd into her mind:

But in 1917, in Russia ... fragmentary images of snow howling steppes, Lenin addressing the crowd, onion spires, Peter and Paul. Kate shakes her head, annoyed at her own ignorance and romanticism, waves her arm to brush the images away. She says, "I can't see how to see it." (68)

Here Kate encounters a second obstacle in her struggle to summon up a figure of the woman lost to history. The images with which she attempts to piece together a specific picture of the girl-typist are only the over-used and stale media representations available to a contemporary Canadian consciousness: snow howling (Russia as savage winter); Lenin and the crowd (the socialist-realist iconography of the Revolution); onion spires (travelogue photos of Moscow); Peter and Paul (the great men of the history books). Nowhere in this repertoire of Russian-ness are there any figures that assist in making visible the young woman of 1917. Caught between the blankness of anonymity and the assemblage of stereotypes, it would appear that the young girl-typist is unrepresentable in Kate's imagination. Her thoughts lapse into a decontextualized series of random images which vaguely suggest "European woman" in the first decades of the twentieth century: Ukrainian peasant dance costume, the middy uniform of the Canadian Girls In Training whose naval motifs unintentionally (and ironically) hold echoes of the Potemkin sailors, the ludicrously inappropriate 1920s flapper style dress. Kate's increasingly unsuccessful musings end up in a mythologized type of the woman runner, a Diana or an Atalanta: "She has long blond hair coiled in braids about her head, and she runs with long powerful strides" (68).

This is perhaps the point to comment on the structure of Flood's story. Subtitled "Notes for a Film," the narrative represents the action as if a film were unfolding before the reader. "Then we see her from the back as she positions herself at an angle to the doorway so as not to seem invasive to the opener" (67) is an example of the way in which the narrator describes Kate when she is about to knock on a door. This doubling of media (writing-as-film, film-as-writing), a doubling that brings to mind the layering techniques of Eisentein's montage, functions to make the reader inescapably conscious of the narrator's manipulation of the characters. Like the director of a film giving orders to set up a shot, the narrator shifts Kate from one incident to another. From the reader's point of view, such a narration blocks the possibility of slipping into the comfortable illusion that reality is unselfconsciously represented in the text. By making it impossible to ignore the narrator's "direction" of the text, a narrative mode which Formalist critics call "the baring of the device," Flood ensures that readers are aware of the fabrication of characters and situation.

But this is not all. The text of "A Young Girl-Typist Ran to Smolny" contains a series of footnotes, forty-eight in number, which elaborate comments, offer alternatives, add details, and provide historical documentation. Visually, the footnotes break up the page of text, making it impossible for the reader's eyes to proceed smoothly through the lines of print. The sentence that ends with Kate's image of a runner's "long powerful strides," for example, is glossed in this way:

> Kate is thinking of the Modern Library logo, and then by association of the Everyman Library motto, "Everyman I will go with thee and be thy guide / In thy most need to go by thy side." Everywoman is not mentioned though many do use books as armour. For example, the woman to whom Kate has just sold a subscription: The day she ended her marriage, she went to the Kingsgate Branch of the Vancouver Public Library and read Dick Francis's *Rat Race* in its entirety. With that padding of the 150-odd pages of cheap thriller between herself and the morning's experience, she felt able to go home and tell her children.
> There are limits though. In 1975 gifted British Columbia poet Pat Lowther was hammered to death by her unadjectived husband in the bedroom of the East Vancouver home they shared (you could say). In her most need, where were you, Erato? (68)

It is tempting to read this footnote as further commentary by an omniscient narrator who is able to disclose the mental processes within Kate's consciousness. Yet this interpretive strategy would not fully account for the abrupt and astonishing shift in tone when the note begins to speak of Pat Lowther's death. What knowledge is being constructed here? What are the relationships among the young girl-typist, Kate, the woman who reads thrillers, and Pat Lowther?

We can begin to unravel the multiple resonances of this footnote if we consider the implications of the Everyman motto: it promises that the wisdom of the classical texts which make up the library's titles will not be simply contemplated but will be intimately connected with human action in the world. Such a claim, however, is put forward only on behalf of the canonical "great books" which have endured through centuries, not on behalf of the ephemeral popular culture texts of mysteries, thrillers, romances. Yet, as Tana Modleski has shown, the readers of these texts actively utilize the reading experience to negotiate the lived contradictions and tensions of their day-to-day existence, thereby casting into doubt any model that structures them as passive consumers.[12] While it is clear that a situated knowledge will be produced by and implicated in action in the knower's life-world, it is also clear that knowledge alone cannot transform oppressive situa-

tions. In this way, the death of Pat Lowther stands as a stark reminder that the written word and the act of writing can be rendered powerless in the face of brute force. From the reflections in this enigmatic footnote emerge the multiple and contradictory interrelations of knowledge and practice.

And so it proves to be in Kate's case. As Kate thinks about the young girl-typist in a text which enacts that process of thought through its use of notes, asides, and commentaries, she creates, or rather recreates, that life. From her own experience of selling the newspaper, she is eventually able to construct the image she sought, an image that takes its form from the overlapping praxis in which both Kate and the girl-typist engage. It is therefore concrete political activity that proves to be the dynamic enabling Kate to envision the other young woman. From the often discouraging and seemingly unimportant task she has undertaken, Kate is eventually able to recognize a kinship with the faceless and nameless woman lost to history. To say this is not to suggest that self overwhelms otherness, nor is it to view the gap separating self and other as unbridgeable. The knowledge that Kate achieves is not empirical (she can never know the woman's name or discover an archival photograph of her), but it does succeed in sorting through the distortions of stale convention and the fantasies of pure speculation. If it is no longer possible to recover the concrete specificity of a past historical moment, it is nevertheless possible, through Kate's own actions, to know a moment of collectivity which takes shape around a common ground of experience.

It should be obvious that the knowledge produced in these texts is a "situated knowledge" constructed out of and formed within the lived experience and day-to-day practices of the two women. As such it cannot fail to express the multiple, often contradictory, and layered marks that lived experience has inscribed on human subjectivities. But it is also worth noting that this is a social and collective form of knowledge. Its construction and elaboration take shape within collec-tively experienced modes of domination, resistance, conflict, interven-tion, and transformation, whether these be Saliha's shared conversa-tion with the Greek mechanic or Kate's struggle to recover the image of a young woman who has vanished within mainstream history. The subjectivities which they assume are plural, heterogeneous, and fractured, but there is no implication that a nihilist scepticism paraly-ses the possibilities for critical intervention and action. In this sense, epistemologies of marked subjectivities put in question the powerless-ness and passivity which have been one outcome of the legitimation crisis in Western epistemologies. A marked subjectivity will not lay

Work, Weather and the Grid: Agriculture in Saskatchewan.
Photo by Patricia Holdsworth. Courtesy of Dunlop Art Gallery.

claim to a universalizing, global, and trans-historical knowledge, but
will grasp partial truths in an effort to understand and transform a
concrete situation. This is the way in which epistemologies of marked
subjectivities offer an empowering ground, not only for feminist
theories, but also for those groups with which feminism may wish to
build alliances.

It would be a mistake to leave the impression that literary texts offer
primary and privileged examples of marked subjectivities. The 1991
exhibition at four galleries in Regina, Saskatchewan, "The Regina Work
Project," provides intriguing evidence of the various strategies through
which situated knowledge can be explored in visual representation.[13]
"Work, Weather and the Grid: Agriculture in Saskatchewan," organized
by the Dunlop Art Gallery and curated by Rosemary Donegan, con-
structs a visual history of prairie farming. The juxtaposition of "high"
art (paintings, sculpture, drawings) with popular culture (advertising,
postcards, illustrations) not only questions the traditional division
between art and day-to-day experience, but also asks the viewer to
reflect on the assumptions that underpin perceptions about agricul-
ture and work. In many cases, the familiar symbolisms of agriculture

end up effacing the labour of men and women. Traditional associations of agriculture and nature, together with the promises to immigrants of an unproblematically bountiful land, imply that agriculture is the result of a pre-given, natural abundance. Alongside these representations of a lush and generous nature are other images that tell a different story of agricultural labour, a story of work marked by the isolation of vast spaces, exhausting physical effort, the vagaries of weather in a harsh climate, and abstract, impersonal market forces. By juxtaposing conflicting visual images and opposing aesthetic forms, the exhibition attempts, in Donegan's words, "to recreate the familiarity, repetition and layering of popular memory that dominates agricultural symbolism."[14] Knowledge of something as apparently "natural" as the worked prairie landscape is not transparent and accessible; instead, it turns out to be both given figuration in and actively shaped through the visual imagery of agricultural labour in the Canadian west. Nor are viewers of "Work, Weather and the Grid" assumed to be passive consumers of knowledge produced elsewhere and by others. Their experience interacts with the artifacts of the exhibition to generate new understandings. As Donegan comments,

> Many people who saw the exhibition know much more about the practice of agriculture in Saskatchewan over the last 50 years than I'm ever going to know. They bring that information with them and weave it into the things I have brought together. What was really exciting, also, about being in the exhibition and listening to people was hearing that "Oh, I remember when...." A picture triggers their imagination and takes them off somewhere, and then they reconnect to another photography down the line.[15]

A corresponding set of issues is raised by the Mackenzie Gallery's exhibition "Working Truths/Powerful Fictions," curated by Jessica Bradley. As the title suggests, the traditional binary opposition of truth and fiction no longer holds: truths are only provisional strategies with which to work; fictions can have a powerful effect in constructing what we call "the real." It is also possible, however, to invert the title ironically: that which we call "truth" works to facilitate our acceptance of uncomfortable, often oppressive, attitudes and beliefs; the power of "fictions" can be employed to dismantle and deconstruct these assumptions. Viewed from this multiple and shifting perspective, knowledge is neither truth nor fiction, but an ongoing process in which what we call "truth" and "fiction" mutually shape, pressure, and trouble each other. Dominique Blain's installation, *No Man's Land*, creates a space, about fifteen feet long containing a nine inch high ridge of earth which

can only be experienced bent over in a crouched position. The viewer sees, near the floor, a line of poorly lit, small photographs of workers from developing countries. From this stooped and awkward stance, confronted with the scent of earth, it is difficult, if not impossible, to retain the easy contemplative gaze with which the gallery visitor all-too-often observes art. For a short time the participant in the installation comes to experience something briefly resembling the backbreaking labour which the images represent. That he or she is never further than a few steps from returning to the reassuring, familiar Western world (and indeed has left that world only in the fiction of the representation) is an irony that cannot be separated from the experience of the installation. The marks of their work on the bodies and consciousnesses of those represented turns out to be a "no man's land" as deadly and disfiguring as the terrible ground between the World War I trenches.

Nancy Hartsock reminds us of the Italian thinker Antonio Gramsci's claim that all people are intellectuals. This is perhaps the most significant implication that these aesthetic practices draw to our attention. What Ternar's and Flood's stories and the Regina Work Project exhibition make inescapably clear is that knowledge is produced in and through the everyday experiences of men and women. While these situated knowledges will inevitably take form in the specific life-world of an individual writer, artist, reader, or viewer, the partial truths that are articulated can facilitate the emergence of groupings and alliances to challenge existing relationships of power. Epistemologies of marked subjectivities are not detached, contemplative forms of knowledge; rather they seek to question, to problematize, to empower, to transform.

Pamela McCallum is Professor of English at the University of Calgary. She is the author of *Literature and Method* and a co-editor of *Feminism Now: Theory and Practice*. Under Marsha Hanen's encouragement, she developed and taught a course in popular culture in the women's studies programme at Calgary; she also worked with Marsha on a project to establish a Gender Studies Institute.

Notes

1 Parts of this chapter were previously published in "The Construction of Knowledge and Epistemologies of Marked Subjectivities," in *University of Toronto Quarterly* 61, No. 3 (1992): 430–6. Used with the permission of the University of Toronto Press.

2 The following represent some important discussions in the now extensive literature on postmodernism and feminism: Craig Owens, "The Discourse

of Others: Feminists and Postmodernists," *The Anti-Aesthetic*, ed. Hal Foster (Port Townsend: Bay Press, 1983); Chris Weedon, *Feminist Practice and Poststructuralist Theory* (Oxford: Basil Blackwell, 1987); Linda Hutcheon, *The Poetics of Postmodernism* (New York: Routledge, 1988), chapter 4 and *The Politics of Postmodernism* (New York: Routledge, 1989), chapter 6; Linda J. Nicholson, ed., *Feminism/Postmodernism* (New York: Routledge, 1990).

3 Rita Felski, "Feminism, Postmodernism and the Critique of Modernity," *Cultural Critique* 13 (Fall 1989): 35.

4 Nancy Hartsock, "Rethinking Modernism: Minority vs Majority Theories," *Cultural Critique* 7 (Fall 1987): 196.

5 Nancy Fraser and Linda Nicholson, "Social Criticism without Philosophy," *Feminism/Postmodernism* 19–38. See also Laura Kipnis, "Feminism: The Political Conscience of Postmodernism?" *Universal Abandon? The Politics of Postmodernism*, ed. Andrew Ross (Minneapolis: U of Minnesota P, 1988) 149–66.

6 Nancy Hartsock, "Postmodernism and Political Change: Issues for Feminist Theory," *Cultural Critique* 14 (Winter 1989–90): 15–33.

7 Michel Foucault, *Power/Knowledge*, ed. and trans. Colin Gordon (Brighton: Harvester, 1980) 142.

8 The term "situated knowledges" comes from Donna Haraway's article "Situated Knowledges: The Science Question in Feminism and the Privilege of Partial Perspective," *Feminist Studies* 14.3 (Fall 1988): 575–99, 23.

9 Yeshim Ternar, "Ajax Là-Bas," *Other Solitudes: Canadian Multicultural Fictions*, ed. Linda Hutcheon and Marion Richmond (Toronto: Oxford UP, 1990) 321–28.

10 Linda Hutcheon, *Splitting Images: Contemporary Canadian Ironies* (Toronto: Oxford UP, 1991) 22.

11 Cynthia Flood, *The Animals in Their Elements* (Vancouver: Talonbooks, 1987) 65–75.

12 Tania Modleski, *Loving With a Vengeance* (London: Methuen, 1982).

13 The exhibition took place May 1—June 30 at The Dunlop Art Gallery, Mackenzie Art Gallery, Neutral Ground, Rosemont Art Gallery. I am grateful to Helen Marzolf, director/curator of the Dunlop Art Gallery, for information on the Regina Work Project.

14 Rosemary Donegan, "Introductory Panel to 'Work, Weather and the Grid: Agriculture in Saskatchewan.'"

15 Quoted in Nancy Tousley, "History and Real People," *Canadian Art* (Winter 1991): 60–65.

8

Locating the Artist's Muse: The Paradox of Femininity in Mary Pratt and Alice Munro[1]

Beverly Matson Rasporich

"It's like that comment by Flaubert: 'Live an orderly way like a bourgeois so that you can be violent and original in your work'."[2] — Alice Munro

One of the most interesting and positive developments in the arts in Canada and elsewhere is the increasing recognition and celebration of women artists. In the visual arts, for example, revisionist art histories are laying claim to those previously lost or ignored female painters of note;[3] where possible, as in the example of Francis Anne Hopkins, who was an exceptional painter of early exploration and the fur trade in Canada, retrospective exhibitions are being held.[4] At the same time, female artists, working in a variety of media, continue to struggle with the difficult task of locating technique, subject matter, and inspiration that are free of patriarchal influence and that foster artistic agency. For two of Canada's most notable and accomplished artists, the writer Alice Munro and the painter Mary Pratt, the struggle is exercised within traditional boundaries in that the culturally inscribed code of femininity underwrites their art. Femininity, described by author Susan Brownmiller as "a brilliant subtle aesthetic" as well as a "rigid code of appearance and behaviour defined by do's and don't do's,"[5] is both a source of creative inspiration and a target of critical contemplation for Munro and Pratt.

More than that, both artists understand and interpret femininity as an unresolvable, elusive, aesthetic paradox. Femininity is a source of beauty and artistic authority. It positively informs their choice of subject matter, their techniques, and even their method of photographic realism. The female as feminine and domestic artist preoccupied with food, fashions, and furnishings has an alluring presence in their art. At the same time, paradoxically, the art of being feminine inhibits female power and limits the woman as artist. Mary Pratt's painting *Cold Cream* comes to mind. The image is that of a young

woman whose "face is emerging from layers of face cream. You can see where she has pulled her fingers across her forehead, her intensity giving the cream the same lines she has in her skin".[6] Here the subject can be interpreted as the art of femininity itself in the young woman's preservation and use of her own face as an artistic canvas. The intensity of the strokes reflects the intensity and power of Pratt's own control of this subject matter. At the same time, the cold cream is a feminine mask that the female and the female as artist is negatively assuming, a mask that projects a corpse-like, deadening disguise (see Fig. 1). *Cold Cream* is a mysterious, ambivalent portrait, one that underscores Brownmiller's observations on her own hard reckoning with femininity: "A powerful aesthetic that is built upon a recognition of powerlessness is a slippery subject to grapple with, for its contradictions are elusive, ephemeral and ultimately impressive" (19).

Both Alice Munro and Mary Pratt are well aware of the mythological vacuum that exists for the female artist as an artistic producer, particularly since her historical role has been that of augmenter of male artistic genius. As art historian Whitney Chadwick has argued, there is a longstanding tradition in Western culture of the female artist as muse and model in a male-centred mythology of the arts.[7] Mary Pratt reveals her sensitivity to this issue when in interview she poses the rhetorical question, "If women are the muse for men, what is the muse for women?"[8] On one level, Mary Pratt's *Cold Cream* can be read as a similar visual inquiry into the dilemma of the female artist who attempts to *engender* art from her own feminine experience, and in the process, becomes her own self-reflexive, self-limiting muse. Alice Munro makes similar metafictional, often desperate, inquiries into the role, the place, and sources of power for the female artist in her fiction.

In Munro's early *bildungsroman, Lives of Girls and Women,* for example, Del Jordan, the adolescent protagonist and developing artist, looks to her mother as a possible muse, one who is interpreted walking "like a priestess ... powerful, a ruler"[9] and is associated with Isis, the ancient Egyptian goddess of fertility. In the retrospective memory of the narrator, however, that definition is dismissed. Similarly, in the short story "Material" from *Something I've Been Meaning to Tell You,* the narrator is the ex-wife of a creative writer, Hugo; through the wife's perspective Munro launches a brilliant ironical attack on the myth of the male artist, the socially prescribed role of the female as supporter and nurturer of his creative efforts, and the female as subject and model for his art. In "Material", Dotty is a woman from Hugo's and the narrator's past for whom, in reality, the self-indulgent and self-aggrandizing Hugo had no real sympathy or interest. Dotty, however,

is used by Hugo as the fictional and winning subject of a short story. The narrator is made bitter and angry by this ironic turn of events in which Dotty, through male enterprise, "has passed into Art."[10]

In a more recent collection, *Friend of My Youth* (1990), with a cover illustration by Mary Pratt, Munro explores, retrospectively and explicitly, the subject of the female poet as a dead, forgotten, and silenced feminine artistic ancestor. "Meneseteung" is a resonant story about a Victorian "poetess," Amelda Roth, brought to Canada in 1854. Her identity is discovered by the modern narrator in an antique book of poetry and in back issues of a local newspaper where the narrator discerns, "there seems to be a mixture of respect and contempt, both for her calling and for her sex—or for their predictable conjuncture."[11] The story then shifts backwards in time to Amelda Roth's imagined life, becoming in the process a powerful portrait on Munro's part of the entrapped female artist.

The "predictable conjuncture" of Amelda Roth's sex and her calling as a poet is consistent with the historical evolution of the place of women in the arts, and the development of the social codes of femininity. Whitney Chadwick identifies Jean-Jacques Rousseau as a primary influence in the genesis of a Western bourgeois ideology of femininity that in the mid-eighteenth century located the female safely in the home, allowing the male to freely pursue his occupations while the female was leisurely employed in artistic activities. From Chadwick's point of view, femininity as a social code and middle class identity were forged during this time. Chadwick explains,

> Although the actual circumstances of middle-class women's lives varied widely, the ideology of femininity which Rousseau and others rationalized as 'natural' to women was a unifying force in making a class identity. The artistic activities of growing numbers of women amateurs working in media like needlework, pastel and watercolour, and executing highly detailed works on a small scale confirmed Enlightenment views that women have an intellect different from and inferior to that of men, that they lack the capacity for abstract reasoning and creativity, but, are better suited for detail work. (*Women, Art and Society* 138)

Munro's Amelda Roth is very much the recipient of this legacy. As the daughter of a prosperous merchant, she is a genteel and protected woman whose efforts as a poet are prescribed by a Victorian code of femininity, part of a middle-class value system that defines her self and even the subjects of her art. As the narrator explains, children's games, family devotion, official historical conquest are the acceptable poetic subjects for Amelda Roth (52).

However, Amelda Roth suffers a moment of horrendous truth. When she ventures out of her safe house to witness a brutally beaten woman in a nearby working class neighbourhood, her world of tidy, bourgeois comfort is ruptured and her aesthetic consciousness provoked to move beyond her previous decorous and "feminine" poetic expressions. She envisions

> ... poems. Or one poem. Isn't that the idea—one very great poem that will contain everything and, oh, that will make all the other poems, the poems she has written, inconsequential, mere trial and error, mere rags? Stars and flowers and birds and trees and angels in the snow and dead children at twilight—that is not the half of it. (69–70)

Amelda has begun to recognize the socially determined boundaries of her life and the limitations of her artistic efforts within them. The consequence is that she can no longer live as she has done, nor is it possible for her to live confined within the bourgeois keep, occupying her leisure hours with acceptable poems, the equivalent of other women's "dazzling production of embroidery" (51). She intuits, too, the impotency of her own gender and her own lack of agency in the public spectacle of the abused woman whose taunting shouts of "Kill me! Kill me!" she has heard alternate with people's cries of "Kill her! Kill her!" as the woman's husband beats her (63). When Amelda chooses not to be chosen in marriage by a respectable burgher and new world entrepreneur, preferring to isolate herself and her poetic impulses, she is doomed to become, not the successful artist, but a local eccentric and a comic figure as she allows her femininity to lapse. Amelda Roth's eulogy in the local newspaper reads in part: "Her attention to decorum and to the care and adornment of her person had suffered, to the degree that she had become, in the eyes of those unmindful of her former pride and daintiness, a familiar eccentric, or even, sadly, a figure of fun" (71).

For this character, a new world poet, artistic inspiration is blocked not only by the strictures of gender convention within a freshly created smalltown Canadian bourgeoisie, but, in a broader sense, by the importation of a European aesthetic value system that is superimposed on new world realities. Her struggle is to locate a free, authentic, and valued aesthetic connection within the Canadian context. Her impulse is to write a poem that "will be—it *is*—'The Meneseteung'. The name of the poem is the name of the river. No, in fact, it is the river, the Meneseteung, that is the poem" (70). In this regard, she is not unlike the Canadian painter Emily Carr, who refused feminine codes of behaviour, isolated herself in British Columbia, and "distilled essential forms from a monumental and imposing nature and presented them

without sentiment, moralizing or anecdote" (Chadwick, *Women, Art and Society* 288). At the same time, for the narrator of Amelda Roth's story, who identifies herself as a fiction maker, and for Alice Munro, their creator, the female artist has become a complex subject and source of creative expression.

In "Meneseteung," Munro has appropriated and resurrected from the world of male privilege the female artist figure as a dead muse—one who was absorbed into a community's mythology as having fallen from grace when she did not maintain precisely the ideal of femininity; in effect, the poet becomes for the narrator-artist a reclaimed *subject*, rescued from the "rubbish" of history (73). A found object, Amelda Roth is revived by the narrator and Munro to become the subject of artistic agency when the narrator explores Amelda's interior life and her struggle for voice; she is also resurrected as an individual when the narrator searches for, discovers, and uncovers her name on her gravestone so that the singular and simple inscription of the poet's name, "Meda," may finally be read as a statement of her person and her existence.

Clearly the status of the female artist and the relationships between gender and art are self-conscious issues for Alice Munro as they are for Mary Pratt, who explains,

> I think of myself quite consciously as a woman painter, and I have quite strong feelings about the women's movement, without really being a part of it.... I do think that it's important for a woman to work within her own frame of reference, and not feel it is inferior to feel the way a woman feels. The minute you try to adopt the mannerisms and attitudes of men, it all breaks down.[12]

Neither of these female artists ignores or transcends the dualism that shapes Western culture, the binary opposites of masculine/feminine, or avoids the artistic coding of them within a bourgeois context. Bourgeois experience, in fact, informs their individual histories and conceptualization of art.

Munro and Pratt are of the same generation, born and brought up in a similar smalltown Canadian milieu during the 1930s and 1940s, Alice Munro in Wingham, Ontario and Mary Pratt in Fredericton, New Brunswick, where the founding and ruling citizens were of Anglo-Canadian Protestant culture, and where a decorous Victorian code of behaviour prevailed as the correct standard. Pratt sprang from this middle class, from a sturdy grey house built in the colonial style where her respectable and conservative Harvard-educated lawyer father was an upstanding patriarch (Gwyn 6). Although Alice Munro was of a

poorer background, her father a fox farmer and later a foundry worker and then a turkey farmer, her mother aspired to and attempted to maintain a middle-class respectability. The old red brick family home in Ontario was filled by Munro's mother with "Victorian antiques to give it elegance."[13] Both Munro and Pratt also assumed the gender conventions of the 1950s, were mothers and housewives, had a number of children—and have struggled for the primacy of art in their lives with Mary Pratt, at least, prepared to "flaunt her middle-class origins and conventional, family-oriented style of life" (Gwyn 8).

The Canadian settler culture to which both belonged was also situated in nature, in a semi-rural landscape that provided creative inspiration. Mary Pratt remembers "driving up the St. John Valley in the springtime, thinking it was beautiful, and wishing I could do for New Brunswick what L.M. Montgomery had done for P.E.I." (Gwyn 6). Alice Munro was encouraged by the location of their family home: "West of us was nothing but fields and the rivers and hills ... in the farming country, it's rare to find this kind of view. It was like a world view to me as a child, and it was like the scene for the end of the world when the sun went down ... you could always see the sunsets" (Rasporich 4). Both women were also separated from this world, however, by virtue of their gender. As Munro has pointed out, the proper location of the female was inside the house (Rasporich 8) and Mary Pratt was exclusively restricted to her "magic, idyllic" backyard, complete with a child's playhouse (Gwyn 6).

Not surprisingly, then, the artists' subjects, techniques, and oeuvres are rooted in the equating of femininity with art, their inspirations located in the artistic significations of generations of feminized women, and the fabrics of their own lives as part of this continuum. "'Women's stuff'" is the phrase she [Mary Pratt] has coined to define this female muse. She means by this the energy that accrues to women out of small things around them: the food that has to be cooked, the socks that have to be picked up, the thank-you letters that have to be written" (Gwyn 19). Both artists unabashedly celebrate "women's stuff" as significant artistic subject by sensually poeticizing with photographic reality, and through the female gaze, a domestic house-inhabited world; images of prepared food, interior design and female fashion, costuming and dress-making predominate. The subjects of Pratt's visual texts—a supper table with its remains of food, a tray of baked apples on tinfoil, a china setting of Florentine design, jars of red currant jelly, a line of white washing hung to dry, her daughters' portraits in wedding dress, an unmade bed in the morning sun, a bowl of mixed fruit—are comparable to Munro's preoccupation with food, furnishings, and

fashion as "material" in her fiction and her positive and pleasurable rendering of them (Rasporich, *Dance of the Sexes* 93–99).

Food, for example, is for both a poetic of feminine artifice, design, luxury, and delight. In Alice Munro's *Who Do You Think You Are?*, the stepmother, Flo, arranges a seductive tray for her step-daughter, Rose:

> Later still a tray will appear. Flo will put it down without a word and go away. A large glass of chocolate milk on it, made with Vita-Malt from the store. Some rich streaks of Vita-Malt around the bottom of the glass. Little sandwiches, neat and appetizing. Canned salmon of the finest quality and reddest colour, plenty of mayonnaise. A couple of butter tarts from a bakery package, Rose's favourites in the sandwich, tart and cookie line.[14]

For Mary Pratt in *Baked Apples on Tinfoil*, "these apples are almost jewels, set in silver, gold, amber, and yet are obviously mundane ... redolent with cinnamon and cloves. They refuse to be boring" (Pratt 42) (see Fig. 2).

Domestic still-life subjects are often vivified by Pratt, while in Munro's stories still-life provides an invitational context. In her description of her painting *Romancing the Casserole*, Pratt points to her own animistic magic-making: "This casserole was made in England, but its inspiration was oriental. When I saw it in the microwave oven, lit by a light so orange that it turned all the whites aqua, it acquired a life of its own" (Pratt 140). Alice Munro's short stories, of course, cannot be reduced solely to analysis by visual presentation. Each story is a complex narrative (sometimes several narrative patterns) of psychological and social complexity, of character motivation and human relations, even of metafictional inquiry on the nature of the artistic process and the making of art. Language is also quite clearly the writer's palette, and Munro's use of literary techniques varies. Even so, it is difficult to read any one of her stories without noting her striking visual power in her use of a domestic, material context and often even her applause of feminine artistry. While, for example, she protests the imprisonment of the female artist by class and gender in her portrait of Amelda Roth in "Meneseteung," she also embraces the beauty and energy of feminine domestic decoration. Like Pratt, she explicitly denies its visual formulation as a static still-life:

> [Amelda's] surroundings—some of her surroundings—in the dining room are these: walls covered with dark-green garlanded wallpaper, lace curtains and mulberry velvet curtains on the windows, a table with a crocheted cloth and a bowl of wax fruit, a pinkish-gray carpet with nosegays of blue and pink roses, a sideboard spread with embroidered

runners and holding various patterned plates and jugs and the silver tea things. A lot of things to watch. For every one of these patterns, decorations seemed charged with life, ready to move and flow and alter. (*Friend of My Youth* 69)

The code of femininity not only informs Pratt's and Munro's interest in domestic subjects but also their technique, particularly in their attention to detail and surface. The ideology of femininity that developed with Rousseau with the claim that women were better suited for "executing highly detailed works on a small scale" has impacted on their art (Chadwick 138). Mary Pratt herself insists: "Women are different from men ... their special role is to convey to men their own reverence for the small and seemingly unimportant. It's almost like the apple that Eve gave to Adam. This is what I give to you, this is what I have, this is what I understand and you don't" (qtd. in Gwyn 19). In a response to Munro's early work, *Dance of the Happy Shades*, critic David Helwig comments on her ability to work in a compressed way, and to expand the minute and the seemingly inconsequential: "Her work consists of an expansion inward rather than outward, the discrimination of tone and language that makes a small event within a provincial society an important human matter. It is perhaps an essentially feminine art."[15] Similarly, Pratt, working her paintings with tiny brush strokes, using the same sable brushes that Victorian ladies used for their watercolours, transforms "routine artifacts of housewifery into aesthetic objects; the prosaic has become alluring" (Gwyn 1).

Both Alice Munro and Mary Pratt are experts at the artistic renderings of the surface realities of the material world, and, as Gerta Moray says of Pratt, "the visual effects of surface reflection." Moray points out that such effects are derived from the painting traditions of northern Europe in painters like Vermeer, but have been subsequently defined and undervalued in Western culture and art traditions as "feminine." Rather, it is the Italian Renaissance tradition which has prevailed, while its elevation of an abstracting and generalized mode of expression has been interpreted as superior "masculine" art. Pratt is close to the feminine "northern tradition" which "approached painting as a matter of describing the visible world in all of its visual particularity, with attention to detail and surface."[16]

Interest in detail and surface is synonymous with femininity, and with the femininized artistry of Pratt and Munro who are concerned with material layers and particularities. Mary Pratt's images are replete with a feminine-derived expression of minutely executed, sensuously portrayed surface textures and coverings: of tinfoil and Saran Wrap,

crumpled brown paper bags, the richly felt skins of baked apples and silver-scaled fish, of roast beef "dressed" in a layer of fat (see Fig. 3). Munro, too, is an expert interpreter of surface realities, including landscape. As I have previously noted of her early work, *Dance of the Happy Shades*:

> A felt sense of Ontario in *Dance* depends in part on Munro's amazing ability to capture its surface life, and in her own words it is texture that she strives for: "... I am certainly a regional writer in that whatever I do I seem only able to make things work ... if I use this ... this plot of land that is mine.... And texture is the thing that I've got to have." (Rasporich 127)

In Munro's quasi-novel, *Lives of Girls and Women*, her protagonist, the maturing Del Jordan, articulates her creator's own artistic mission of capturing the sensate particularities and details of her smalltown environs, "every last thing, every layer of speech and thought, stroke of light on bark or walls, every smell, pothole, pain, crack, delusion, held still and held together—radiant, everlasting."[17]

Attention to detail and surface is acutely felt and seen in both artists' preoccupation with dress. If the art of femininity asks for the female face as a primary canvas, it also asks that female clothing be a textured tactile skin of external disguise and inviting sexual masquerade. In her discussions of the social construction of gender, Susan Brownmiller asks, "Who would deny that dressing feminine can be quite creative? A woman with a closetful of clothes for different moods and occasions is an amateur actress and a wily practitioner of the visual arts." The aesthetic pleasure derived from the artistry of decorative manipulation of a female's second skin, even though its purpose is to objectify the female, to make her more sexually alluring, is difficult to defeat. As Brownmiller goes on to point out, "Every wave of feminism has foundered on the question of dress reform. I suppose it is asking too much of women to give up their chief outward expression of the feminine difference, their continuing reassurance to men and to themselves that a male is a male because a female dresses and looks and acts like another sort of creature" (79).

Alice Munro cannot give up this aesthetic pleasure of gender difference and coloured felt surfaces in fashion.

> Sheer crepe, satin, velvet, slub rayon, organdie, cashmere, brocade, flowered silk, pink chenille, powder-blue angora; full black taffeta skirts, short coats coloured robin's egg blue, cerise, red, lime green, a soft grey dress with embroidered flowers, a dull rose hat and flowers, a dark red marino wool dress, brown and white checkered slacks and yellow top— such is the stuff of Munro's fiction. (Rasporich, 97–98)

Cold Cream (1983). Oil on gessoed board, 19 × 14 in.
Courtesy of Mary Pratt.

Baked Apples on Tinfoil (1969). Oil on panel, 16 × 24 in.
Courtesy of Mary Pratt.

Roast Beef (1977). Oil on panel, 16.5 × 22.5 in.
Courtesy of Mary Pratt.

Girl in Glitz (1987). Oil on masonite, 30 × 45.25 in.
Courtesy of Mary Pratt.

Her own reckoning is that her artistic liberation—her most important inspiration—came through clothes. "The idea of using experience came to me with 'The Peace of Utrecht' which was after my mother's death when I went home.... I went to my grandmother's house and she showed me my mother's clothes ... from that time on I had this new thing about writing" (qtd. in Rasporich 14). While a description of a variety of female clothes and their fabrics in Munro's work suggests a textural extravagance and an appealing, hedonistic emotive affect, Pratt's imaging of actual female clothing is much more limited and has centred almost singularly on the wedding dress rendered iconic from a distanced perspective.

Traditionally, the wedding dress is social proof and symbol of the marriage contract, a visual statement of the bride's virginal status and her proper exchange as unblemished goods. Of Pratt's five paintings where the subject is wedding dress, three are portraits of women for whom the dress is self-expression, a costume of personal choice and artistry. The icon of the dress in the iconography of the marriage ritual is reconstructed as a private, even idiosyncratic choice in *Anne in My Garden*, a portrait of her daughter Anne in an Elizabethan-style dress; unfamiliar with wedding conventions, Anne chose this fashion because she was studying "The Faerie Queen" (Pratt 144). Similarly, *Barby in the Dress She Made Herself* is a portrait of her daughter Barby in a self-made dress, painted as a luminous, exquisitely detailed costume. Pratt breaches traditional iconographic representation here in the individualization of the subject. Moray comments: "the expression on the bride's face and the tense clasping of her hands indicate that the psychological experience, the ceremonial dress, and the conventional pose are incommensurate elements" (Moray 35). *Student of Ancient Chinese Literature* is a portrait of a bride whose "wedding dress was very old, from a different time" (Pratt 150) and is less visually interesting than the painted subject herself contextualized sitting at a table with a suggestively oriental vase of flowers. The wedding dress here simply complements and expresses the bride's interests and her person. If, to some degree, Pratt is usurping the conventional interpretation of dressing the bride as symbolic *object* in these portraits by sidestepping the importance of the costume in the interest of her female subject's interiority, her renderings of wedding dresses as *empty* dress are much more suggestive and critical of the feminine status quo.

The first, entitled *Wedding Dress* (1975), is a stark, luminous, white, almost shroud-like image of a simple wedding dress hung on a closet door to unwrinkle before the ceremony, and the second, also entitled *Wedding Dress* (1986), is a painting of a dress hung on a tree in a darkly

shadowed natural world. Although both of these images are superficially comforting and pleasing in their associations with youth, innocence, and virtue, there is a disturbing sub-text. As Jane Gaines, citing Edward Maeder, explains, "in this century, clothing conforms more closely to the body than at any other time in history"[18] and "clothing without body" offers us an untenable position. The "ghostly garment is too corpse-like and is fully reminiscent of the empty space for woman produced by theories of culture derived from male models." Quoting from Roland Barthes on the designer Erté, "the body gives existence to the dress, 'for it is impossible to conceive of a dress without a body ... the empty garment, without head and limbs ... is death, not the neutral absence of the body but the body mutilated, decapitated'" (Gaines 2). Pratt herself has determined the image of the dress (1986 painting) to be "sacrificial" (Pratt 142) and the other dress (1975 painting) in its simplicity, as she discovered it and before she painted it, to be a hopeful, ultimately unrealizable iconic sign: "I saw the dress, glowing in reflected sun. It was simple and entirely without artifice. For a few minutes the intricacies of my life fell away, and I believed I could be uncomplicated" (Pratt 72). In these paintings the ideology of femininity substantiated by marriage is superficially affirmed but concurrently deconstructed. In Moray's analysis, in Pratt's art traditional symbols of socially defined femininity "can appear at first to be endorsements of a woman's traditional world, but a contradiction is apparent in the very conditions of their making. The artist has distanced herself from that world to make objects of use into objects of contemplation" (Moray 35).

As Susan Brownmiller has suggested, the paradox of femininity is that it creates a "brilliant subtle aesthetic," one that can relay enormous pleasure as a "creative outlet" or for "the sake of art" (15), but the dark side is that femininity insists on restrictions, on limited horizons, on immobilization and passivity, on the objectification of the female through the male gaze, and on an artificial construction of female selfness as desirable object rather than desiring subject. Like Pratt, Munro also, explores and protests the complexities of femininity's double-sidedness. Her fictions are shot through with exposures of femininity's trappings both for ordinary women and for the female artist. In the short story "Thanks for the Ride," for example, an aspirant working-class girl is seduced by a middle-class male; anticipated in the description of her feminine dress is her passive and sorry unwrapping like a cheap Christmas gift. Her costume spells out her victimization: "Lois came in, wearing a dress of yellow-green stuff—stiff and shiny like Christmas wrappings—high-heeled shoes, rhinestones, and a lot of

dark powder over her freckles."[19] In "Meneseteung" Amelda Roth as a female obviously cannot function as a free artistic agent, and as a woman she is bound and strangled by the feminine code of superficiality and gentility which is a surface veneer—one that does not even allow for the physical realities of the female life or the physical actuality of the female body. Munro exposes these realities with a vengeance when she has Amelda view the body of the woman beaten by her drunk husband.

> A woman's body heaped up there, turned on her side with her face squashed down into the earth. Amelda can't see her face. But there is a bare breast let loose, brown nipple pulled long like a cow's teat, and a bare haunch and leg, the haunch showing a bruise as big as a sunflower. The unbruised skin is grayish, like a plucked, raw drumstick. Some kind of nightgown or all-purpose dress she has on. Smelling of vomit. Urine, drink, vomit. (65)

In this story Munro implies that femininity contributes to the *cover-up* of the physical brutalization of women at male hands. Similarly in a few of Pratt's paintings surface beauty gives way to an exposed, nightmare vision of the female condition. The most explicit of these is *Service Station*, in which the carcass of a dead moose is a metaphor for woman, screaming "murder, rape, clinical dissection, torture."

A central motif and metaphor in the work of both Pratt and Munro is that of peeled skin, raw flesh, severed animal parts, dead meat (Rasporich 171–72); this cluster of related images explodes the mythology and ideology of femininity and its surface artifice, demonstrates a female anxiety about victimization and the profound understanding that in life "as in art for a long time men have fragmented, distorted and cut women's bodies into pieces of false perspective."[20] The butchering of women through the male gaze and at male hands is illustrated by the pornographic reference in Munro's "Spelling" from *Who Do You Think You Are?* where "every magazine rack in every town was serving up slices and cutlets of bare flesh" (189). Munro's heroines also internalize the male-determined disgust for the reality of the female body when not disguised through the artifices of femininity. However much this is protested by Munro, as through her character Rose who is "ashamed of, burdened by, the whole physical fact of herself, the whole outspread naked digesting putrefying fact" that could make her "flesh ... seem disastrous; thick and porous, grey and spotty" (*Who* 173), she cannot reverse this attitude of physical self-loathing, a dictum of feminine ideology. She can only expose it with despair and melancholy.

Mary Pratt is more constrained than Munro, much more evasive in

her representation of the female body. Her images of *Eviscerated Chickens* and split and splayed, mutilated fish (*Summer Fish*), and her "parcelled flesh" of *Roast Beef,* displaying "'other qualities'" (Pratt 86) only hint at their metaphoric possibilities regarding female physicality. Her images of containment—a turkey wrapped in tinfoil, a steamed pudding similarly wrapped—illustrate her preference for maintaining the beautiful surfaces of domesticity and bourgeois femininity. Her evolution into the traditional convention of painting the female nude reveals a similar restraint.

The convention of painting the female nude has insisted on the female body as creative inspiration for the male artist and as an erotic, perfected art object (women were barred from the study of the nude model from the sixteenth to the nineteenth centuries; Chadwick 7). Moreover, as Susan Brownmiller explains, the idealization of the feminine form in the female nude may alter in any given age, but the fact remains that the tyranny of whatever ideal feminine shape is in vogue is felt by a woman whenever she thinks—"or whenever a man thinks and tells a woman—that her hips are too wide, her thighs are too large, her breasts are too small" (Brownmiller 23–24). The imaging of the female nude by the male artist, then, is an erotic, objectified image of ideal femininity and male desire.

Mary Pratt's passage into painting the female nude has been difficult. Gerta Moray describes the inherent problems:

> When Mary Pratt was already a successful artist, she was asked why she did not paint the nude. Her reaction was, "Oh, I couldn't do that. That's for men to do. I wouldn't feel right." But then she had second thoughts. Logically, it seemed to her that women above all should be interpreters of their own bodies. The male monopoly should be challenged. Instinctively she had understood that she was entering on masculine territory. Indeed, many contemporary feminist artists have refused representation of the nude female body on the grounds that the whole genre is still too loaded with its past function as an agency conditioning women into a psychic role of passivity and sexual subordination to men. (Moray 34)

Pratt reversed her decision and appropriated from her artist-husband, Christopher Pratt, photographic studies of a nude model, Donna, and also engaged Donna herself to pose for a series of photos in which she would be involved in routine daily activities such as taking a bath or putting on cosmetics. In Moray's critical estimation, "to look at the most remarkable of these canvases—*Girl in My Dressing Gown* (1981), *Girl in Red Turban* (1981), *Cold Cream* (1983), *Donna* (1986)—is actually to see a succession of different personae. Mary Pratt's images are neither

images answering to male desire, nor to some essence of womanhood. They are images of masquerade" (Moray 35).

Masquerade is certainly an element in these paintings, demonstrating the artist's protest at the "making up" of a woman. Perhaps the most obvious of these is *Cold Cream* in which the portrait of Donna from the shoulders up is masked, in a painterly way, through the application of a thick cold cream, accomplished by allowing the white underpainting of gesso to dominate the face. The result is a semi-grotesque wounded image of a woman bleeding white. At the same time, Pratt's female nudes are vacant, static figures, reminiscent in part of commercial, male-oriented photographic images of women. As shadowed illusions, they are queried through their unusual and unconventional postures, the play of light, their masquerading, even as in *Girl in Glitz* (see Fig. 5) by the imperfect indentations that clothes make on the body. Nonetheless, they also still answer to the ideology of gender conventions, to the male perspective and to male desire that dictates "naked woman as art; naked women as statues, preserved in silence, immovable, at once violable and ever still, preserved in vulnerability."[21]

Although Pratt recognizes the tradition of considering the naked woman vulnerable, preferring "to think of them as abandoning layers of artifice" (Pratt 154), she cannot escape the inescapable: the vitiation of female desire within a masculine-defined artistic convention and the socially defined construct that equates the feminine with passivity and objectification so that "we are constantly turned back on ourselves, to the images of ourselves watching ourselves in the mirrors as objects" (Daurio 97). Paddy O'Brien applauds Pratt's attempts as a woman to paint a nude woman—to break through "psychological or emotional barriers of feminine creativity"—but points to Pratt's discomfort with the female nude, an artificial posing of them in three of her paintings, concluding that "she treats them as still-life, and although well-painted, there is a stiffness about these girls" and an inability to delve "into human flesh with the same uninhibited delight that she gives to inanimate flesh."[22] Pratt's own codification of female nudes from borrowed slides is that of "found objects" (Gwyn 17) and these are objects that she often presents as idealized female forms. The figure of Donna in *Blue Bath Water* (1983), for example, is one of unblemished skin, flat stomach, a "pearlescent body" (Pratt 124), indicating a strong nod on Mary Pratt's part in the direction of male fantasy.

It can also be argued that the female nude as subject in Pratt's paintings is less a series of individualized women, or "a succession of different personae," than it is a site of spectatorship and voyeurism on

the part of the female artist, as well as a locus of sexual politics. Christopher Pratt identifies Mary Pratt's spectating situation when he says that her gaze is that of "a woman looking at a naked woman who was looking at me, she was a spectator after the fact at a very private circumstance" (Moray 17). Mary Pratt is in the position of being in erotic complicity with both views, the male artist's erotic framing and objectification of the female nude, and the nude model's understanding of her self as a desirable object. The result is a voyeuristic painting like *Girl In My Dressing Gown* (1981) in which Donna, dressed in Mary's gown, looking at Christopher, is a sexual semi-robed figure. At play here, too, is the tension of sexual competition, dictated by femininity, of two women for the man's attention. The female nude as the site of sexual voyeurism for Pratt is most acutely felt in *Girl in Glitz*. The model's pose for Christopher and Pratt's painting of her clearly mirror the girl's awareness of herself as a desirable sexual object.

This is not to say that Pratt, or for that matter, Munro, is uninterested in the quest for autonomous female identity beyond the prescriptions of femininity. Indeed, the quest itself is metaphorically inscribed in their art as a paradoxical and dangerously felt attempt to denude the nude, in Pratt's case, to lay bare what is falsely bare, bespoken by artificially constraining the nude through her wearing of small articles of clothing. Also, the slight scarring of her figures through the lasting impressions of tight-fitting clothing left on female flesh, as the marks of zippers and jeans on the stomach of *Girl in Glitz* and of socks on the ankles of *Donna*, remarks on the trace of external constraints on the body and suggests with touching irony the impossibility of realizing a genuine naked female identity on canvas. Such visual texts are subversive protestations about the difficulties of female agency at their most tactful. Munro's narratives are less so in that hers is a typically heavily ironic and, occasionally, jeering voice. A good example of this and a fitting parallel to Pratt's *Donna* series is the short story "Oranges and Apples" from *Friend of My Youth*.

Central to the Munro story is the theme of the female as desirable, erotic object through the male gaze (the story is told from a husband's point of view). An unspoken romantic triangle develops between the husband, Murray, his wife, Barbara, and a friend, Victor, who is occupying an apartment on the married couple's property. When Murray arrives home unexpectedly to find Barbara sunbathing and Victor watching her, Murray becomes a sexual voyeur and Munro the recorder of the socio-sexual and artistic reality of the female figure— feminized, framed, objectified, and controlled through male interest.

> When [Murray] looked at Victor through the binoculars, he saw a face like his own—a face partly hidden by binoculars. Victor had them, too. Victor was looking through binoculars at Barbara.
>
> ... Murray could feel the heat of the room and the sweat-slicked hard seat of the chair and the man's powerful but controlled sexual excitement. And looking at Barbara he could feel the glow along the surface of her body, the energy all collected at the skin, as she gave herself up to this assault.... It was obscene and enthralling and unbearable.
>
> Murray could see himself—a man with binoculars watching a man with binoculars watching a woman. A scene from a movie. A comedy. (126–27)

Munro's ironic perspective that claims this situation on one level to be a comedy extends to Barbara's costume, an absurd feminine contraption designed for sexual invitation:

> Barbara was lying on the faded quilt, stained with sun-tan oil, that they used when they went to the beach. She was wearing her strapless black bathing suit, a garment that resembled a corset and would not be considered at all attractive in a few years' time. It cut straight across the thighs and pushed them together; it tightly confined the waist and stomach and hips, and uplifted and thrust out the breasts so that they appeared to be made of something as least as firm as Styrofoam. (125–26)

Both Pratt and Munro, then, seek aesthetic inspiration from femininity but concurrently resist and critique its male-ordered paradigms that insist on falsity, inferiority and the denial of the female and the woman artist as subjective Ego. In effect, they mirror in their artistic endeavours the feminine dilemma which Simone de Beauvoir described of the female adolescent attempting to mature:

> Not only is she torn ... between the past and the future, but in addition conflict breaks out between her original claim to be subject, active, free and, on the other hand, her erotic urges and the social pressure to accept herself as passive object. Her spontaneous tendency is to regard herself as the essential: how can she make up her mind to become the inessential: But if I can accomplish my destiny only as the other, how shall I give up my Ego?[23]

As artists, Pratt and Munro are faced with the same dilemma: if they choose to celebrate feminine artistic subjects and techniques that are inherently devalued and by definition deny an expressive ego and its realities, how can they guarantee the worth of their art and their individual expressions?

For Munro's and Pratt's generation of artists, the preoccupation with locating the artistic self as subject has been undoubtedly influenced by feminism. Rita Felski, writing in *Beyond Feminist Aesthetics*, points out that "it is in the 1970s, after the more overtly politicized culture of the 1960s, that the problem of self-identity re-emerges as a major cultural preoccupation within Western society." She goes on to argue that feminism has stimulated women's writing as a main forum for self-analysis and a "realistic" literary discourse that stresses "the feelings and responses of the experiencing subject.... Even if the social world is depicted in detail, as in the American feminist realist novel, it is always subordinated to the central biographical theme of the heroine's development."[24] This is certainly true of Munro's fiction of adolescent (and artistic) development, *Lives of Girls and Women*, and the great majority of her short stories are rendered from the point of view of an experiencing female (who is sometimes an artist) subject. Ultimately, locating the experiential self in the external world and imbuing the world with subjective feelings and emotions informs both Munro's and Pratt's central artistic method—that of photographic realism, a method that is highly compatible with feminine ideology.

Mary Pratt's genre as a painter is that of representational art, her method photographic with the camera her main tool. Pratt paints directly from photographs, explaining that she has strong emotional reactions to external objects, "moments of vision" that can be captured by the camera, referenced, and then transcribed, with particular attention to light and shadow, into art. As Moray points out, these images "so magically preserved" are also symbols "of loss. For what is recorded there is tied to the moment in time when the record was made, and so, by definition, is irretrievably past, dead. This is what gives photographs their poignancy" (24).

Alice Munro's short stories also often depend on poignant, marvellous recollected moments of vision and truth: epiphanies, especially in such short stories as "Walker Brothers Cowboy" and "Images" from her early work, *Dance of the Happy Shades*. The image of the photograph itself also reappears as a motif in her fiction, offering, allusively, structural support for her narrative strategy of recalling the past in the present. In the short story "Winter Wind," for example, from *Something I've Been Meaning to Tell You*, the narrator nostalgically recollects the sights and sounds and smells of her childhood, depending in part on a family photograph and its images as a way of retrieving the past. The narrator reveals, "I salvaged it, and have taken it with me wherever I go."[25] The artist-figure is identified, too, as a photographer in the epilogue of *Lives of Girls and Women*. Munro's work is remarkably

the literary equivalent of Pratt's, her characters and events often presented suspended in memory as if they were acutely focused and detailed snapshots.

In the work of these two artists, the personal self subjectively interprets and carefully, photographically, documents the world around her. Moray explains of Pratt:

> These images are guaranteed to be things that the artist saw. They at the same time have a strong emotional undertow, because of the world they evoke. We know that what we see in her paintings must be predominantly her personal objects, places, and people. This gives the paintings the dimension of an autobiographical record, and suggests that some of them can be read as *memorabilia* of the artist's life. Each of them has the quality of an individual observation and event. In this way the paintings have a kinship with snapshots, by which we try to hold on to the memory of significant events in our lives. (25)

This observation could also be applied to the narrating voices of Munro's short stories, which are autobiographical in tone, and to Munro's own artistic process since she claims that her characters are aspects of herself and that she writes from experience (Rasporich 23).

This recording of times past, the formulation of art as subjective, emotive memorabilia, is also very much a feminine accomplishment. That longstanding equation of femininity with emotion and feeling, and masculinity with intellect is practised through women being "keepers of the heart, keepers of the sentimental memory. In diaries, packets of old love letters and family albums, in slender books of poetry in which a flower is pressed, a woman's emotional history is preserved. Remembrance of things past—the birthday, the anniversary, the death—is a feminine province" (Brownmiller 215–16).

Moreover, the oeuvre of photographic realism is highly compatible with the ideology of femininity that emphasizes the minute, the particular, and surface realities. As Susan Sontag says of the photographic image, "photography reinforces a nominalist view of social reality as consisting of small units of an apparently infinite number— as the number of photographs that could be taken of anything is unlimited. Through photographs, the world becomes a series of unrelated, freestanding particles; and history past and present, a set of anecdotes and *faits divers*."[26] For Mary Pratt, this anecdotal viewpoint has resulted in some criticism of her work for its lack of a controlling philosophy, while literary critics have been puzzled why Munro is unable to move beyond the anecdotal short story form into the traditional novelistic genre. Sontag also points out the surface and

emotive character of the photographic image when she comments: "The ultimate wisdom of the photographic image is to say: 'There is the surface—Now think—or rather feel, intuit—what is beyond it, what the reality must be like if it looks this way'" (Sontag 23). The genius of both Pratt and Munro is obviously their feminine ability to evocatively capture appearances but at the same time to suggest the other contemplative or subversive realities beyond them.

In the final analysis, it is the paradox of femininity that may be the ultimate muse of these two artists; certainly femininity impacts on their choice of subjects, their techniques and their artistic *visions*. As representational artists and pseudo-photographers, each is the controlling I/eye, framing and envisioning material reality with subjective authority. For them, as for many contemporary female artists, the personal is also the political. That "other reality" that the reader and viewer is asked to feel and intuit in a "feminine" way beyond the beautifully composed feminized surfaces is loaded with dark, thoughtful, often disturbing messages about women's social and artistic lives. And if Munro's heroine, Del Jordan, the developing artist of *Lives of Girls and Women*, early in her life worries about an article in a newspaper with its negative claim that "for a woman, everything is personal; no idea is of any interest to her by itself, but must be translated into her own experience; in works of art she always sees her own life, or her daydreams" (150), she also acquires (through viewing a photograph) the confident artistic credo of her author that "peoples' lives ... were dull, simple, amazing and unfathomable—deep caves paved over with kitchen linoleum" (210). Similarly, Mary Pratt expresses her faith in her own "gut reactions" (Gwyn 12) to her choice of object-subjects, acknowledging shadow realities and subterranean depths, as in *Blue Grapes and a Yellow Apple* (1984), painted with bright rich colours but "with a deep shadow under the table" (Pratt 138). Clearly, the experience of being a woman, translated into the deep double-sidedness of femininity, is an artistic inspiration for Alice Munro as writer and Mary Pratt as painter.

Beverly J. Rasporich is Professor of Canadian Studies and currently Associate Dean in the Faculty of General Studies at the University of Calgary. Research interests include the arts in Canada, ethnic and Native literature, Canadian humour and culture, and women in Canadian arts and letters. She is the author of numerous articles on these subjects, *Art and Gender in the Fiction of Alice Munro* (1990), and co-editor of *A Passion for Identity: An Introduction to Canadian Studies* (1993). As director of the Effective Writing Service (1983–1988), she worked directly for Marsha Hanen who was then Dean of the Faculty of General Studies. By encouraging, supporting, and inviting participation in the creation of interdisciplinary programmes, Marsha

promoted her professional and intellectual development. Marsha Hanen remains an inspiration as a person of charm and thoughtful intellect who initiates positive possibilities for others. Dr. Hanen is an innovative educator, the ideal university administrator.

Notes

1 I am indebted to Gerta Moray and Sandra Gwyn for their research and writing on Mary Pratt. As well, I have depended on some of my earlier writing on Alice Munro for the preparation of this article.

2 Catherine S. Ross, *Alice Munro: A Double Life* (Toronto: ECW Press, 1992) 16.

3 See Whitney Chadwick, *Women, Art and Society* (London: Thames and Hudson, 1990).

4 See Janet E. Clark and Robert Stacey, *Francis Anne Hopkins 1838–1919* (Thunder Bay Art Gallery, 1990).

5 Susan Brownmiller, *Femininity* (New York: Fawcett Columbine, 1984) 18.

6 Mary Pratt, *Mary Pratt* (Toronto: McGraw-Hill Ryerson, 1989) 126.

7 See Chadwick 19–20. For a discussion of the female as artistic muse in the Surrealist movement, see Whitney Chadwick, *Women Artists and the Surrealist Movement* (London: Thames and Hudson, 1991).

8 Mary Pratt, cited in Sandra Gwyn, Introduction, *Mary Pratt* 18.

9 Alice Munro, *Lives of Girls and Women* (Scarborough: New American Library of Canada, 1971) 67.

10 Alice Munro, *Something I've Been Meaning to Tell You* (Scarborough: New American Library of Canada, 1974) 35.

11 Alice Munro, *Friend of My Youth* (Toronto: McClelland and Stewart, 1990) 50.

12 Mary Pratt, cited in Sandra Gwyn, Introduction, *Mary Pratt* 14–15.

13 Beverly Rasporich, *Dances of the Sexes: Art and Gender in the Fiction of Alice Munro* (Edmonton: U of Alberta P, 1990) 4.

14 Alice Munro, *Who Do You Think You Are?* (Scarborough: Signet, 1978) 19.

15 David Helwig, "Dance of the Happy Shades", *Queen's Quarterly* 77 (Spring 1970): 128.

16 Gerta Moray, "Critical Essay," *Mary Pratt* 29.

17 Alice Munro, *Lives of Girls and Women* (1971; Scarborough: Signet, 1974) 210.

18 Jane Gaines, "Introduction: Fabricating the Female Body," *Fabrications, Costume and the Female Body*, eds. Jane Gaines and Charlotte Herzog (New York: Routledge, 1990) 2.

19 Alice Munro, *Dance of the Happy Shades* (Toronto: McGraw-Hill Ryerson, 1968) 51.

20 Maggie Humm, "Feminist Literary Criticism in America and England," *Woman's Writing*, ed. Moira Monteith (Great Britain: Harvester Press, 1986) 105.

21 Beverley Daurio, "The Problem of Desire," *Language In Her Eye* (Toronto: Coach House Press, 1990) 96.

22 Paddy O'Brien, "Mary Pratt," *Canadian Woman Studies* 3.3 (Spring 1982): 38.

23 Simone de Beauvoir, *The Second Sex*, trans. H.M. Parshley (New York: Alfred A. Knopf, 1968) 336.

24 Rita Felski, *Beyond Feminist Aesthetics* (Cambridge: Harvard UP, 1989) 81–82.

25 Alice Munro, *Something I've Been Meaning to Tell You* (Toronto: New American Library of Canada, 1974) 155.

26 Susan Sontag, *On Photography* (New York: Farrar, Straus and Giroux, 1973) 22–23.

9

Contemporary Art and Critical Theory in Canada

ALICE MANSELL

Art practices in Canada since the early 1980s have purportedly been identified as "smart," in that the artists involved have been able to refer to critical theories (usually derived from literature, cultural studies, psychology, or other text-based disciplines) that relate to their works. The size and character of the Canadian art system as presented in the major national publications of this time (*Parachute*, *C Magazine*, *Vanguard*), and in the public and artist-run galleries they reported on, allowed these venues to offer what many artists, critics, and scholars began to see as work that represented a national sensibility. While one may argue the case for the truth of this perception given the limited sample listed above, these were the venues where major works and workers were expected to be represented, and they clearly presented the use of theory to prescribe, and simultaneously proscribe, appropriate practices which were also seen as national tendencies. From Vancouver to Halifax, the works that were seriously acknowledged exhibited a set of similar methodologies, which were couched in overt references to critical positions sited in theories outside of art.

Even if we allow that at a given period in time cultural practices such as art production use common terms and structures in order to communicate with others in the field, we need to understand how and why certain terms and structures become the dominant forms of discourse. If critical theory is used to critique our traditional historic European masterpieces, why is it that our current artists and practices still reflect the traditional patterns of gender, race, class, and region? Why have the critical theories that are ostensibly suited to critique cultural, social, and economic values and practices in other disciplines not enabled us to include other artists and work models than those that resemble the traditional western European canon of masterpieces and master artists? Could those critical theories be operating to reinforce the values that postmodern artists and scholars thought were at least being questioned, if not subverted?

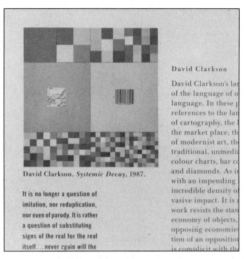

Fig. 1. David Clarkson, *Systemic Decay* (1986).
Courtesy of David Clarkson. Photo by W. Geleynse.

An example of such possible reinforcing tendencies may be seen in the following work in a recent exhibition. Although the exhibition contained the work of both male and female artists, it seemed to represent reference to, and reverence for, the authority of the theory text: as I have argued elsewhere, the critical theory operates as surtext.[1]

This work by David Clarkson called *Systemic Decay* (Fig. 1) appeared in the exhibition "Active Surplus" in 1988. The reading of this work in the exhibition required the reading of the catalogue, which implicitly situates the work under the authority of the quoted text. In the catalogue a small black and white reproduction of the work is dominated by the quotation in large print: "It is no longer a question of imitation, nor reduplication, nor even of parody. It is rather a question of substituting signs of the real for the real itself ... never again will the real have to be reproduced."[2] Thus, by installation, and by referential dependence on the catalogue and its structure, the visual work *Systemic Decay*, becomes subtexted more powerfully than the commonly held sense of endorsement such a referenced quotation use might imply. It is literally constructed by its reference.

This example should not be seen as a lament at the predominance of the "linear logic" of text *over* visual image implied by positioning the visual work as a footnote and illustration. Neither am I trying to restore the primacy of the art object over the preponderant attention given to critic, curator, or art historian as the authority in defining the meanings of the art works, or in "executing the text" as Barthes punned it.[3] And I do not wish at this time to make a case for the artist being seen as an authority, or primary participant in defining meanings. However,

by looking at the ways that works are presented, in these cases under the implied authority of certain quoted critical theories, we may be able to see how that practice prevents visual works from questioning and even disrupting, traditionally defined identities or categories of artists and art practices. By seeing the ways that critical theories do *not* critique conventional categories, we may imagine ways that some theories can become the critical tools they are reputed to be, rather than mere signs of unquestioned authority. As tools they may empower other voices of gender, race, and location to truly enter and extend the fields of discussion.

In this essay, I will confine my discussion to one critical strategy that engages with issues of appropriation, and to the strategies some Canadian artists have used in appropriating references to art historical masterpieces in order to participate in contemporary art dialogues. Included will be an inquiry into how such references work for and against the status quo in representations of gender, race, and national location. Although there are many other ways in which critical theories and methods are used to define or confine art and art historical practices, the concern here will be centred on the ways that the act of reference to monuments in the canon can either close down or open up critique of gender, place, and race.

Let us begin by interrogating the use of appropriated images by artists, especially the appropriation of canonized artists' works. Craig Owens in "The Allegorical Impulse: Toward a Theory of Postmodernism" argued that when an artist appropriates an image, that quotation becomes embedded in its new context, and thereafter changes the way we see, and read, the original image.[4] Thus it is the act of appropriation that needs to be examined to determine how meanings are constructed in both the original work and the quoting work. Or as Lacan argues, we should peer through projected images to see the underlying systems that give rise to them: the symbolic order, the techniques, the structures or functional categories in the art world that give rise to such appropriations. For example, *The Craft of the Contaminated* by Andy Fabo (Fig. 2) appropriates the formal and narrative structure of Gericault's *The Raft of the Medusa*, of 1819 (Fig. 3), which depicted the survivors of a shipwreck on a raft, abandoned to starvation and storms by passing ships, until they resorted to cannibalism and other unspeakable desperations. Fabo uses the convention of oil painting on wood to picture the plight of some fellow Canadians. Oil paint and wood are used to build both art and rafts. Fabo's use of these materials can therefore be seen as allegorical. The maple leaf flag, the native teepee, and the figures brandishing a burning flag to the unseeing image of a

Fig. 2. Andy Fabo, *The Craft of the Contaminated* (1984) Oil on wood.
Courtesy of Andy Fabo. Photo by W. Geleynse.

ship on a television screen may allow us to see the original work's meanings through Fabo's re-presentation of its imagery modes with contemporary reference codes.

> Gericault depicts the exciting moment when the men on the raft first glimpse the rescue ship. From the prostrate bodies of the dead and dying in the fore-ground, the composition is built to a rousing climax in the group that supports the frantically waving black, so that the forward surge of the survivors parallels the movement of the raft itself.[5]

Fabo has re-enacted the composition, the figural poses, and the materials of the Gericault painting in heightened colour and paint gesture. In this way he frames his portrayal of those identity categories he believes are seen as the pariahs in our contemporary Canadian context, the contaminated carriers of race, gender, disease, and impotent nationality. In Fabo's case, our appreciation of the original Romantic Realist masterpiece— "the spirit of heroic drama" (Janson, 585)—may now be recognized as a narrative constructed to be read as an incident involving ordinary people and ordinary biases elevated via a dramatic crisis tableau, a picturesque scene of the "other."[6] By

Fig. 3. Gericault, *The Raft of the Medusa* (1819). Courtesy of
Service Photographique © Photo R.M.N. Photo by W. Geleynse.

hooking his work to a "masterpiece," Fabo presents his own implied
identity as similar to the historically identified heroic painter, Gericault.
He uses the authority of this assumed identity to add credibility to his
interpretation of familiar Canadian political concerns. Thus he uses
the authority gained by appropriating the historical form of the work
and the reputation of the artist to expose the ways that race and class
have been depicted. He forces the viewer to see the historical and
contemporary images through the double lens of the appropriated and
appropriating works.

In this example we can see that the categories of masterpiece and
master artist are used by the artist to give the viewer a sense of his
credibility as a social commentator and of his status as a serious artist
like those who comprise the European lineage we have come to think
of as constituting the History of Art. While his work does throw into
question accepted interpretations of the "picturesque crisis," the
viewer can also override the critical reading and identify the work as
belonging in the category of fine art as a consequence of his use of oil
paint in a gestural (painterly) style. Through his reference to Gericault
and his style, he can be seen as belonging to the accepted traditions of
art history. Thus, just as quotation from, or citation of, an authority in
other disciplines allows the author to gain closure on an argument
through invocation of proof in the words of writers and texts we have
come to view as true or important, the artist can give his work an
authority that will demand attention from viewer and critic alike.

These signs of authority are often identified as the signs of quality.
Viewers, specialist and non-specialist alike, are easily led to judge a
work's effectiveness or quality by how closely it resembles a work

already anointed as a masterpiece. A work that could be viewed this way is *Self-Portrait as Max Beckmann* by Chris Cran, wherein the artist has depicted himself literally in the pose, costume, and technique of the self-portrait painted by Max Beckmann, *Selbstbildnis, im Smoking*, in 1927. This work may be interpreted as a strategy whereby the Canadian artist can insert himself into the lineage and identity of the canonized German artist, Max Beckmann. By using compositions, materials, depictive skills, gestures, and subject matters that are recognized as like those to whom the name "master" has been attached, the artist can cast him/herself into the category of important artist.

Although Fabo can be seen to infiltrate the art system to pose questions about identity vis-à-vis nationality, race, and sexuality, he negotiates from a familiar male perspective even if he can claim marginal status as gay and Canadian. Is it possible for a female artist to interrogate these traditions in a similar manner, when references to canonized female artists and female subject-centred narratives are so limited? And what happens if she assumes the vestments, gestures, and materials of the masters? Although the homosocial and the feminine have been part of the connoted identity attributes of important artists, such attributes or qualities have been described, and thus given reality from an almost exclusively male perspective.[7]

In art, culture, and society, descriptors of female characteristics and character have been depicted so pervasively by males that it was only in the second half of the twentieth century that we came to know why there were "no great women artists."[8] In theatre and opera the surtext of male perspective is acknowledged in a line from a recent rendition of Madame Butterfly in which all characters turn out to be male.

> Song: Miss Chin? Why in the Peking Opera, are women's
> roles played by men?
> Chin: I don't know. Maybe, a reactionary remnant of
> male—
> Song: No. Because only a man knows how a woman is
> supposed to act.[9]

We derive some of our most authoritative designations of sex and gender from psychoanalytic theories. In North America, the authorities cited are German: Freud and his forefathers and progeny of German philosophers. From this tradition we have come to see the European site of rationality and logic in a melding of psychology and philosophy that is situated in the "great texts" by the "great minds" of Western civilization. Thus, by invoking or quoting from these texts, we not only

refer to specific terms or structures but also assume the mantle of coherence and closure implied by these authorities. If we are aware of the ways authority can be assumed from the texts that have emanated from great minds of reason, can we not question the structures and systems that have identified them as such? Can we not break the circularity of cultural monuments that seem intent on reproduction of reputation, and the necessary exclusion of truly critical or transformative art practices? If we are prohibited from considering the gender and nationality of theoretical authorities, do we not continue to endorse the male artist heroes and their works? To explore these questions, I will now turn to the works of some contemporary women whose art practices have involved references to European male artist heroes and practices.

Joyce Wieland, in the late 1970s and early 1980s, developed some works first in pencil crayon, and then in oil on canvas, which by title, size composition, and shape can be seen as referring to great historical figures like Tiepolo and Chardin. These artist models chosen by Wieland have been described by historians as feminine: "the grace and felicity of his touch" (of Tiepolo, Janson 503), and "devoid of bravura, his brush work renders the light on the coloured surfaces with a creamy touch that is both analytic and subtly poetic" (of Chardin, Janson 540). By first choosing to use a non-prestigious medium, coloured pencil, and then to follow that with the production of small oval and circular works in oil on canvas, she has thrown into question the authority of oil painting as the mark of serious art work. As a woman of a "certain age," in alluding to a work done by a historically noted master, she could be seen to compel the viewer and critic to reconsider the ways in which we attribute mastery to gender and age in a way that excludes the female subject. She has chosen male artist models as exemplars of her self-described "intuitive process, unconsciously weaving many threads—mystical and partaking of William Blake's mysticism; impressionistic and enjoying the light, movement and colour (as well as format) of the work of Giovanni Battista Tiepolo."[10]

According to Marie Fleming, Wieland frames negative stereotypic notions of embodiments of the feminine with their masculine master artist authors. Thus, she has used the canonically approved male-derived mantle of "feminine" colour, size, form, and process to contrast with the irony of contemporary critical denigration of those qualities as essentialist, instinctive signs of women artists' bodies in their work. This essentialist notion comes from assumptions that women are biologically bound to instinctively produce work as a function of their physical makeup, whereas men employ their rational minds to produce

Fig. 4. Joyce Wieland, *The Artist on Fire* (1983).
Courtesy of the Robert McLaughlin Gallery, Oshawa, Ontario.

work that supersedes particulars of everyday existence. Accordingly women will naturally produce "feminine" form, gesture, and content, bound inextricably to fragments or moments of their particular personal lived experience. By emulating the artists anointed as masters, Wieland reveals the similarity of "feminine" qualities they have chosen to employ in their work, and those she has chosen to use in hers. She therefore demonstrates how the same qualities are differently valued according to the sex of the artist: men's works have been valorized, whereas hers are maligned.

To further unmask the site of privilege, in some of the titles, such as *The End of Life as She Knew It* and *He Giveth Her Tulips Light* both of 1981, she uses the form of the titles given to the historical monuments. This device plays on our assumptions of male authority and credibility as the causal relationship for the ways that historical references determine the form and content of proper pictorial narratives. These works clearly poke fun at grand heroic male narratives and the heroic artist identity that is read into the requirements for their creation. Her ironic act of quoting destabilizes content and creator categories.

A self-portrait, *The Artist on Fire* 1983 (Fig. 4), depicts the artist "with a bit of history and a lot of ambiguity.... The artist has recreated herself, a memory of a building and a reflection of that memory-illusions of delusions ... the canvas on the easel becomes yet another staged event, and so suggests the conceit of many mirrors reflecting from one to the

other both interior and exterior aspects" (Fleming 105). The gentle irony of her historical and material references works on her own artistic identity which has for three decades continued to contradict imposed standards of correct political practices of gender and depiction.[11]

Another artist with similar disruptive tendencies is Sheila Butler. Her oil on canvas painting, *The Flaying of Marsyas* of 1990 (Fig. 5) quotes from the same-titled painting by Titian, the Italian master painter of the sixteenth century. She asserts her conscious choice of this work to serve a specific agenda. This work is part of an ongoing series in which she is attempting an examination of the concept of the skin as the container of identity, and therefore suggesting that the skin is like a costume. Its sight and site are seen as signs of categories of individuals whose experiences and identities will be suppressed and of individuals who can generate interpretation, as personal entity and aesthetic form. The skin is perceived to be the parameter of agency allowing the male to be the active subject who projects the female as object. The quoted image of Marsyas, hung to be flayed, is painted in the full-bodied tones reminiscent of Titian's signature work. "In Titian's hands, the possibilities of oil technique—rich creamy highlights, deep, dark tones that are yet transparent and delicately modulated—now are fully realized; the separate brush strokes, hardly visible before become increasingly free" (Janson 437). This quotation from the most widely used survey of art history textbook gives us a sense of the colour, tonal range, and type of brush stroke that Butler re-enacts. We should also note that her use of Titian's title re-enacts the manner in which he invoked references to a classical myth, and so can be seen as yet another link in the chain of authority and meaning constructed in the history of western European art.

Butler uses the titled reference to flaying, the removal of Marsyas's skin, to imply a violent and dramatic event. Thus, she is able to maintain the reference to the body as a means of conceptualizing identity without becoming complicit in a depiction of such a brutal spectacle. The title refers to the act of removing the skin, and to the myth which is emblematic of the concept that appearance is the surface covering individual personal identity, however that might be construed in various historical contexts.

To the lower right of Marsyas is a drawing of a seated female figure, lines scraped and etched into a thick skin of flesh-coloured paint. The delineated external head form is split and peeled back to mid-chest to reveal a more well-defined frontal inner portrait, the mythic "inner" identity, the specific gendered person. This bisected image is vigorously inscribed into the heavy flesh of the oil paint which conventionally acts

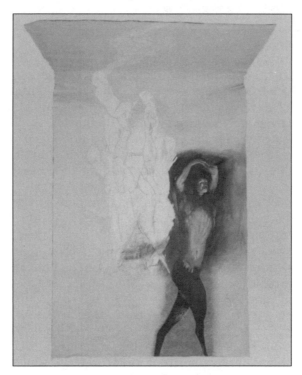

Fig. 5. Sheila Butler, *The Flaying of Marsyas* (1990).
Courtesy of Sheila Butler. Photo by W. Geleynse.

as the skin of the easel painting—the material signature of high, or important, art objects. By invading that skin she disrupts its surface as the sign of high art authority. She uses canvas, the traditional high art ground for oil paint, but chooses to hang the unstretched canvas down the wall and out over the floor. In this way she further implies the canvas's physical and metaphoric role as a flayed, hanging skin, separated from its traditional body form as a stretched and framed easel picture. Emerging from the seated female figure onto the floor is an outline of a baby, which melds into a swimming figure. The canvas and image begin high on the wall in high art tradition and then culminate at the spectator's feet. The heads of the seated figure and Marsyas are at eye-level, and then the bodies descend to the floor. The baby and the implied suspension of the swimmer in water call up connotations of birth, the emergence of skin from skin, and the physical signs of multiple identities, the synchronic and diachronic role assumptions that must complicate art practices.[12]

This work confronts the viewer with the task of reading the implied body of the artist through the body of the art work, the painting, in order to place and displace it in the context of patriarchal Western painting practices. The gendered identity of appearance of the female artist's

body thus enters the system whereby its physical form, skin and flesh, are recognized as biologically constructed. Since this entrance still reads as strange, or unfamiliar, that gendered body exposes the continuing cultural construction of the female as feminine and thereby an object of vision rather than the active masculine agent who is "naturally" the artist-subject who envisions the female object.

In addition, Butler plays on assumptions about technique and skill that lead us to continue to value painting above drawing. Modernist art practices still direct us to value paintings as complete and unified aesthetic objects with "universal" qualities. Drawings, often called sketches, are seen merely as preliminary to paintings. They are records of immediate perception, preliminary drafts or outlines of an image or concept. This work, *The Flaying of Marsyas,* can be seen to be not only dismantling projected male artist identity codes, but also literally exposing the body of the material art object, or the method of its embodiment.

Allyson Clay is another Canadian artist who has used citations of historical art monuments in her exploration of textual and pictorial narrative. In the works *Paper Boats* and *Encounter* from "Traces..." of 1990, she has bolted together two panels to form a diptych, a work made up of two adjoining painted panels. "Images of skies from famous paintings are painted on the right hand panel and decorative architectural surfaces are painted on the left. Texts, or small stories, are silkscreened onto one or both panels."[13] The artist has commissioned the preparation of the surface finishes on the left from a commercial decorating firm. Those finishes were chosen from a repertoire of *faux antique* looks that can be applied to, and disguise, a variety of architectural interior surfaces. The skies on the right also have an indeterminate historical look about them, as they emulate the atmospheric styles in "great" paintings. Over the patina of time implied by these surfaces Clay has printed, with the glaring clarity of contemporary silkscreen technology, short texts that carry an overload of the personal and the present. The assumed "universal" meanings attributed to the value of the historical monument are overlaid with the banality of the everyday anecdote.

In recent years, Clay has employed the distanced tone of lists of directions or recipes in guide works and books designed to lead the reader through the execution of a painting, the proper preparation of a ground for painting, or the performance of movements through space as a frame to enclose personal, poetic, emotional, sensual words and phrases associated with the instinctive, non-rational categories commonly associated with the feminine sensibility. These inserted im-

Fig. 6. Allyson Clay, *#2* (performance for one person in any interior space from loci, 1990).
Courtesy of Allyson Clay. Photo by W. Geleynse.

proper voices rupture that veneer of objectivity, the descriptions of how to literally make a painting that parodies the legacy of modernism in Canada. The words used in the descriptions are synonyms of mastery: words like "command," "control," "direct," "govern," "dominate," "manage," "regulate," "rule." They form the visually apparent, perceptually repeatable appearance of the painted and written works as in this excerpt from PROJECT: #2 (performance for one person in any interior space), from loci (Fig. 6).[14]

The sequence of visual details that read as "objective" descriptors of the ordered, the logical, the rational system, and that stand in for the recorded genealogy of art as monument and technique is abruptly contradicted by the insistent confusion of gendered voices contaminating the rationally "pure and sublime" ground of the art object. All the voice-overs are implicitly female in tone, content, and form. Thus, the authority of the author and the artist and our assumptions of proper pictorial decorum are disrupted. In this case, Clay is employing work that does not contain its own meaning, but that exposes the ways order is imposed by the critical context, the social and political structures of contemporary cultural industry.

Many other Canadian women artists' practices, like those of Joanne Tod, Betty Goodwin, and Jamelie Hassan, should be considered. They have successfully employed other strategies of appropriation to subvert traditional Eurocentric orders of quality, proper identity, and content. However, in the interest of brevity, I will conclude this essay with a description of the practice I know best: my own.

As an artist whose education occurred in a period and place of high modernist values in western Canada, I have long been aware of the ways that artists in Canada have looked to other cultures and disciplines for benchmarks and stable standards in a rapidly changing culture. In *Masterpieces of Canadian Art from the National Gallery of Canada*, author David Burnett states in the introduction, "My selection was based partly on the contribution that individual artists have made to art in Canada. Lucius O'Brien or William Raphael, for instance, would not rank as innovative if weighed in a European context, but their achievements in setting standards and giving direction to art in Canada were most substantial."[15] Although the statement can be interpreted as a positive affirmation of Canadian experience, it might also reflect the history of Canadian art as that of colonials imitating the master styles or discourses of British and French art. Although the population of Canada is now derived from the Americas, Asia, Africa, eastern and western Europe, we still look to western Europe as the seat of civilization. America, especially New York, provides the model for art professionalism, or financial success, but critical success and control of meaning, even if covert, reside in western European models. And the influx of theoretical models, the mantle of smart art, has done little to disrupt assumptions of gender and location embedded in judgements about the quality of art works.

Although many feminist theorists and artists have argued that high art, especially painting and sculpture, is by its very nature patriarchal and invested with hierarchies of power and exclusion, many Canadian women artists have been concerned that such arguments leave the field unchallenged.

> Feminism will always be disabled by the principal terms of modernist art history: its formalism and ahistoricism, its reverence for the avant-garde and the individual artist hero, its concept of art as individual expression or social reflection, its sense of itself as objective and disinterested, its pursuit of universal values at once transcendent (of mundane social realities) and intrinsic (to the autonomous work of art, severed from the social circumstances of its production and circulation).[16]

Since I was confronted by a personal and cultural legacy of male master models, it seemed appropriate if not prudent to see if the mantle of the traditional medium of painting, coupled with the overt strategy of the artist's self-portrait might allow me to "see" my place as a Canadian and as a woman. If the assumption of the gestures and narratives of the masters by the wrong body could reveal the pose of authority, might it allow dismantling and dispersal of systems of

Fig. 7. Alice Mansell, *Cultured Identities* (1991).
Photo by W. Geleynse.

exclusion? And might we, as representatives of differing race, ethnic, and class identities in Canada, collaborate in such a way as to allow collective, individual, and partial identities to be valued for what they are, rather than for what they can emulate?

I don't believe that individual works and practices can change society. But each little incursion may allow a few viewers to read the ways that the meanings and powers of images form and deform how we see ourselves. For a recent exhibition, called "Cultured Identities," I produced seven paintings framed as doorways to signify seven ways out of the gallery, and the conundrum of the weight of Western art history. As such they frame questions about appearances that are commonly read as identity categories. All works overtly quoted image and gesture from the masters: Ingres, Courbet, Dekooning, Warhol, Beckmann, and Beuys. By re-enacting the compositions, narratives, and materials of the originals through the texts of feminist theories, I was able to experience and explore the sites of discomfort entailed in assuming each costume, each role, each material gesture of the masculine artist identity as it was constructed in their works. For example, while painting the last work of this group, also titled *Cultured*

Identities, I appropriated a part of one of my own discards—an old painting of an iris flower, an image of my mother from a photograph I took in 1972, and a self-portrait image from the 1930s by Max Beckmann, the German expressionist painter referred to earlier. In most of the other works references were made to male artists and implied masculine depiction models. In this work, after posing the image of my mother next to Beckmann, it became evident that the role of the artist could be seen to be performed by either of the two workers depicted. Max Beckmann was defined by his signature colour and brush work and mirrored to himself as he made his own image, and recognized as agent of his own identity as the master-artist. His place next to the woman, of uncertain ethnicity, intently cutting the fabric/canvas covered with irises throws into question the proper name/identity for each worker. Is her work with colour and form just work, or is it art? How has the medium of oil paint on canvas/fabric as I have used it, both as material to construct the work and as a reference to the Beckmann monuments, been the material site of its identity as art? The inclusion of flowers in the door frame provided a different class and cultural model of decoration wherein simplicity, coherence, and unity are not valorized as they are in Western high art objects. The indeterminacy of role of the depicted and the depiction should allow the viewer to find a space to assess her/his own cultural perspective, and to prompt questions about the ways visible characteristics are read as the signs of categories of stable identity. Thus, such an art form becomes, as Mary Kelly stated, not only a cultural practice defined by its own beauty as visual object, but also a construction and reflection of meanings that surround and give rise to it, and to us.

Alice Mansell is a practising artist and writer who uses text, drawing, painting, photography, and video. She is presently Professor and Chair of the Department of Visual Arts at the University of Western Ontario. Her studio and critical practices are directed toward exposing and exploring the ways gender, national origin, race, and ethnicity play into the traces of the artist, and form her or his identity and authority in contemporary Canadian context. She has exhibited and published works in Canada, the United States, and Germany. Marsha Hanen's sound professional advice and personal support at an especially crucial time in her tenure in the art department at the University of Calgary allowed her to pursue her critical art practices with the confidence they have required. Marsha's own academic achievements, coupled with integrity and an unflagging support for feminist politics in private and public life, continue to be an inspiration to many women.

Notes

1 The reference term "surtext" was prompted by the practice of projecting the translated text above the stage in performances of Italian or German opera in North America. Such a literal and figurative elevation of the "text" seems to privilege the written text as the key to meaning over gesture, tableau, emphasis, pace, and costume, all the auditory and visual elements of the works.

2 Baudrillard, *The Implosion of Meaning in the Media*, qtd. in Bruce Grenville, "Active Surplus: the economy of the object," *Active Surplus* (Toronto: The Power Plant, 1988): 20.

3 R. Barthes, "From Work to Text", trans. S. Heath *Image/Music/Text* (New York: The Noonday Press, 1977) 163.

4 Craig Owens, "The Allegorical Impulse: Toward a Theory of Postmodernism," *Art After Modernism: Rethinking Representation*, ed. Brian Wallis (New York: New Museum of Contemporary Art, 1984) 221–23.

5 H. W. Janson, *History of Art*, 2nd ed. (New York: Abrams, 1977) 586.

6 Cultural theorists like Trinh Minh-ha in *Women, Native, Other: Writing Postcoloniality and Feminism* (Indianapolis: Indiana UP, 1989), question the male-as-norm, and the ways that women and non-Europeans are identified as other-than-the norm.

7 Eve Sedgewick in *Between Men: English Literature and Male Homosocial Desire* (New York: Columbia UP, 1985), describes the primacy of the relationships between men which is first social and then sexual.

8 In *Art and Sexual Politics*, eds. T. Hess and E. Baker (Toronto: Macmillan, 1973), Linda Nochlin in her landmark essay "Why have there been no great women artists?" discusses the systemic biases in education and cultural institutions which have excluded women and their work.

9 David Henry Hwang, *M. Butterfly* (New York: New American Library, 1989), II.vii.

10 Marie Fleming, "Joyce Wieland," *Joyce Wieland* (Toronto: Art Gallery of Ontario, 1987) 97–98.

11 See Jay Scott, "Full Circle, True Patriot Womanhood: The 30-year Passage of Joyce Wieland," *Canadian Art* 4.1 (Spring 1987): 56–63. Scott describes Wieland's career as the outsider, always claiming an intuitive process while resolutely acknowledging her location and perspective as the political situation of her gender, her nationalism, and her personal experience.

12 "The term 'art practices' puts process back into art production in contrast to a critical framework which overvalues the art object itself" (Mary Kelly, "Re-Viewing Modernist Criticism," *Screen* 22.3 [1981]: 58).

13 From a short description of "Projects since 1988" prepared by the artist.

14 Allyson Clay, PROJECT: #2 (performance for one person in any interior space), from loci, *Front: Vancouver's Inter-arts Magazine* (Jan. 1990): 12–13.

15 David Burnett, *Masterpieces of Canadian Art from the National Gallery of Canada* (Edmonton: Hurtig, 1990) ix.

16 Lisa Tickner, "Feminism, Art History and Sexual Difference," *Genders* 3 (1988): 94.

10

Women in Music: Is There a Difference?
Variations on the Theme of Gender in Music

Marcia J. Epstein

Prelude

Recent scholarship on the arts has revealed a "women's subculture" in such areas as literature, visual arts, and dance. There has been considerable resistance, however, to raising the issue of gender and applying the methods of feminist criticism to music. The main objection raised is that music, as a non-representational and non-verbal abstraction, is not definable by terms referring to gender. Music simply *is*, depending on nothing but its own internal rules to communicate its meaning, which may be largely dependent on individual listener response.

The traditional attitude is only now being questioned by a new generation of critics whose work has excited controversy.[1] This chapter is an exploration of some of the issues raised by gender-based (often feminist) analysis of "classical" music (here called by its more accurate title of "art music") with brief excursions into the culture of contemporary popular music. It does not present definitive answers to the question posed by the title, nor to any of the others raised within the text, among which is a consideration of whether there is anything in music that can be called a feminist or feminine style—any particular devices or techniques that are more likely to be used by women composers than by men. Think of it as a set of variations on the theme of gender in music.

The musical form called "Theme and Variations" is a venerable one, having its roots in the sixteenth century and becoming increasingly popular in the eighteenth and nineteenth. It is still used frequently as a means of structuring a piece of instrumental music, usually for a solo instrument such as the piano. The composer first defines a theme, a discrete section of music that makes sense within the rhetorical structures of melody, harmony, and rhythm. It is often an easily remembered melody, simply stated and carrying a certain charm for

the listener, like the tune of a popular song. The composer then subjects the theme to various modifications, playing it faster or slower, changing the rhythm or harmony, ornamenting it with frills and trills and tendrils. The original basic theme may return at the end, in a recapitulation section. This is a map of the form.[2] This chapter follows the same plan, enabling you as reader to follow the experience of a listener, and thus to approximate one of the possible structures of musical composition.

<div align="center">THEME</div>

What is the meaning of gender in music? Can attributes of masculine and feminine identity be applied to music, or is their attribution simply a game intellectuals play without reference to the intentions of composers? If the attributions are valid, are they consciously applied by composers, or do the qualities associated with gender flourish unrecognized, waiting for critics to decode them? Is there any such thing as *inherently* gendered music, apart from conscious efforts by composers to produce it? These and other related questions form a complex web that threatens to entrap the unwary critic. Strong opinions can be found on both sides of any given question, and truth seems at times to reside in the eye—or ear—of the beholder. When the conflicts are set in balance and the unanswerables are set aside, two theories emerge as potential maps of the territory. The first interprets the visualization of Western music as a clue to its domination by male paradigms; the second regards the structures of its most prominent forms as essentially male patterns of conflict and resolution. A brief examination of each is included here as a tool for defining the problem.

<div align="center">MUSIC AS VISUAL ART</div>

In an article titled "Music and Male Hegemony," musicologist John Shepherd presents the provocative thesis that the development of Western classical music as a *visual* art is a male paradigm.[3] To Shepherd, the visualization and resulting abstraction of music is a product of the eighteenth-century European Enlightenment period, when human nature was seen as a series of opposites: mind and body, reason and emotion, male and female, eye and ear. The mind, reason, and the eye (which has the capacity to measure the external world) were associated with the male gender. The body, emotion (with its attendant risk of dangerous irrationality), and the ear (which cannot measure, but can evoke perilous emotion) were the domain of the female. Music, he argues, was removed from the realm of the female (emotional ecstasy, frenzy, sensuality, dancing) by means of rationalizing princi-

ples: irrevocable rules of composition and increasing reliance on visual scores.

In order to place Shepherd's theory in context, a brief account of the function of notation in Western art music may prove useful. To performers in this tradition, the score—the written roadmap of the music—is the final arbiter for most decisions of interpretation. While some performers and conductors elect to add elements not indicated in the score, or ignore some that are called for, the main task of a musician is to follow the composer's intentions as conveyed by visual symbols. This stands in stark contrast to most non-Western cultures, where even the most intricate art music is taught "by ear," and the systems of notation (if any) are vague by Western standards, intended to jog the memory for a piece already known. The notion of learning a piece for the first time through a set of visual symbols, with no reference to sound, would strike musicians from India or the Orient as absurd.

Western music was given its first known visual mapping by monks in the ninth century who sought to provide their communities with mnemonic devices for the music of their worship services. The indications were necessary because some items of Christian liturgical chant, which became increasingly complex at this time, are performed only once in a year, and the singers might not be expected to remember them. Notation was developed and refined into a loosely standardized system with regional variants by the twelfth century, and included most of the elements in use today by the fifteenth century. The forms used were not identical to modern ones, but the parameters chosen for emphasis—pitch and duration of notes, meter, correlation of notes with syllables of text, coordination of diverse strands in the musical texture, indications of when to start and when to stop—were the same ones in modern usage. Some variables—speed, phrasing, and sometimes instrumentation—were left longer to the choice and skill of performers. By the eighteenth century, further codification of notation was linked with greater reliance on codified rules of composition.[4]

European art music, rising from a culture devoted to scientific inquiry, was given an aura of rational objectivity: it was the way it was because that was the most "natural", the most "logical" way. In the words of one influential composer and theorist of the eighteenth century, the rules of harmony are presented as *a priori* truths:

> Music is a science which ought to have certain rules; these rules ought to be derived from self-evident principle; and this principle can scarcely be known to us without the help of mathematics.[5]

This insistence on rationalism in connection with the art form most closely linked to emotional affect is a heritage of the eighteenth century that has been carried forward to the present time. Its association with what Shepherd regards as masculine attitudes, as well as European ethnocentrism, is perhaps the source of present-day concern with the cultural influences of gender.

Music as Battleground

A second area of Western art music in which the influence of "male" paradigms may be found is that of structure. Since the eighteenth century, musical structure has been based on the principles of tonal harmony and on musical forms analogous to oratory and narrative: they begin with a clear thematic statement in the home key, progress through a series of conflicts, ambiguities, and digressions into other keys, and end with a resolution in the home key. Like the errant prince in a folktale, the musical theme returns home having conquered a host of temptations and distractions. Like the hero, it is always victorious: the music sounds unfinished until the theme comes home. This structure dominated the composition of Western music in the late eighteenth through nineteenth centuries. It is still influential, and even now no composer can graduate to the ranks of the first-rate (or of any professional status) without demonstrating a mastery of it.

European solutions to the problem of musical form have long been regarded as superior by Western critics and historians. How could music be written without the drama inherent in hierarchically structured forms?[6] The first cracks in the monolith appeared with the work of ethnomusicologists, who began to regard music as a culturally determined form of expression and saw the Western structures as part of a larger spectrum. Feminist critic and musicologist Susan McClary, among others, now interprets European art music as a male paradigm that turns music into a battle between victor and vanquished, or—metaphorically—between male and female, with traditional attributes of each gender mapped onto the relationship of melodic themes within a piece of music (7–23).

Essential to many of the most frequently and intricately developed narrative musical structures is a dialogue (or conflict) between the "first" or "main" melodic theme and the "second" theme. It is often the role of the second theme to draw attention away from the first, to divert it into wandering, and to present a contrast that complements it. The attribute of femininity has thus been mapped onto it, particularly when the second theme is softer, more lyrical, than the first, as was often the case in music written before the twentieth century. Since the first

theme is always the one on which narrative closure depends, its triumph at the end of the piece is inevitable. Any other solution would derail the piece, leaving it unfinished and unsatisfying. In the orchestral works of the Baroque period (seventeenth and early eighteenth centuries) the two themes often complement each other, leading merry chases in witty dialogue, functioning in gendered terms as a courtship in which closure is achieved by the female accepting the terms of the male, no longer holding out for independence. By the end of the eighteenth century and through the nineteenth, according to McClary's analysis, the two themes are more often in conflict, with the female aggressively attempting to distract and subvert the male through strange and dissonant digressions, and the male insisting on a return to the orderly world of the home key. In this interpretation, the dissonance of the second theme represents the frenzied, irrational, emotional realm of the female, which is conquered (destroyed or tamed) by the ordered, predictable, insistent rationality of the masculine first theme. The musical rhetoric of the seventeenth through nineteenth centuries, the formative period for Western art music, is thus seen by McClary as a symbolic representation of the tensions inherent in Western society: competition, aggression, and gender conflict.

If Western art music is today regarded by many as remote and elitist, it is perhaps because of the inflexible heritage of European rationalism. Tied to a visualized rhetoric and to an aesthetic of dichotomy and conflict, art music doesn't "swing." The association of popular genres in music with underclass subcultures (Blacks, American Hispanics, rural and urban drifters) is no accident. These groups, excluded from the rationality of the European heritage, developed a looser music based on the ear and on oral culture, with room for "swing" and for dancing. It is characterized by improvisation (jazz), by repetitive refrain structures (pop and country), and by emotional appeal. "High culture" music is still divided from "low culture" music, with the former given the attributes of rationality and normative status (masculine), while the latter is regarded as seductive and deviant (feminine).[7]

Where, then, do actual women fit? Historically, they were often excluded from the creation, and sometimes the performance, of high culture music. There were, however, a few women who succeeded as composers in each of the stylistic eras of art music.[8] Often they were the daughters, wives, or sisters of male composers; sometimes they were prominent performers who launched into writing their own material. In the history of popular culture, women played important roles as performers and presumably as creative artists. Their identity as performers was always suspect, however: from ancient Greece and

Egypt through the early twentieth century, women musicians, dancers, and actresses were associated with prostitution and scorned by the "respectable" populace. Displaying the female body on stage was a suspect activity, believed to incite otherwise rational male spectators to unseemly thoughts and actions.

The realm of art music was kept pure, protected from all but the rarest presence of women, by two factors: the exclusion of women from academic music theory and scholarship, which determined aesthetic policy, and their relegation to domestic life, which confined them to amateur status. Male dominance of the academic discipline of music entrenched what might be called the "androcentric ear"—the assumption that the structures and solutions devised throughout history by male composers were normative, and were in fact the only possible solutions. Association of women with domestic music-making kept them from developing the skills and the rigorously self-critical attitudes essential to professional performance, to composition, and to analytical overviews of the art of music. Until well into the twentieth century, high culture music was a man's world, comparable to mathematics or philosophy.

And so we arrive at the second half of the twentieth century: the crash of falling barriers is heard in the land, and the old restrictions no longer hold. Women are studying composition in universities, receiving major commissions, and being included in textbooks on contemporary music. No history of Canadian music would be complete without Violet Archer, Norma Beecroft, Jean Coulthard, Barbara Pentland. Increasingly, composition is becoming a gender-neutral domain. Or is it? What follows is a series of explorations probing the question from different perspectives.

VARIATION 1: "MUSIC IS BEYOND SUCH DISTINCTIONS"

The history of music, like that of other art forms in the Western world, has until recently been a chronicle of Great Men. Music differs from the other arts, however, in that its content has traditionally been regarded as too abstract for the kind of sociological analysis applied to other areas: while songs carry social meaning through their lyrics, instrumental music is seen by traditional critics and historians as "pure" music, as remote from social context as "pure" mathematics.

> Unlike literature or the plastic arts, which generally speaking cannot be understood apart from the designative symbols they employ, most musical experience is meaningful without any reference to the extramusical world. Whether a piece of music arouses connotations depends to a great

extent upon the presence of cues, either musical or extramusical, which tend to activate connotative responses.[9]

As a response to the assumption of abstract purity, feminist critics are now attempting to analyze music in terms of its socio-historical context, regarding each style as a product of its culture, including political structures, class relations, interaction with neighbouring territories or subcultures, and gender relations. An example is McClary's refutation of the notion that the exclusion of women from composing was an accident of history, based on such factors as women's lack of technical training or preoccupation with domestic responsibilities.

Women have, of course, been discouraged from writing or painting as well, and feminist scholars in literary and art history have already made the barriers hindering women in those areas familiar. But there are additional factors that still make female participation in music riskier than in either literature or the visual arts. First, the charismatic performance of one's music is often crucial to its promotion and transmission.... Second, musical discourse has been carefully guarded from female participation in part because of its ability to articulate patterns of desire. Music is an extremely powerful medium, all the more so because most listeners have little rational control over the way it influences them. The mind/body split that has plagued Western culture for centuries shows up most paradoxically in attitudes toward music: the most cerebral, nonmaterial of media is at the same time the medium most capable of engaging the body. This confusion over whether music belongs with mind or with body is intensified when the fundamental binary opposition of masculine/feminine is mapped onto it. To the very large extent that mind is defined as masculine and body as feminine in Western culture, music is always in danger of being perceived as a feminine (or effeminate) enterprise altogether. And one of the means of asserting masculine control over the medium is by denying the very possibility of participation by women. For how can an enterprise be feminine if actual women are excluded? (151–52)

The relation of women to the realm of professional Western art music is thus seen by feminist critics as having been under male control throughout much of history. This assessment directly challenges the notion that music is not conducive to gender-based analysis, and that the exclusion of women from the profession of composing resulted *de facto* from their lack of professional training. The historical validity of the feminist analysis is plausible, given the fact that women have not, until the twentieth century, been numerous among the ranks of

composers. The problem of access to professional training may, of course, be seen as part of the larger pattern of exclusion in historical terms. At the present time, however, it is not usually perceived as a barrier. Professional composers who are women are no longer a rarity. How, then, do they regard the question of gender in music?

VARIATION 2: "DON'T CALL *ME* A WOMAN COMPOSER!"

Resistance to the concept of gender-consciousness in music appears to come not only from theorists and historians of traditional bent, but also from within the ranks of composers who feel that their work must be judged according to abstract universal standards of value rather than culturally influenced norms. The notion of having an adjective expressing gender, regional identity, or ethnic background attached to their names is seen as an undesirable limitation that may compromise their status in the historical community of creators. This is, perhaps, particularly true of women who make a profession of composing.

In a letter sent to women members of the Canadian Music Society, an organization for recognized professional composers, I posed a series of questions relating to issues of gender in music (see Appendix). Of ten respondents, seven regarded gender as irrelevant to music, and stated that masculine and feminine qualities were either non-existent or were purely stylistic, and unrelated to the gender of the composer.

> Sometimes clichés are formed as to a style of music, perhaps obviously expressed by calling soft gentle melodies feminine and hard driving rhythms with large brassy orchestrations masculine. I don't think these characteristics are a result of the composer, but are mainly the result of association [with] a sex in general. A male composer can write the gentlest of lullabies while a woman can write with so-called masculine rhythmic vitality.[10]

The question of gender was seen by some respondents in this group as something significant in historical terms, but not particularly relevant to their own work or to that of other present-day composers. Some ambivalence was expressed, however, on the related issue of career advancement:

> When I write music, I do not think in terms of male/female. I catch a star and try to make it mine before it/he/she/ disappears from my mind.... I feel gender-consciousness throws music and musicians into encampments.... In the light of history, I do feel that women have been discouraged from creative art in general. Universities and conservatories still are filled with and chaired by men. But this is slowly changing, thank goodness.[11]

My main response is that the question of gender is unimportant, and I can only assume that so much attention is being paid to the question by virtue of the raised consciousness of women's rights.... The truth of the matter is that if one is compelled to follow a certain, perhaps inescapable path, the challenges are always difficult and success is elusive, and it all requires hard work and, hopefully, a modicum of talent. This [is] not peculiar to either male or female, or variations in between. There is no such thing as feminine music or masculine music to my mind, there is music—good music, mediocre music, and bad music, and those who call themselves composers in the latter two categories should step aside (although they are for the most part not to be discouraged). Even what is "good" music is a major question, as this is primarily determined today by subjective viewpoints.[12]

This attitude is also held by one of the pioneering figures in Canadian composition, Violet Archer, whose career as a musician began in the 1930s.

I'm interested in having a chance to judge whether there *is* a difference: I don't think there is in our time. Perhaps there was in the early part of our century. I don't think my work sounds like "women's music": what is that? Is there a clear definition? In Clara Schumann's time, women were not considered capable of writing music. Ethel Smythe's teacher showed some of her music to Brahms, but couldn't tell him it was by a woman. She had a hard time—was regarded as a freak. It took a long time to convince people that women could write music. But that has changed.... From my own experience, women are regarded with respect in what has been a man's world.... When I write, I want it to be music *as* music, not female music. I don't even know what that is.[13]

Another respondent expressed her disagreement with the potential for divisiveness, which she saw as a result of gender-consciousness:

To me, music is a unifier (creating new wholenesses) rather than a divider. While I am a woman composer, and experience life as a woman, and like women, I feel no animosity to the men composers I like and respect. I fear for women composers when I hear them ganging up on men composers.... We can help appreciate each other and support each other humanly and musically, but I recoil at feminist notions such as "Let's get men to play our works; make them our servants for a change." Let music *unite*! (S. Richard)

The opinion held by many women active in the field of composition in Canada today, then, is that there is no particular difference between their music and that written by men. Any perceived distinctions, which

seem to be matters pertaining to career opportunities rather than actual stylistic distinctions in the music, are regarded as being historical rather than contemporary. Some see associations for women composers as being effective and even necessary, however, in helping to overcome the career handicaps that women may face even today.

> Contemporary composers have to wait a long time to get performances. Conductors and performers have to be convinced. The management doesn't want to lose an audience. These societies provide opportunities for performance, it's one of their goals to make women's music heard (Archer).

Thus, "women's music" is often perceived by those who write it as belonging to women only because it happens to be written by them. If women composers band together in organizations to promote each other's works, they may be viewed as having a professional disadvantage (because such organizations are necessary), or as having an advantage over men, since they can join both women's and mixed organizations. In no case, however, is the woman composer ignorant of music written by men: her entire training is accomplished through reference to earlier historical styles, and many if not all of her teachers are men. For this reason, some critics of the present time feel that the picture is incomplete.

Variation 3: "We can't read the map yet"

Suppose that you, at your present age, are given the task of inventing a language. You may borrow a few elements of grammar and vocabulary from your native language, but the large structural components and most of the vocabulary must be recalled from a vague Jungian collective memory of prehistoric dialects mixed with new words of your own coinage. This is the approximate task faced by women composers who search for a style that is not imitative of traditional structures.

One respondent to the survey questions observed that it may be too early to judge the line along which gender divisions may eventually be drawn:

> As far as style goes, I believe that it is far too early to be able to detect any patterns in the compositions of women composers. Present day women composers have heard compositions by men from all time periods almost exclusively during their childhood and, more intensively, during higher education in music. As well, they are inundated by this music on a day-to-day basis through broadcasts. Also, a large majority of present day women composers have had male composers as their teachers in composition.... Surely, this kind of environment would tend to colour

women's compositions to some extent. Perhaps, when the next genera-tion or the one after that has had an opportunity to perform and hear the music of and study with the present-day women composers, women will be freer to compose without such a strong male influence; it is difficult to predict if we will find a difference between the music of male and female composers at that time.[14]

The question of inherence appears to be crucial in defining the parameters of "feminine" or "feminist" musical style. No inherent differences can—as yet—be recognized as factors that distinguish the work of women from that of men. Defining feminine style as lyrical and masculine style as forceful would, for example, place much of Violet Archer's work in the masculine category. Clearly, such distinctions are too simplistic to be entirely valid, and the question remains: are there any distinct musical elements associated with the work of women composers?

VARIATION 4: "SISTERS ARE OUT THERE DOING IT"

If the search for inherence is left in abeyance, attention falls on a small repertoire of works by present-day women who continue to experiment with intentionally feminine approaches to music. Along with these works of art music is a growing genre of popular women's music, complete with its own market-niche and recording studios. It merits a brief examination before returning to the realm of art music.

Among the many lines drawn between art music and popular music is the one delineating feminist content. Women's music in the popular field is distinguished by texts rather than musical content, but its creators, listeners, and—especially—marketers regard it as a distinct genre. Songwriters and performers, who are often the same person, may characterize themselves as feminists or as lesbians and aim their work primarily at an audience of women. Others direct their appeal to a general audience. Song texts, in addition to love lyrics and songs with political content unrelated to gender, may deal with such issues as birth, childhood (especially the experiences of girls), child abuse, rape, battering of women, single motherhood, and recovery from assault or abuse. Musical settings cover a range of styles from folk ballads to jazz to blues to rock in its many guises, and do not in general differ from the music of male songwriters. Arrangements and performance styles, however, tend toward a clearer, less "raunchy" sound than that promoted by some male singers of hard rock, although some female performers may parody the aggressive extremes of male style as a way to emphasize gender stereotypes.[15]

The question of inherent gender differences in women's music, then,

must remain unresolved for both art music and popular music. If the expectation of inherence is removed, however, a path is opened for the exploration of conscious attempts to create a feminist aesthetic in music. Such attempts may be approached by isolating the stylistic elements perceived as masculine and reversing, altering, or creating alternatives to them. An example of alternative paradigms can be seen in the work of American composer Janika Vandervelde, whose composition titled *Genesis II* is cited by McClary. Vandervelde's decision to examine and circumvent the elements she perceived as masculine in her musical training resulted in a series of works that feature elements crafted to portray feminine concerns.

> *Genesis II* opens with what Vandervelde intends as a musical image of childbirth: the pulsation of a fetal heartbeat, the intensifying strains of labour, and the sudden emergence into a fresh and calm new world.... The fresh new world that comes into being as a result of this prologue contains two kinds of music, each organizing time in a different way. On the one hand, we are presented with a minimalistic "clockwork" pattern in the piano: a pattern that repeats cyclically but which, because it is internally marked by asymmetries of rhythm and pitch, is endlessly fascinating—almost like the facets of a crystal that seems to change with each turn. It creates a sense of existence *in* time that is stable, ordered, yet "timeless."... And on the other hand, we have the string parts in the ensemble. Once past the first section, in which they coexist peaceably with the clockwork, they present us with the goal-oriented gestures of self-expression and striving that typically characterize Western concert music. (McClary, 116–18)

In interpreting the piece, McClary cites the reaction of her students to hearing it, noting a difference between the responses of women, who found the stable opening section familiar and the entrance of the strings intrusive, and those of men, who were impatient with the initial stability and relieved by the activity of the string parts (124). Whether these responses are universal or not, the composer seems to have made a statement about differences (whether real or metaphorical) in the ways that women and men perceive the world. In this light, she represents a small but growing number of composers exploring the issue of gender in music.

VARIATION 5: CONFESSIONS OF A COMPOSER

It is here, gentle reader, that I throw off the cloak of the analytical observer and stand revealed for what I am—a participant in the controversy. Throughout the spring and summer of 1991 I was at work on a conscious attempt at feminist composition: a choral liturgy of God

the Mother, titled *Laudes Matris*. A brief description of its genesis may serve here to exemplify the process of composing a gendered piece of art music.

The project was inspired in part by my long-term interest in the traditional spiritual practices of women in various ancient cultures. I chose texts from a variety of scriptural traditions—Sumerian, Gnostic, Buddhist; one excerpt from the work of the medieval woman theologian Julian of Norwich; and one contemporary text. All refer either to ancient goddesses in various aspects, or to the Judeo-Christian God as Mother. One aspect of the work's "feminism" was based on the imagery of its texts, which, when edited and arranged in five separate sections, assumed a form resembling the traditional Catholic mass. The notion of a liturgy was thus confirmed by the form as well as the content of textual materials. How, then, to underscore its feminine aspect through music? One answer lay in the use of paradigm reversal.

The use of conscious paradigm reversal presumes identification of the paradigms to be reversed. I selected the following musical conventions for alteration:

1. Tonal rhetoric, the assumption that any given chord (three or more notes played or sung simultaneously, producing either consonance or dissonance) will lead by the rules of traditional tonal harmony to another specific chord, producing a sense of linear progression. It is somewhat analogous to the arrangement of words in a sentence and sentences in a prose paragraph: syntax, as well as content, conveys meaning. My decision to change this aspect resulted in musical structures analogous to stream-of-consciousness technique in literature, in which each word or phrase leads to a complex network of associated images, concepts, or homologous words.[16] Although tonal ambiguities are not gender-related—they have occurred throughout the works of twentieth-century composers of both genders in a variety of contexts—they serve the purpose of avoiding the narrative implications of traditional tonality.[17]

2. Narrative closure, the assertion of a specific home key at the end of a piece in order to make it sound finished. In some cases, the tonal ambiguity of *Laudes Matris* is emphasized by ending each section in either a complex chord that spans more than one tonal area, or a very sparse one that eludes identification with a particular key. I also employed the late medieval method of building harmonies on melodic progressions rather than harmonic ones. This technique contributed both an "ancient" quality

and a harmonic logic that avoids hierarchy, since each vocal line functions as an independent melody in some sections of the piece, rather than acting as harmonic support for a principal melody.

3. The tradition in choral writing of ending a piece with a full choral texture (all voices active, producing a "grand finale" conclusion). The conclusion of *Laudes Matris* changes abruptly from full choir to a contralto soloist singing in low register, a musical anticlimax underscoring a textual climax in which the listener is implored to remember the presence of the mother-goddess. It is intended to create the impression that the piece continues even after silence has fallen, an illustration of the act of remembering and a negation of linear narrative conventions in music.

Another solution to the problem of how to write women's music involved the use of musical techniques derived from ethnic practices particular to women in societies where the performance of music is gender-specific. The most prominent of these, to audiences accustomed to western European sonorities, is the singing style practised by women in the Balkans, particularly Bulgaria and Macedonia. Two factors are involved: tone production in a low vocal register combined with a somewhat harsh delivery approaching a shout, and harmony that features parallel seconds (notes adjacent to each other on a diatonic scale, which are extremely dissonant when sounded together). This method, which combines the style of peasant music from neighbouring Turkey with the sonorities of the Balkan bagpipe, is traditionally sung by groups of three women: one lead singer and two who produce a drone that clashes and struggles with the principal melody. The effect, to Western ears, is both startling and thrilling, possessed of enormous vitality. It is incorporated at times into the choral work to underscore emphatic points in the text, and it imitates the vital, insistent quality of the Balkan songs. A second ethnic practice is the use of small hand-drums and tambourines of the types played by women in parts of the Middle East and Africa, and among Native cultures of the Americas. They lend to the voices an underlying web of intensity, suggestive of heartbeats, of velocity, and of an intricate perpetual dance. The drums alternate at times with windchimes, an instrument whose delicate sonorities and unpredictable results may represent to listeners the antithesis of rationalized, highly structured Western music.

What I intend with *Laudes Matris* is to evoke the essence of the feminine side of divinity, whether she be called goddess, earth-mother,

or mother-God. The result is not yet apparent, and will no doubt unfold and ripen with time.

<div align="center">RECAPITULATION</div>

The question, then, remains for the present unanswered. Whether one regards it in the first place as a significant question depends on whether one accepts or rejects the premise that there are inherent differences in consciousness, in approach to the world, between men and women. If the question of inherent differences is at this time unanswerable, that of cultural differences remains. Have women been conditioned to compose according to male models of what constitutes good music? Does the music of the Western heritage reflect gender stereotyping traditional to that heritage? Much depends, as well, on one's acceptance or rejection of the concept of mapping gender qualities onto musical styles. Between the opposing camps of acceptors and rejectors lies a vast territory of questions, assumptions, and attitudes. It remains for you, the reader, the listener, to explore.

Marcia Epstein is a cultural historian and musicologist, teaching interdisciplinary Western heritage courses for the Faculty of General Studies, University of Calgary. In another simultaneous incarnation, she is a working composer. Marsha Hanen, who first hired Marcia to work at the Faculty of General Studies in 1987, encouraged her to realize that the two identities did not have to be kept separate, and that she need not envision a fork in the road. Marsha has since been proven right, which is one among many reasons for gratitude.

Appendix

Questionnaire sent to women members of the Canadian Music Society:

1. In your opinion, is there any such thing as "feminine" or "feminist" style in contemporary or traditional classical music? If so, what are its characteristics?
2. Is "feminine" style necessarily limited to women composers, or do you know of men who produce it?
3. Do you have experience of writing music from a woman's perspective? If so, what are your impressions of the process?
4. Do you feel that the question of gender in music is important?
5. Have any additional questions or areas of investigation been raised for you by this topic?

Notes

1 See especially the pioneering work of Susan McClary, *Feminine Endings: Music, Gender, and Society* (Minneapolis: U of Minnesota P, 1991); and Richard Leppert and Susan McClary, eds., *Music and Society: The Politics of Composition, Performance and Reception* (Cambridge: Cambridge UP, 1987).

2 For a clear exposition of the theme and variations form, listen to Mozart's "Variations on *Ah, vous dirai-je, maman*" in C major, K300E [K265].

3 John Shepherd, "Music and male hegemony," in Leppert and McClary 151–72.

4 This is, of course, a vastly simplified history of notation. More complete overviews are provided in a number of standard texts on the history of Western music; e.g., Donald J. Grout, *A History of Western Music*, 4th ed. (New York: Norton, 1988).

5 Jean-Philippe Rameau, *Traité de l'harmonie*, 1722. Excerpted in translation in Oliver Strunk, ed., *Source Readings in Music History* (New York: W. W. Norton, 1950) 566.

6 The association of music with conflict-based narrative is a peculiarly Western concept, as is the primacy of harmonic structures over those of melody and rhythm. The music of India, for example, does not leave its home key, and builds its structures from the interplay of complex melodic improvisations with intricate rhythms. The music of sub-Saharan Africa is based on repetitive rhythmic patterns that sustain interest by overlapping layer upon layer until the listener is forced to create variety by shifting focus from the full texture to individual parts. Dramatic conflict, long seen by Western critics as the only reasonable way to structure music, is in fact a culture-specific solution that tells more about the society of its origin than it does about the nature of music itself.

7 An obvious objection can be raised here: many genres of current popular music display aggressively masculine attitudes, lyrics, and performance styles. The association of popular music in general with feminine attributes is based on the traditional rhetoric of gender. If it seems inadequate to describe late twentieth-century phenomena, it is perhaps because the tradition has been deconstructed and the rules have changed: irrationality is now a recognized potential of both genders. For a discussion of gender issues in the performance of current rock music, see Shepherd (163–71).

8 For a history of women in European music, see Jane Bowers and Judith Tick, eds., *Women Making Music: The Western Art Tradition, 1150–1950* (Urbana: U of Illinois P, 1986).

9 Leonard B. Meyer, *Emotion and Meaning in Music* (Chicago: U of Chicago P, 1956) 264. Meyer himself is one of the founders of the sociological perspective on music; his work represents a reaction to the affect-laden prose of romantic criticism, which persisted well into the twentieth century.

 Among the musical cues that can arouse responses are such factors as tempo (speed), meter (beat), modality (major or minor keys), tone quality, volume, textural density and contrast, and orchestration. The acceptable range of each of these factors can be seen as a function of the culture that produced each successive musical style: thus, for example, orchestras of the industrialized nineteenth century and present-day urban society accept as normal a range of vocal and instrumental tone qualities that would have been considered raucous, rude, or abrasive in Mozart's time.

10 Saskatchewan composer Elizabeth Raum, letter to the author, 14 April 1991.

11 British Columbia composer Sylvia Richard, letter to the author, undated.

12 Ontario composer Norma Beecroft, letter to the author, 11 July 1991.

13 Alberta composer Dr. Violet Archer, interview with the author, 29 August 1991.

14 Ontario composer Nancy Telford, letter to the author, 17 April 1991.

15 For an analysis of vocal timbre as an element of gender characterization in popular music, see Shepherd (163–71).

16 For examples of stream-of-consciousness technique, see especially the novels of James Joyce, *Ulysses* and *Finnegan's Wake*.

17 Pioneering work in the deconstruction of tonality was done by Arnold Schoenberg in the early decades of the twentieth century: his tone-rows were based on numerical, rather than tonal, order.

11

Mrs. E.: A Personal Memoir

MARILYN ENGLE

I am still unable to decide in what way this is significant: whenever I try to consider what made Gladys McKelvie Egbert such a powerful musical and personal influence in the lives of so many of Canada's musicians and music lovers, myself among them, memories force their way to the front of my consciousness. Not at all similar to those that most often fill the pages of books or articles about the dedicated master teacher—what he said about this Beethoven sonata or she about that Chopin scherzo—my memories often seem tangential, even trivial, having more to do with atmosphere than substance. Surely it ought to be easy enough to pluck any number of relevant and inspirational remarks from a cornucopia of recollections of Mrs. Egbert; after all, I studied with her for a longer period, I believe, than any other student. Yet I find it impossible to by-pass memories that seem insistent on "having their day" before I can address what would seem to be more relevant musical or pedagogical issues. Perhaps (for now this is only speculation) the cathectic intensity of these recollections is an indicator; perhaps within the jumble of information that constitutes this "block" are some of the answers I seek about Gladys Egbert's teaching. In any case, I have no choice but to attend to them, to walk through them, as it were, in the order they present themselves, on the road to what may or may not turn out to be the central issues.

What sort of memories then? Passing the long fieldstone fence that borders the large property on Elbow Drive in Calgary, noting the colour of the individual stones as one progresses along its perimeter. Turning into the sidewalk to face the imposing red brick house that backs onto the river. If I have the time to walk around behind the house, and down to the edge of the water, I might very well meet up with a family of ducks. For now, though, it is time to cross the lushly pebbled circular driveway. This stretch of road has its own importance and character: when seated at the grand piano in the far corner of the living room, in

the alcove at the junction of the rows of leaded windows, you can hear the cars before they come into view, crunching and spitting up the gravel as they round the house, signalling the arrival of the next pupil, all too soon and, occasionally, far too late.

Climbing the jute-carpeted steps onto the battleship-grey veranda, passing the dining room window. If the curtains are not drawn, a view of the piano, yards away through dining room, hallway, and living room. A brief glance helps to establish the level of activity. Is anyone playing? What is he or she playing? An instantaneous aural assessment: the identity of the player can be determined by the piece being played. How is it going? Can I, will I, do as well?

In those few seconds it takes to pass the window, to look, to listen, and to walk round the porch to the front door, I experience an internal inquisition in miniature. Have I practised enough? Will my work be found adequate to merit some fervently desired and, because hard won, absolutely trusted words of praise? If, on this occasion, my practising hasn't been up to par, could my playing magically be found worthy even if I don't really "deserve it?" Is it right that it should be deemed acceptable under these circumstances? Even sometimes? This inner interrogation is re-enacted at least once each week during the school year; sometimes the trip around the porch occurs even twice in a single day, a trip home to practise some specific passage or work in a new manner (or sometimes with a new, improved attitude) taking place in the interim. Ahead, the immense oak door with its gleaming brass fittings. Never locked when Mrs. E. is at home, this is to be opened very quietly: courtesy has long ago been introduced as an imperative here. Even Robbie, Mrs. Egbert's Scottie, perennially stationed just inside the door, is well schooled in this regard, so that salutations in the entry/ cloak room are restricted to *sotto voce* woofs and murmured greetings, discreet pats and answering licks, while boots are removed and one's coat hung up on a hook beside the door.

And now, two possible scenarios. If no lesson is in progress, tiptoeing in past the softly ticking grandfather clock, moving across the dense, plush carpet, across the polished hardwood border that separates the hallway from the living room, over to a down-stuffed chintz-covered chair on the left (piano) side of the room, the one closest to the door, on the near side of the fireplace. The sofa on the opposite side of the room and the brocade chair by the stereo are always left to Mrs. Egbert for those times when she wants to sit back and assess the larger effect of a performance. (At all other times, she can be found sitting next to, or standing behind the student playing, ready to illustrate a critical point.) From time to time, someone's mother has headed for one of Mrs.

Gladys McKelvie Egbert

Egbert's chairs, and sat there "by accident." Of course, this thrilling *faux pas* is noted only privately by the student, Mrs. Egbert being far too polite to point out the error. On these occasions, however, the room has a distinctly different atmosphere, as if something had been disarranged.

Presently, from heavenward (upstairs), the familiar, cultured voice floats down: "Go right in and warm up, darling." Then the next leg of the trip, across the carpet, past the fireplace and the second matching chintz chair nearer to the piano; around (in later years) the small upright piano in the corner (purchased so that we don't always have to descend to the basement when two pianos are needed to practise concertos); over to the large (in the earliest years, dauntingly large) studio grand piano.

At the keyboard: where to begin? It is understood that this can be no neutral, value-free extemporization, for Mrs. Egbert's attention will be drawn to everything audible, even pre-audible! The period of assessment is certain to begin with the very first note. Soon enough, though, through my musical fits and starts, I can hear the sound of footsteps,

padding down the softly creaking, carpeted stairs into the front hallway. A few more steps, and in walks Mrs. Egbert.

Here she is then, upright, awkwardly graceful, immaculately groomed, in a summer English linen frock or a winter Chanel-style wool suit, the epitome of everyone's description of her: "a real lady." The curtain has gone up, the star has entered from the wings, and now the show is about to begin.

Or else (in the alternate scenario), even from the cloakroom, the energy bubbles and spills out from the living room into the hallway. Short spurts of music, Mrs. Egbert's voice above, exhorting and cajoling, frequent stops for discussion and correction, her voice then returning to a more patrician level and tone, further attempts, more imperatives. Now I am to creep in quietly across the velvet lawn of the carpet, acres long it seems, to perch on the chintz chair nearer to the piano. Protocol dictates the exchange of the briefest of greetings all around, then the business of the lesson continues as before. Any embarrassment or self-consciousness that might afflict the student at centre stage is not to be given any notice: the tables might, at any moment, be turned, after all. In any case, as I later deduce, listening in is considered an experience so valuable for students that it overrides any other consideration.

For the moment, though, the experience is less reflective, simply reactive. The other student is playing a different composition than those I am currently playing, something new! It might be another Bach invention, or a Kuhlau sonatina, or a more difficult Bach prelude and fugue, or a Beethoven sonata—a piece, a level to aspire to. Possibly the piece is in a different style altogether, one I've only heard about, perhaps piece and style are entirely unfamiliar to me.

This is another world entirely from that outside the house, outside the boundary of the fieldstone wall, from that of the people in the cars that whiz by along Elbow Drive. The world inside this living room is filled with excitement, adventure, glamour. In our world, Mrs. Egbert describes the appearance of the people, the costumes, the furniture of the world of the music being played; Mrs. Egbert sings; she dances the minuet, the waltz. Sometimes, turning to me, the observer, curled up in my chair, enthralled by the proceedings, she acknowledges my presence, saying, "You *do* like this piece, don't you, darling?" I am delighted to realize that this lesson is intended for me too. I begin to realize that the world of this composition can be mine as well. To enter it, all I need to do is to play the piece my fellow student is playing, or one like it. Progressively, I will understand, ever more powerfully, that beyond the aesthetic pleasure I can experience through my enjoyment

of the combination of sounds, music can function for me as a way of knowing, a way of understanding a myriad of concepts about culture, history, style. I will know that it can also serve as a means of gaining access to my own perceptions, to the world of taste, of judgements and opinions. I will always be indebted to Mrs. Egbert for opening the doors and leading me through into that world.

Saturday, the day we frequently have group classes, is the time for reinforcing this process of music-yielding-world. Now the living room is filled with all the other kids, arms wrapped around knees for support, scrunching about on the carpet, searching for the most comfortable, sometimes the most inconspicuous spot. For the girls, finding some way to avoid having to squirm too much (this wrinkles the skirt and makes the socks come down untidily) becomes a priority. Those present are of widely differing ages, although all are still at school. (Teachers come to study at other times). We are not a large group. We all know what a privilege it is to be among the select few, who—this is the official view, at least—have earned the right to be sitting in that room. The responsibility entailed by that exclusivity means that everyone is in a remarkably similar mood: excitement alternating with rank terror.

Whenever possible, Mrs. Egbert arranges the classes to focus on a particular theme or activity. One week, everyone plays Bach—inventions, sinfonias, and preludes and fugues; another week, sonatinas and sonatas; another, Debussy preludes; another, Bartók pieces. If some students are working on Chopin waltzes, for example, Mrs. Egbert plays us recordings of the complete opus. Occasionally we listen to works we aren't likely to hear either at the Philharmonic concerts, the Celebrity Series, or Jeunesses Musicales. (Everyone studying with Mrs. Egbert understands that attending those events is part of the curriculum.) Sometimes miniature competitions are held, with prizes. Once, I am instructed finally to "cool it!" (or some early 1960s equivalent) for attempting to hog (acquire) the entire cache of nickel prizes for the most pieces played by ear. We are expected to try our very best but never to forget that courtesy and modesty are close cousins. All pupils are required to assess the performances of their peers; this is not only Mrs. Egbert's job. Here too, courtesy is an important issue, for the performer's anxieties demand consideration, a point we all have come to understand. No one is allowed to criticize insensitively or without demonstrable reasons.

The rewards we receive for undergoing this trial by fire are manifold; some are immediate, others long-term. Invariably a treat concludes the Saturday class, wonderful cookies or cake, produced by Jean Laurie,

Mrs. Egbert's crisply white-uniformed, unfailingly cheerful Scottish housekeeper. The accompanying lemonade or milk will, as one's years advance, be replaced by tea—only the finest, of course—served in a proper sterling silver tea service, with linen (never paper) tea napkins on the tray. In addition to this alluring incentive, there is the prospect of a still larger cache of music which, thanks to the familiarity with it acquired through the classes, can be re-examined and enjoyed later. We all develop a taste, thanks to Mrs. E.'s encouragement, for critical thinking, for problem solving. This is truly the *Gradus ad Parnassum*, for much praise is attached to intelligence and polish in the performance of even the tiniest piece.

It becomes increasingly clear to all of us that if we can perform here, in this situation, playing in any other context will almost certainly be the proverbial "piece of cake." As reinforcement for this notion, Mrs. Egbert often refers to her own experiences of combating performance butterflies by reciting (and enacting) for us the special litany favoured by the students of Ernest Hutchison, one of her former teachers in New York. Muttered in 3/4 time, to each step proceeding across the platform from the wings to the piano, it goes, "Dammit, I played it at Hutchie's, dammit I played it at Hutchie's...."

Parenthetically, apropos of the preparations for the psychological challenges of performances, I recall a last-minute refresher lesson, noon-time, the day of my Grade Six Royal Conservatory examination (at age eleven). Having only recently heard of the concept of nervousness, I had come to the conclusion that it was an appropriate reaction to the special challenge presented by piano exams. I had been experimenting with assertions of my nervousness on my older brother during our drive over to Mrs. Egbert's house, and he seemed to receive them with admirable seriousness. Perhaps my face had even assumed the colour and tone appropriate to such a mood, for I can recall Mrs. Egbert asking me what the matter was, as she, my brother, and I stood by the piano. "I'm nervous," I began. There was an immediate, sharp intake of breath, a beet-toned flushing of Mrs. Egbert's face, and an appalled, peremptory, "You're *no such thing*!!" This utterly shocking response had an effect equivalent to being jolted awake by a pail of ice-cold water. Thoroughly cured of such heretical notions, I sat down and began to play with complete calm.

What other memories are attached to those Saturday classes? One, in particular, stands out. As a coda to the class, many of us who lived in more or less the same direction would stroll homeward, stopping off at someone's house *en route*. Here, in a less structured setting, we often prolonged our pleasure in each other's company by ingestion of still

more cookies to accompany additional performances, sometimes of four-hand (duet) music, sometimes of popular songs or jazz. I can remember bizarre readings of Bach's Goldberg Variations (Glenn Gould was everyone's hero in those days), played in duet form, one person for each hand. Attempting to keep the musical pulse while fighting with your neighbour for the optimal position to play your required notes, particularly as the music increased in difficulty and complexity with the handcrossings, resulted in more hilarity than perfection. These post-class meetings played an important part in alleviating the special sense of isolation that afflicts all musicians, especially pianists, who not only must practise alone, but perform alone most of the time. It was a paradoxical situation: Mrs. Egbert had demanded a kind of monastic dedication from us in order to achieve extraordinary standards. Now, thanks to her, we found ourselves in a unique position of being able to have this special kind of glorious fun together. It was inevitable that those spun-out Saturday afternoons would breed lifelong friendships, romances, and, years hence, marriages.

Surveying my recollections now, many years after the events that engendered them, I find memories emerging that serve more as indicators, reflections of attitudes and of standards, than of specifically musical advice. Not for a moment do I believe that this reflects any lack of inspiration in the teaching. On the contrary, these memories bear witness to a climate that allowed both teaching and learning to have a quality of being supercharged.

Another memory forces its way to the surface. This takes place at an orchestral rehearsal for one of my first important concerto engagements. The setting is the rehearsal hall of the Jubilee Auditorium. In addition to the orchestra, the conductor and I are on the stage, Mrs. Egbert, an audience of one below, present for the purpose of quality control, at least as far as I, her pupil, am concerned. Everyone is hard at work. I try my utmost to present the difficult piano part without blemish; the conductor attends to the orchestra. Suddenly, the piece unravels and we come apart, the piano going down one road, the orchestra down various others all at once. The conductor, normally a honey-voiced, sycophantic sort of man in the presence of Mrs. E., explodes, raging against the necessity of being forced to give amateurs (like me) a chance. I am in a state of profound embarrassment and puzzlement, unable to understand why he has reacted this way. Somehow, we resume and continue. While playing, I am busily constructing some thesis about young people who, through a social contract I haven't previously grasped, need to take the rap for any problem involving adults.

Finally, not nearly soon enough, the intermission break comes. I am just rising from the piano bench when, to my right, I notice that the lone audience member has also risen and is approaching the stage. In her most patrician, most thrillingly haughty voice, one distinctly audible to all present, Mrs. Egbert proclaims, "Mr. X. (the conductor), I'm *ashamed* of you!!! You know *perfectly* well, that was *your* mistake, not hers. Why, she knows that piece crab-fashion! I would have thought better of you than to blame someone unfairly!" Mrs. Egbert is well aware of the longstanding tradition of conductors being treated with unwavering respect and deference. Nevertheless, she has reacted in much the same spirit as a mother grizzly perceiving danger to her cub. The only difference is the nature of the threat and the eloquence of the response. Within seconds, the stunned conductor abjectly apologizes to Mrs. Egbert. This does not satisfy her! She insists that he owes me an apology as well, and you may believe that the deed is done the following day, in her own living room. The passing years and the inevitable increase in my own sophistication only enhance my admiration of the heroism and integrity of this woman.

Important and emblematic as such memories clearly are for me, I have found myself wanting to interview others of her students and to compare my experiences and perceptions with theirs. Perhaps it is always a shock having something confirmed that one has only sensed. One student after another, some much older than myself, others around the same age, refers immediately, then repeatedly—without any prompting—to the scene of the action, the background against which their lessons took place. One Egbert colleague wonders if these events, the lessons and classes, could even have taken place anywhere else, as though there were some magic, some mystery associated with this one location. Curiously enough, an article I encounter in the Glenbow's clipping file contains a photograph of the house on Elbow Drive with a caption that asks, "Do you remember? ... Music pupils of Dr. Gladys Egbert will...." On reflection, I do recall important lessons that took place elsewhere, in CBC studios in Vancouver, Winnipeg, Toronto, or Montreal, Mrs. Egbert having accompanied me to important performances, often in competitions. Nevertheless, it cannot be denied that she seemed to take power from that house, or the house from her. The combined *gestalt*, Mrs. Egbert plus house, exerted a magnetic attraction for all who visited and spent time there. This was true in joyful times, when the house might be full of loved ones or, perhaps, the sophisticated and exotically accented artists who, if they visited Calgary, invariably gravitated there, gracing the dining room, hallway, and living room with their laughter and their blue cigar smoke.

It was true later as well, on those quiet June evenings when I would go to visit her upon my return from the year's studies in New York, when it would be just the two of us. The house then was darker, quieter. Judge Egbert had left her a widow, her children had grown up and left. Robbie was no longer at his station by the front door. Yet how wonderful it was, we two gabbing like teenage friends long into the night, she, through my bizarre anecdotes, vicariously participating in the musical and social climate of New York.

The official story on Gladys McKelvie Egbert, the one kept in the Glenbow Museum's clipping file, goes back to 1912. Here are newspaper reports of the remarkable talent she demonstrated for performance from her earliest years. They tell of the honours she received as a student at the Royal Academy in London, England where—as a result of winning a gold medal from the Royal Academy and the Royal College of Music for the highest marks in the music examinations ever given in Canada—she had been studying since the age of twelve, on a two-year scholarship (later extended to three-years), the first and the youngest Canadian ever to receive such an award. We had all heard Mrs. Egbert's occasional references to her studies in London and to the famous musicians she had known, men whose names could be found on the covers of the Associated Board editions of Bach and Beethoven works and on the jackets of records. Few of us realized, however, how very young Gladys Egbert had been when she left the tiny, remote Calgary of 1910 to live in London. Those of us who had, as young teenagers, taken a six-week course at the distant Banff School of Fine Arts would have been shocked to learn that she had lived alone in London in her thirteenth and fourteenth year of life, her mother having stayed with her for only the first year of her studies. Mrs. Egbert never spoke about her difficulties, about the loneliness she must have experienced, then or later. She also never revealed how she felt about giving up the company of such distinguished peers in London, or relinquishing important opportunities later in New York, to return to a small, provincial Canadian town where she was compelled to make do with what must have been, owing to Calgary's size in 1916, an extremely limited talent pool. What obviously motivated and sustained her was her conviction, one she had developed and carried home with her, about the utmost importance of the highest quality musical education being made available to all who might benefit from it. She herself had been blessed not only with extraordinary gifts but with a glorious opportunity. Her talent had been fostered by her first teachers in Calgary. Thanks to them it had been possible for her to go forth and experience the culture of the greater world. Now she felt a need to

reciprocate. Gladys McKelvie Egbert was a cultural patriot, loyal to her country, her province, and her city.

Never did Mrs. Egbert make us aware of all that she had achieved. It wasn't so much a case of her not taking pride in her own accomplishments, I believe; it was simply that she found it morally indefensible and aesthetically repugnant to boast. In 1936 she had been elected a fellow of the Royal Academy of Music, the first North American to be so honoured; yet it was left to others to decipher for us the significance of the initials F.R.A.M that sometimes accompanied her name in print. She certainly cherished the honorary doctorate she received from the University of Calgary in 1965. To her students, however, she was always (at her own request) just Mrs. Egbert. (Our pet name, Mrs. E., was used in absentia.) In the 1960s she achieved almost legendary status across Canada as a teacher, when year after year, one student after another won the CBC Competition, no small feat considering the odds of that much talent and accomplishment emerging from one teacher's studio in a city neither the largest nor the most centrally located in the country. Mrs. Egbert, however, defined accomplishment for herself; to her it connoted having higher and higher standards of musical performance that derived from understanding ever more clearly what might be possible. There was, according to this formula, never any room for smugness, either in herself or in her students, for there was always something new to learn.

This is tellingly illustrated by the following story. In 1966 I was to leave Calgary to go to the Juilliard School of Music in New York City. I had visited New York in the spring of that year to meet and play for the famous pedagogue with whom I was to study. In order to improve my ease in playing—I had fallen victim to some technical problems that develop from overuse and tension—this grand lady recommended study prior to my audition in the fall, either with her in London, England, or with a young New York teacher I'd heard of—a sort of technical Miss Fix-It—who taught during the summer at the Aspen Music School in Colorado. I decided on Aspen. After a nine-week course of intensive, radically different regimes, I returned to Calgary to prepare my audition program with Mrs. Egbert. Only a few notes into my first lesson, Mrs. Egbert stopped me; a few notes later and she stopped me again. "What did you do? Why are you doing that? How did you learn this? What did she say about...?" I was nonplussed by the unending questions and not at all certain whether Mrs. Egbert was pleased with the results of my course.

Soon enough, however, the reasons for the inquisition became clear. Within the week, Mrs. Egbert had put her stable of eager students on

hold and was arranging a trip to New York where she would take a fortnight-long course of lessons, every two or three days, with the young teacher. I had heard, of course, of her studies with some of New York's most renowned teachers, both before and after her marriage in 1924. It was impossible, however, not to be astonished by Mrs. Egbert's utter lack of embarrassment, given her immense reputation and station; by her willingness, even her alacrity to meet, to commune, and even to study with a woman only half of her seventy years of age. She had decided that there existed someone who could give her new perspectives on the mysteries of piano performance and, more specifically, the instruction of it. For Mrs. Egbert, this trip to New York was nothing less than a pilgrimage; she was looking not so much for a person as for the Grail of Knowledge, and no inconvenience, no impediment of pride would deter her from the quest.

So often when we encounter people who have a quality of natural grandeur, their small faults seem to be writ large. We Egbert students often chafed under the pressure of meeting what seemed impossible standards. It sometimes appeared as though she lacked compassion or appreciation for our struggles and our sacrifices. Once we had made the commitment to enter her sacred realm, music's sacred realm, however, it was understood that what many of our peers considered central to their lives—games, sports, make-up, boys—were to be viewed as ancillary, obstructions to progress. I remember once sitting in the living room, waiting for my lesson while Mrs. Egbert continued working with the girl before me. Suddenly stopping the girl mid-piece, in a state of exasperation, Mrs. Egbert demanded to know what-the-devil could be going through her (the student's) head. "Oh, Mrs. Egbert," replied this sixteen year old, tears breaking through her words, "I'm IN LUUUUUVVV!" I was scandalized to see Mrs. Egbert throw her arms heavenward and emit an only semi-genteel oath. "How unsympathetic she is!" I remember thinking. "Hasn't she ever been in love?" (This anecdote is repeated often, amid gales of laughter, whenever gatherings of Egbert alumni take place.)

In the main, however, our awareness that she gave every iota of her available energy to us very much tempered our complacence and occasional resentment. How can I forget the sight of Mrs. Egbert, exhausted and flu-ish, lying on the sofa in her pink negligee, helping us to perfect our pieces for the upcoming music festival, while between laryngitic corrections she sipped a few mouthfuls of the broth Jean had brought her on a tray? All this, of course, we merely took for granted; it was only to be expected.

But how did Mrs. Egbert actually teach? The answer will always

Vivace assai

Vivace assai (♩ 96-108)

Joseph Haydn

senza rit.

Fine

remain elusive. One anecdote, however, may give an idea of her uniquely inspirational style. One of my strongest recollections—interestingly enough, one shared equally by other students—is of playing a little piece by Haydn at about the age of ten or eleven.[1] Even though we were fed a varied diet that included such composers as Prokofiev, Bartók, and later, Berg, Mrs. Egbert had a special love and affinity for music of the baroque and classic periods. This little Haydn "Vivace Assai" was a particular favourite of hers, judging from the number of people who were assigned it (see above). Mrs. Egbert had the habit of devising words and setting them to the melody of the piano pieces, forming in the process a little song for her students to sing. Her choice for this one made a big impression on everyone, and we all loved singing, "How I love Papa Haydn, he's a very jolly man. Bright and gay, bright and gay, I could play him all the day!" When some years later the

tune bound up with its "text" came into my mind and I was unable to banish it, I questioned the value and wisdom of her notion. "After all," I asked myself, from my twenty-year-old, newly sophisticated vantage point, "Isn't music of this (instrumental classic) type supposed to refer to nothing other than itself? Doesn't the introduction of words excessively limit one's reaction to the piece? Furthermore, isn't the idea all a bit corny?" The best explanation I could come up with was, "Oh, that's all very well for kids, but...."

I have since grown to understand that beyond its fun and sheer silliness, this little verse is an amazingly powerful heuristic tool. If I now were to attempt to give a student explicit instructions for playing these few lines of music to get her to produce the special sense of character, buoyancy, and humour that such music requires; if I were to try to describe the physical requirements, or attempt to estimate precisely the amount of time needed in performance in order to communicate to the audience a feeling of lift on the upbeat and an almost agogic (delayed) effect on the downbeat, I am not sure I could do it better. Mrs. Egbert's little song was a practical demonstration of the power of metaphor and analogy. It was not only for the affective pull of the lyrics. The shape of the verse, in smaller and larger units, also helped students to acquire a sense of musical idea-units, morphemes, if you will; it enabled them to grasp the structure, the shape of a musical phrase; it helped them to understand what flows and what articulates (rather like musical vowels and consonants and musical punctuation).

Focusing on the tune helped students to develop a hierarchical sense. Some critics might suggest that we have in Haydn's little piece a typical, rather simple organization of musical bars, with a stress falling on every other bar (1, 3, 5, 7, etc.). Mrs. Egbert's solution was not nearly so primitive. Although the words "love," "Haydn," "very," and "man" all fall on main beats, the semantic stress of the text favours "love" and "Haydn," with a slightly stronger lean on "love." "Very" and "man," owing to their placement and function in the verbal phrase, are rather less important. Thanks to its alliance with the words, the music can be seen by the student to reflect this same stress. Thus, in performance, instead of a rather mechanical effect (strong/weak/strong/weak etc.) it is possible to create a far more elegant realization. Of course, the power of the rationale was invisible to all those who played this little piece. We knew only that we "understood" it and loved it; as a result we were able to play with enthusiasm and great conviction.

I understand, as I consider the ramifications of this example, that this kind of memory is, after all, in no way trivial, nor is it tangential.

By these means and others like them, Mrs. Egbert imparted a fundamental understanding of style. We were given the opportunity to acquire this understanding in an unique context, one where delight grounded the learning of principles. Can any teacher give students a greater gift?

My feelings toward Mrs. Egbert remain a complex mixture of gratitude, loss, and resentment—I am often frustrated and angry that she should have had to die so relatively young (at 72), at a time when, if anything, her openness and her penchant for learning were increasing. It seems impossible, twenty-five years later, that she should not still be available whenever I might need her to stimulate, encourage, exasperate, mollify, and reward me with her praise. It seems impossible that she should not be here in my adulthood, when we could truly be both friends and colleagues. So impossible, in fact, that driving past the house, still I turn to look to check if everything is fine; to see whether— in late December—the dining room curtains are open, making it possible, even from far off, to catch a glimpse of the enormous, bulb-laden, angel-haired, tinselled Christmas tree, stretching the full nine feet to the ceiling. Looking toward the house is an automatic ritual that forms a part of my life and, I believe, that of everyone who studied with her. It is both a tribute and a gesture of attachment.

A native Calgarian, **Marilyn Engle** received national and international exposure by winning the CBC Competition, the J. S. Bach International Competition, the Music Teachers' National Association Competition, and a major prize in the Washington International Competition. Performing widely on radio and television, she has given numerous solo and chamber recitals and has appeared as a soloist with orchestras in North America, Europe, and the Orient. After earning graduate degrees in performance from the Juilliard School and in musicology from New York University, Ms. Engle returned to Calgary in 1975 to join the faculty of the University of Calgary's Department of Music. Along with her extensive performing and teaching activities, she continues to give masterclasses and adjudicate music competitions in Canada and abroad. She has known and admired Marsha for as long as she can remember—the Pearlmans and the Engles having been lifelong friends.

Note

1 "Vivace Assai" by Joseph Haydn, in *Early Classics for the Piano* ed. Alfred Mirovitch (New York: Schirmer, 1955) 14. The "Vivace Assai" is from *Twelve Little Pieces for the Piano* by Haydn, four of which are included in the volume cited above.

12

Prairie Pioneers: Canadian Women in Dance

ANNE FLYNN

I'm looking at a photo of myself at about age seven or eight standing in front of a fake fireplace in my parents' home wearing a baggy leotard and tights, and my very own black patent leather tap shoes with giant ribbons. One foot is pointing to the side in toe tap position and my arms are held symmetrically to the front diagonals. There were ceramic tiles in front of this false fireplace and so it was the only place in the house where I was allowed to dance, except for the kitchen, which was usually too crowded with bodies. I remember posing for this photo and I remember the many hours that I spent tapping away in this setting.

I imagine that thousands of Canadian women can conjure up their own variation on this image: the little girl who wants to be a beautiful dancer. It seems to be one of those little documented developmental stages into which we enter and from which we exit without great fuss, leaving behind perhaps a photo image or a costume, or simply a memory that one's muscles will never forget. The connections between women and dance are abundant and varied and in this article I want to describe some of the ways that women have shaped the Canadian dance experience. Then, moving from the general to the specific, the national to the local, I will discuss the lives and contributions of some Alberta women who have shaped the development of the Alberta dance community as we now know it. This is not meant as an exhaustive history of Canadian or Albertan women in dance, but merely as one attempt to document the relatively hidden work of Canadian women dancers. Since dance is such a broad field, inclusive of forms ranging from ballet to square dance and performed in multiple settings that include theatres, gymnasiums and private homes, I will introduce the theme of women in dance by looking at some of these settings and forms to give the reader a backdrop against which to place these particular histories.

THEATRE DANCE

Theatre dance includes those forms that are performed in a theatrical setting, most typically ballet, jazz, modern, and a number of other culture specific dance forms that are arranged for the concert stage. In general, the dancers are trained professionals or amateurs (unpaid) and audiences pay an admission price to enter the performing space. In his book on the history of theatre dance in Canada, Max Wyman notes:

> The pioneers of theatre dancing in Canada knew that terrible isolation well. They numbered not more than a handful to begin with, and they were scattered across the face of the second-largest country on earth. Few of them were native-born Canadians. Until as late as the 1970s, leadership in dance in Canada was almost exclusively in the hands of immigrants, initially from Europe, later from the United States. Most of them were women.[1]

Currently in Canada there are more female dancers in professional companies and considerably more women compete for these positions. Inside the profession it is often noted that men have to be merely adequate dancers for a chance at a job while women have to be outstanding since there are considerably more women from which to choose. Most professional dancers begin their training in a studio setting at relatively young ages. The studio operators are generally women, the teachers are women, and the students are largely young girls. Surrounded still by many sexist stereotypes, it is difficult for young boys to undertake serious theatrical dance training without alienating themselves from the social milieu in which they must function. Quite often, men come to dancing at a later age, perhaps through sports or drama. Since our public school systems offer minimal, if any, exposure to theatre dance, it is primarily through the private studio that future professional dancers begin their training, and this setting is largely the domain of women.

In the history of the ballet tradition, choreographers and artistic directors of companies have predominantly been men. While women make up a greater portion of the dancers, men have gained wide recognition for their choreography. The majority of the world's ballet companies have been directed by men and so it is a curious fact that the three largest ballet companies in Canada were all founded by women. The Royal Winnipeg Ballet, which celebrated its fiftieth anniversary in 1989, was founded by Gweneth Lloyd and Betty Farrally after they left England for Winnipeg in 1937. It is Canada's oldest ballet

company. In 1950 the National Ballet of Canada was formed under the direction of Celia Franca who had also come to Canada from England; in 1957 Les Grands Ballets Canadiens was officially incorporated under the direction of Ludmilla Chiriaeff; and the Alberta Ballet Company began in 1960 as Dance Interlude directed by Ruth Carse (Wyman 15).

In the modern dance world women have always been leaders. A new style of theatre dance that had its beginnings in the early twentieth century, the philosophy of the modern dance movement was laid down by American women such as Isadora Duncan, Ruth St. Denis, Martha Graham, and Doris Humphrey.[2] In Canada there was Maude Allan.[3] Early modern dancers rebelled against the highly structured and rigid codifications of ballet. They wanted to free the body from constraining corsets and toe shoes and to plant the feet firmly on the ground. While a discussion of the development of modern dance is too complex for this setting, it is important to note that Canadian women have been very active in the modern dance movement. There are modern dance companies in every province under the artistic direction of women, and women, more than men, have significantly shaped the course of contemporary theatre dance in Canada.[4]

In addition to dance companies there exists a category of choreographers and dancers known as "independents". These are individuals who work alone or in collectives without the support of a company structure. They generally produce their own work, apply for their own grants, develop their own audiences, plan their own tours, and earn very little money. Women are strongly present in this segment of the dance community, which is consistent with their notably strong presence in the modern dance form in general.

DANCE IN EDUCATION

The history of dance in Canadian public schools is strongly linked to women teachers who continue to work hard for its inclusion in the curriculum. Male teachers are rarely involved in public school dance programmes. Taught largely through physical education programmes and in some drama studies programmes, dance has only recently been recognized as a separate subject area like history or math and in only a few provinces.[5] In Alberta, dance is still taught as part of either physical education or drama, and is offered as a separate option in some junior high schools. There is a unique dance programme at Victoria Composite High School in Edmonton,[6] but elsewhere in the province the inclusion of dance is largely dependent on personnel. In schools with a well-qualified dance teacher, students have access to

option courses and extra-curricular programmes, while schools without qualified teachers offer very little dance exposure. Except in Ontario and Quebec, faculties of education do not recognize dance as a certifiable subject area and so those who wish to teach dance in the public school system must earn undergraduate degrees in other areas such as physical education or drama. The situation has been quite problematic for the development of dance as an independent discipline that is more appropriately studied alongside other subject areas in the arts, humanities, and social sciences, not subsumed under either physical education or drama.

One organization that has worked at both the provincial and national level on behalf of dance in education is the Dance Committee of the Canadian Association of Health, Physical Education and Recreation (CAHPER). Founded by a group of women, most of whom were teaching dance at either the university level or in public schools, the Dance Committee has worked on behalf of dance in the schools for over twenty five years. While some men have been involved with the committee over the course of its existence, it has been largely made up of women.

Six Canadian universities offer undergraduate degree programmes in dance and these programmes are staffed almost exclusively by women. In 1991, out of the roughly forty dance professors and instructors working in Canadian dance degree programmes, four were men.[7] While I do not have the current statistics on the breakdown of male to female dance students, I think it is quite safe to assume that women far outnumber men. Dance in education, both in public schools and at the college and university level, tends still to be the domain of women who have made enormous contributions to this developing field.

SOCIAL AND RECREATIONAL DANCE

Social dances are participatory in nature as distinct from theatre dance forms where some people dance and others watch. The term "social dance" refers to a broad category that includes ballroom, square dance, folk and ethnic dances, vernacular or "current" dances, two-stepping, and many other specific dance forms. It is in this area of social dancing that we find the greatest balance between male and female participants. Many social forms require partners and these are generally mixed couples as in square dancing or ballroom. Physical education programmes generally include some instruction in one or more of these dance forms and most of us learn basic enough steps to be able to dance at the graduations or weddings we attend.

Theatre dance forms such as ballet, jazz, tap, or modern are often

taught in a recreational setting where the emphasis is on participation rather than serious technical training. It is in this sense that I use the term "recreational" when referring to these dance forms. In this setting, again, we find mostly women teachers and women participants. Men tend not to engage in these theatre dance forms, though the last ten years have seen another wave of increased participation by men in jazz and tap. However, most community-based or continuing education dance programmes are coordinated by and for women.

Women are an overwhelming presence in the dance world, both in Canada and elsewhere. In the professional dance community, within educational institutions, and in recreational settings women have been greatly involved in shaping our experiences of dance, more so than in the other fine and performing arts. The arts have often been characterized as feminine and this is clearly the case with dance. It is associated with feeling and expression, with the subjective and intuitive, and most importantly with the body. Since women have also been associated with these characteristics it is not altogether surprising that women and dance have a long and rich history.

In the next part of this article I would like to focus on three Alberta women who have made particular contributions to the development of our dance community: Alice Murdoch Adams, Ruth Carse, and Dorothy Harris. Each of these women was a pioneer of dance in her own unique ways and it is with enormous respect and admiration that I attempt to tell their stories.[8]

ALICE MURDOCH ADAMS

Alice Murdoch Adams was the recipient of the first Alberta Dance Award given by the Alberta Dance Alliance in 1989. When she was told that she would be receiving the award, she wanted to know why anyone would want to give it to her. After all, she hadn't been active in the dance community since the 1950s. Alice agreed to accept the award as long as she didn't have to make a speech, and the dance community was able to learn about the life and work of one of its earliest pioneers.

Alice was born on March 5, 1908 in Edinburgh, Scotland. Her family emigrated to Canada when she was three years old and settled in Cranbrook. They returned to Scotland in 1914 for a year, and that is when Alice took her first highland dance classes. Her family settled in Calgary when they moved back to Canada permanently, but Alice did not resume her dance studies until junior high school. She then quit school so she could work to pay for dance classes.

Alice's first teacher was Jean Gauld under whom she studied highland dance for almost ten years. Alice remembers that as an

Alice Adams with the guys! Courtesy of Alice Murdoch Adams.

advanced student she often taught the first part of class because Jean was late, a habit that eventually led to Alice's becoming Jean's assistant. Typical of dance schools at that time, Jean's studio was in her home. In 1926–27 when Alice was just eighteen she began her travels, which would lead her to London, Paris, New York, Seattle, and Los Angeles to study dance. This was her first opportunity to train in forms such as ballet, tap, and ballroom and was the start of a lengthy career as a dancer, choreographer, costume designer, teacher, and businesswoman.

In 1927 Alice opened the Alice Murdoch School of Dance located first in her family's basement and then in several locations in downtown Calgary. Other than Penley's studio, which offered ballroom, Alice's school was the only one in Calgary. She offered classes in ballet, tap, acrobatics, highland, character, ballroom, and even exercise classes for adult women. Initially, Alice taught all the classes herself from 8:00 to 10:00 p.m. weekdays and all day Saturdays. The school had approximately two hundred students who ranged from children of three to adults. After she had spent several years downtown, Alice's parents helped her to buy a house on 4 Street and 14 Avenue S.W. where she could live and teach. Alice's own family lived in the back of

the house and basement while the living room served as the studio. In addition, Alice eventually opened a branch of her school in Lethbridge, which was run by her assistant Lola Strand, though Alice would travel to Lethbridge on the train to teach on a regular basis. She also taught regularly in Stavely, Claresholm, Vulcan, and Drumheller. When asked what would happen if she got sick, Alice responded that she never got sick, or if she did she just kept on teaching.

Alice spent every summer taking classes in New York. She studied at the Ned Wayburn School of Dance, learning all the latest steps and styles. She recalls the rompers they wore in dance classes and how they would wring them out and hang them to dry, changing in between classes. She also mentions that for safety in the big city her mother insisted she wear a money belt under her dance rompers and so her money was always wet. Alice had two aunts who lived in the greater New York vicinity and she would stay with one or the other of them until she got settled into a place in Manhattan closer to the studio. These summers in New York provided Alice with new teaching material, new music, and, very importantly, new dance shoes; Mr Capezio, the world-famous dance shoemaker, made Alice's shoes. Alice laughed when she told me that her first two children were born in August so as not to interfere with either her annual trek to New York or her teaching schedule. Alice also spent some time studying in Los Angeles and Seattle, but most of her training took place in New York.

From 1927 to 1949 the Alice Murdoch School of Dance was a very active place. Besides the two hundred-odd students that visited the house weekly to take classes, Sundays were reserved for rehearsals and the basement change room seconded as a reading room stacked with dance magazines. Alice was a prolific choreographer who created hundreds of dances in twenty years. She held an annual recital or revue that in 1943, for example, consisted of forty-one dances, seven musicians and over one hundred and fifty performers. These annual reviews took place in the Grand Theatre where they would sell out the over one thousand seats. She also choreographed shows for the Palace and Capitol Theatres, which took place between the movies. For two years Alice created a new thirty-minute show every week for the Capitol Theatre; each show was supposed to relate in some way to the theme of the movie. For all these shows and revues, Alice designed and cut the patterns for the costumes while parents and other helpers did the sewing and construction.

Perhaps one of the most unusual periods of Alice Murdoch's career occurred during the period of World War II when she choreographed and produced shows to entertain the troops. Alice estimates that

between 1939 and 1943 they performed close to four hundred shows in towns throughout Alberta. The materials for costumes and sets would come from a major sponsor such as Burke's or Eaton's, the government paid for transportation and food, and the performers volunteered their time as part of the war effort. Alice's show was sponsored by Adams Radio Parlours, her husband's store. The performers travelled by bus and would generally return to Calgary immediately following a show, driving home in the early hours of the morning. Alice's son Ron began touring with the show as soon as he was old enough to play the accordion. Also during these years Alice's group would perform shows at country and town fairs around the province.

In 1949 Alice had three vertebral discs removed and this in combination with other factors marked the finale of the Alice Murdoch School of Dance, the Grand Theatre revues, and an entire era of dance making and teaching. However, the work would continue through Alice's sister and then her daughter. Alice's sister Jean was seventeen years her junior and Alice was her dance teacher. Jean became a competitive highland dancer and even travelled to Scotland to compete in the world championships; she won the world title. So when Alice closed the doors to her studio, Jean opened a new one in another Calgary house renovated to accommodate a studio and there she began to train Alice's daughter, Vicki Adams Willis.

Alice thought that she was through with the dance world in 1949. She had worked seven days a week for over twenty years and raised two children. Her husband encouraged her to hang up her dancing shoes and put her feet up. So, when her third child, Vicki, was born in 1950, Alice had no intention of involving her in dance. This was not to be the case. Vicki saw her aunt Jean teaching classes and she begged for lessons. By the time she was in university Vicki also began travelling to New York and Europe to study dance, and then returned to Calgary to teach and choreograph. Vicki taught in the Faculty of Fine Arts at the University of Calgary for fifteen years before leaving to work full-time as artistic director of her company, Decidedly Jazz Danceworks. The company has a very successful school where hundreds of people arrive weekly for their classes. The dance styles have changed, and the music has too. Rompers have given way to spandex and cotton/lycra. But something in the spirit of Alice Murdoch's work is being kept alive every time her daughter begins that familiar count to eight.

<div align="center">RUTH CARSE</div>

In September 1991 the Alberta Ballet celebrated its twenty-fifth anniversary at a gala performance with guest appearances by the Royal

Ruth Carse, 1950, at Radio City Music Hall, New York.
Courtesy of Ruth Carse.

Winnipeg's Evelyn Hart and the National Ballet's Rex Harrington. Tickets sold for $133.00. Ruth Carse founded this company back in the sixties when dancers, choreographers, composers, costume designers, and so on worked for free. She founded a volunteer dance company that survived on the energy of its participants, its audiences, and the undaunted determination of Ms. Carse.

Ruth Carse was born on December 7, 1916 in Edmonton, Alberta and was one of five children. Her father had emigrated to Canada from Scotland and in 1905 settled in Edmonton where he met Ruth's mother, whose family managed the boarding house where he lived. When Ruth expressed interest in taking dancing lessons, her father saw to it that she studied highland dance. At age six Ruth began studying with Madame Boucher who rolled back the carpets and taught classes in her living room. Chairs were used as barres and Ruth came to realize much later that Madame Boucher was in fact teaching a system of training based on the British Ballet Organization.

As Ruth's interest and skill in dance grew, she left Madame Boucher's living room and began studying at the Kinney School of Dance, which was operated by two sisters, one of whom had studied in Toronto with

Boris Volkoff, a Russian dancer/choreographer who operated a ballet school and company. Throughout her teenage years, Ruth danced at the Kinney School and began performing. At the age of twenty-one, Ruth was encouraged to continue her dance studies and therefore had to leave Alberta. Ruth reminisces that her father wagered a hundred dollars that Ruth would be back home in a month. Ruth won the bet.

In 1937 she moved to Toronto to study with Boris Volkoff and eventually became a soloist with the Volkoff Ballet. Ruth danced with the company for ten years, performing regularly in Toronto, touring in Ontario, and participating in a number of ballet festivals. The extraordinary thing about these ten years is that none of the dancers were paid. They all had day jobs and rehearsed and performed at night and on weekends. Ruth started working in the checking department of a Toronto advertising firm and eventually became manager of the department while maintaining the position of soloist in one of Canada's original ballet companies. During this time, Ruth also went to England every two years to study.

One of Ruth's contemporaries was Mildred Herman (Melissa Hayden) who went from Volkoff's to New York where she began an illustrious career as a soloist for the New York City Ballet. While Ruth's greatest interest in dance had always been teaching, she decided in 1949 that she should take the plunge and see how she would fare as a dancer in New York. Soon after her arrival in New York, she was given a partial scholarship to the prestigious American School of Ballet and so was exposed to new styles of ballet training. Ruth also auditioned for dance work whenever possible and was hired by the Yiddish Theatre in Brooklyn where she danced in a new musical every week. She recalls this time with great fondness and says that the dancers were treated "beautifully". She also remembers her time with the Radio City Ballet, where she worked for two years, as being quite luxurious. First of all, she was actually being paid to dance. The dancers performed in four shows a day which lasted ten minutes each, and they had professional dressing rooms, costumes, make-up, and even hairdryers. During breaks between shows Ruth would travel uptown to Carnegie Hall on the bus, wearing full stage make-up and dark glasses, to take a ballet class. Then, one day Ruth received a phone call from the stage manager of the Volkoff Ballet who encouraged her to fly to Toronto to audition for the brand new National Ballet of Canada. Ruth auditioned, was hired, and went back to New York to finish her contract with the Radio City Ballet before returning permanently to Canada.

Ruth's career at the National Ballet Company lasted only three months and she recalls that director Celia Franca was not very pleased

when Ruth made the decision to resign. From 1952 to 1954 Ruth remained in Toronto and began studying the British-based Royal Academy of Dance (RAD) training system at the Canadian School of Ballet under Gweneth Lloyd. Eventually Ruth started teaching the RAD system in the Toronto area, which marked the beginning of a forty-year teaching career. During this time Ruth was also part of Norman McClaren's early electronic experiments and she appeared in a number of CBC television variety shows. In the summer of 1954 while Ruth was studying in England, an unfortunate accident that resulted in a torn achilles tendon became the final end marker of her performing career. Shortly after the accident Ruth was asked to come to Edmonton to teach for her friend Muriel Taylor who was on maternity leave from the studio she operated, and Edmonton has been Ruth's home ever since.

In addition to teaching, Ruth began choreographing almost immediately after her return to Edmonton. She did the choreography for musicals such as Oklahoma, Brigadoon, and South Pacific, which were being produced by the Edmonton Light Opera Company. She also started a group called Dance Interlude, which eventually would become the Alberta Ballet. Dance Interlude toured throughout the province beginning in the town of Tofield. By 1960 Dance Interlude was renamed the Edmonton Ballet and by 1966 it became the Alberta Ballet Company. It was not until 1971, however, that the ABC became fully professional, which meant that salaries were paid. Until that time Ms. Carse and the dancers trained, rehearsed, and performed without remuneration.

Also in 1971, the Alberta Ballet Company School was established and Ruth became the director. The school and the company operated together until the late 1970s when they separated for administrative reasons, though the school was still the primary training ground for future company members. In 1974 when Ruth became an examiner for the Royal Academy of Dance, which required considerable time and travel, she resigned as artistic director of the company. In 1976 Brydon Paige was appointed artistic director and his association lasted for over ten years. He was followed by Ali Pourfarrok, who is the current artistic director. Ruth continued teaching for the school and examining for the Royal Academy until she retired in 1986.

These days Ruth Carse is supposed to be retired. She goes to Hawaii in the winter, but she still teaches, coaches, adjudicates, and consults. She is the recipient of a number of awards and honours including the Order of Canada and in 1989 she received the prestigious Dance in Canada Award for outstanding contributions to the dance community. Recognized by her colleagues as one of the major pioneers of profes-

sional dance in this country, Ruth Carse returned to her home on the prairies to build a company and a school. Guided by her muse and strengthened by the support of her family, she just kept dancing, and dancing, and dancing.

DOROTHY WARD HARRIS

Dorothy Harris taught dance at the University of Alberta for twenty-six years before retiring in August 1990. She was among the first group of dancers to hold a full-time position in a Canadian university and she is without question a pioneer in the field of dance education. Her teaching brought her into contact with thousands of students, some of whom have gone on to successful careers as both performers and teachers. She has worked in provincial, national, and international organizations and anyone in the field of post-secondary dance education knows her name.

Dorothy was born on May 28, 1925 in Edmonton, one of three children. Her family moved to Trail, B.C. for several years, but by 1932 they were settled in Calgary. At age eight Dorothy began taking dance classes at the Alice Murdoch School of Dance where she studied ballet, tap, and acrobatics at a cost of five dollars for twelve lessons. She studied with Alice for about seven years during which time she performed in the annual reviews at the Grand Theatre, in Christmas and New Year's Eve shows, and with Alice's touring group to county fairs around the province. Dorothy was especially talented in acrobatics due partially to extraordinary back flexibility, and Alice choreographed several solos which Dorothy often performed. Dorothy remembers these days with enormous affection. She remembers having to heat hair curling irons on Bunsen burners in the basement of the Grand Theatre and receiving chocolate or flowers as payment for performing. Her mother constructed all her costumes based on the patterns designed by Miss Murdoch. When she entered Crescent Heights High School, Dorothy thought that her dancing days were over, but while she participated in a whole new variety of activities, she also continued dancing in high school productions of operettas and musicals. When Dorothy was in grade twelve, her family moved to Edmonton and Dorothy followed reluctantly. She entered the University of Alberta the following year and completed a Bachelor of Arts degree in 1946.

During university Dorothy spent two summers attending a recreation leadership programme at Mount Royal College in Calgary. She learned to teach Swedish gymnastics and a wide variety of other activities, and became interested in recreation studies. After graduation from the University of Alberta, Dorothy worked at the university library for a year and in the summer of 1947 she began course work in

Dorothy Harris, age 12, at the Alice Murdoch School of the Dance.
Courtesy of Dorothy Harris.

recreation at the University of Minnesota. This is when she took her first modern dance class. In the fall of 1947 Dorothy decided to pursue a masters degree in physical education at the University of Wisconsin where she was admitted pending the completion of one year of undergraduate physical education courses. Dorothy remembers this year as the one that changed her life. She took a dance course with Margaret H'Doubler, a very prominent dance educator who was largely responsible for the establishment of the first university degree programme in dance in America, and she was hooked. Dance became her central focus once again and she would spend the next forty years completely engaged in the dance world. Dorothy completed two years of study at the University of Wisconsin but left to accept a teaching position before finishing the degree.

In the fall of 1949 Dorothy began teaching in the physical education department at the University of Arkansas. She taught courses in dance, soccer, volleyball, and softball and ran a number of extra-curricular dance programmes, which included ballroom, square, creative dance for children, and a performing group called Orchesis. This was also the year that Dorothy met and married her husband. After two years at the University of Arkansas, Dorothy accepted a

position at Arkansas State where she had similar responsibilities. She stayed for one year and then taught at the high school level for one year. Dorothy and her husband then moved to Colorado Springs where they started a family: between 1955 and 1961 Dorothy had four children. She also taught high school for one year in Colorado Springs.

In the early sixties the family returned to Edmonton and Dorothy found work in both the library and registrar's office at the University of Alberta. A student assistant who worked with Dorothy brought news one day that the physical education department was hiring someone to teach dance and Dorothy immediately applied. She was hired on a part-time basis to begin with, and in the fall of 1965 she became a full-time faculty member. This was the beginning of a twenty-six year career as a dance educator that would take her all over the world and into the lives of thousands of students.

Dorothy's greatest affinity is for modern dance, but she has taught a wide variety of dance forms. Soon after she joined the University of Alberta faculty she designed a movement course for drama students to satisfy their physical education requirement and she remembers this course with great fondness. Having started a performing group, Orchesis, which produced an annual concert, Dorothy recruited a number of dancers from this movement course, including Peggy Baker and Brian Webb, both of whom continued on to successful dance careers. By the early 1970s, however, the drama department would not allow students to participate in Orchesis and the movement course was moved from physical education to drama. Dorothy regarded this as a tremendous loss and the end of a very exciting time in dance education at the University of Alberta. In the mid-seventies Dorothy and her dance colleagues tried to win support for a degree in dance, but the university did not support it. Dance would only remain a small part of the overall physical education curriculum, so Dorothy simply continued working with whatever resources and energy were available.

The number of people holding full-time appointments and teaching dance in universities was minuscule in the 1960s. Most of the appointments were in physical education, so it is not surprising that Canada's first national dance committee emerged from the Canadian Association of Health, Physical Education and Recreation. In 1965 the CAHPER Dance Committee was formed; its first national chairperson was Rose Hill, a professor at McMaster University. Dorothy Harris was part of this inaugural committee and in 1969 she became national chairperson. She held this position for four years and recalls that their most significant accomplishment was the organization of the 1971 BiNational Dance Conference which took place in Waterloo. This was

the first attempt to bring together dance academics from Canada and the United States and while the conference organizing committees were drawn from four hundred American dance academics, Canada had eighteen organizers. Dorothy recalls that the conference was highly successful and the group of Canadians in attendance created a bond that has lasted for twenty years.

In addition to the CAHPER Dance Committee, Dorothy served on the national board of the Dance in Canada Association (DICA) as the Alberta regional representative (1979–83) and was part of the DICA conference organizing committee for the 1975 conference held in Edmonton. DICA honoured Dorothy with a Service Award. Dorothy was also treasurer of Dance and the Child International (DACI) from 1978 to 1982 and was part of the DACI organizing committee for its 1978 Edmonton conference. As she was involved at both the national and international levels, it is no surprise that Dorothy turned her attention to the local scene, and in 1979 she instigated a meeting of the Alberta dance community, sponsored by Alberta Culture, which resulted in the formation of the Alberta Dance Alliance, a non-profit service organization. Dorothy served on the ADA board of directors from its inception in 1979 until 1987.

On August 31, 1990 Dorothy Harris retired from the University of Alberta after twenty-six years of service. She continues to live in Edmonton and is involved with two dance-related business enterprises. She is still attending conferences, writing about dance, thinking about dance, and living a life that is still moved and inspired by the magic we call dance.

CONCLUSION

These three women were childhood dancers who all began their training in the living rooms of three other women, who likely began their training in the living rooms of three other women. Dance, in many cultures around the world, is passed on from one generation to the next in very informal contexts and as part of a whole range of learned cultural traditions and attitudes. Adams, Carse, and Harris were involved in the worlds of theatre dance and education; they were artists, teachers, choreographers, producers, costume designers, and administrators. The body of their combined achievements in dance is extraordinary and they represent only a fraction of the women in Canada who have worked and continue to work in all areas of the dance field. From Native American traditional dances to experimental modern theatrical dances, women are both carrying on traditions and creating new modes of expression. While the context of training in dance has changed quite dramatically in the last fifty years and there are now

specially designed studios where the floor construction has been tested for its biomechanical safety, on some levels the basic tradition of passing the knowledge of dance from one individual to another down through the generations remains much the same. In Canada, it is largely through the work of women that the experience of dance continues to touch our lives.

Anne Flynn is Associate Professor of Dance in the Faculty of Physical Education at the University of Calgary where she has taught since 1978. She has performed and taught in many places in Canada as well as in Germany and the United States. In 1987 she co-founded Dance Connection magazine for which she has written numerous articles. Recently she has been researching the history of dance in Alberta. She was introduced to Marsha Hanen by Alison Wylie, and became familiar with Marsha's work while research-ing subjective/objective distinction in the philosophy of science. They participated in a conference on the effects of feminist approaches to research methodologies and had a number of discussions about dance in a liberal studies context. Marsha has great respect for the arts and their role in education.

Notes

1 Max Wyman, *Dance Canada* (Vancouver: Douglas and McIntyre, 1989) 15.

2 For information on the history of modern dance in America see Sally Banes, *Terpsichore in Sneakers* (Madison: U of Wisconsin P, 1983); Don McDonagh, *The Rise and Fall and Rise of Modern Dance* (Chicago: Chicago Review, 1990); Richard Kraus, Sarah Chapman, and Brenda Dixon, *History of the Dance in Art and Education* (New Jersey: Prentice Hall, 1991).

3 See Felix Cherniavsky, *The Salome Dancer: The Life and Times of Maude Allan* (Toronto: McClelland and Stewart, 1991).

4 For more information on the history of theatre dance in Canada see Max Wyman.

5 Only Ontario and Quebec have fully developed curriculums for dance, K to 12.

6 For a brief description of this program see *Dance Connection*, (Dec./Jan. 1988).

7 These figures are based on degree programme information that I received from each of the schools in January 1991. In some cases it was not clear who was currently on staff, so these figures are only an estimate.

8 The material for these profiles came from personal interviews conducted with each of the women in their homes or mine during August 1991. The interviews were video- and audiotaped.

13

Edging Off the Cliff

ARITHA VAN HERK

I have never become a writer.

A woman's freedom to make any kind of public or formal declaration of art or principle is a freedom curtailed and constrained by custom, determined by a world that has proclaimed what she should desire, censored and isolated her from the legitimacy of her own desires. The territory of the artist appears to suggest a space of freedom for women, freedom of expression for women who want to practise their art. But actual practice proves otherwise: this inviting space is duplicitous because it has been defined, circumscribed, and conveyanced by male imperatives. This territory does not make itself happily available to women, so daring to conceive of herself as potential or actual artist is damnably difficult, almost impossible, for the aspirant. Inevitably, the creation, production, and distribution of women's art is contaminated by the hegemonic male model, which can afford clever doubts about its after all time-proven correctness. Daring to intrude on, to insert herself into this canonized context is daunting for even the bravest woman artist. For those of us who are not brave, it is an act closely akin to suicide, an act closely akin to enacting a perpetual denial. And so, unbravely, I did not become a writer.

I am a coward. Writing within and against the literary establishment has been, for me, a gesture larger than faith and more defiant than edging off a cliff. With every movement of my typing fingers, I step from a precipice. Each time, I try to orient myself. Gingerly, I crawl toward the edge, peer down at the jumble of rocks far, far below. I try to imagine the moment of freedom, of exhilaration, that I will encounter when an updraft of air wafts me softly through imaginary air, but mostly I am reminded of broken bones and grazed skin, of the spine-shattering thump of articulation that tumbles to the very concrete ground. Again and again, I refuse to become a writer.

Merely to begin, the female artist has to be able to conceive of herself

as potential artist. Second, having tried to make art, she must break into a constructed world that is not inclined to see or to accept her art; indeed, she is actively discouraged from any misguided notion that she might be able to carve out a small place within the artistic area she is trying to enter. Third, the woman encounters resistance to her "being" an artist: barriers—physical, social, emotional barriers—are erected. It is a struggle to "be" an artist when income, family, work, personal relationships, and self-perception are distracting complications.

Here then, is the source of my cowardice. When I try now to pinpoint the moment at which I knew that I did not want to be a writer, the moment when I believed that I could do nothing else, the moment when writing was a word carved in my future, I face a monstrous sense of malfeasance, impossibilities that insisted for years on their power. Those impossibilities continue to haunt my life: in the middle of the night I hear their imprecations; walking through leaves on a glorious fall day I am suddenly reminded of one more insurmountable barrier to any tenuous hope I might dare to harbour of writing, merely *writing*, the act itself. Still, still, one edges toward the cliff. And still, still, I have never become a writer.

It is essential to separate being the writer from the active act of writing. They are different states, although one requires as much confidence as the other. Wanting to write challenged my cowardice, made me garner all my fool's courage as backup for my nervous leap. Reconciled to its difficulties, I gauged the leap, the drop, the jar of the impact. All right, I dared to think: I write; I *should* want to become a writer.

And yet, I still lack the capacity to imagine myself a writer. I rely on being told that I occupy my uneasy position from voices outside of myself, originating elsewhere. I have never become a writer. Even more drastic, I have never dared to become a writer. I write, secretly, and with a tremendous sense of illegitimacy, even guilt, with every word I dare to inscribe. And so I write into and out of a terrible denial.

We long to identify the origins of our moments of doubt or verification somewhere in our childhoods, to locate our formative moments in a time when we could not be blamed for the actions around us, when innocence was protection. Believe me, whatever naive intention is attributed to a child's discoveries, I have always known absolutely that writing is no innocent activity but loaded and corrupt, a gesture that implicates me in whatever words result.

Permit me an oxymoron. No parent, no teacher, no lover, no writerly mentor, ever told me I should write. And yet, this assertion is not true. They all told me that I should, I *must* write, they were all full of good will

towards me, full of suggestions for my future success, full of genuine concern that I live a happy life. How then to reconcile this contradiction with my inability to become a writer?

It would be logical to begin with my early childhood, but I would rather go backwards, trace my terrible reluctance from this moment in reverse. Now, it is my women friends who remind me to write, who encourage me in my faltering sense that I might still want to become a writer. They ask about my work, they argue that my last book was worthy, they remind me that they are waiting to read my next encounter with words, they insist that writing is an activity I should continue, however desperate and trying other concerns are. They are quick to shield me from the ready obstructions to most women's art: that women should provide the world with volunteer labour, should act as mentors, muses, and caretakers for the many issues and people who rely on this exploitation of half the population's time. And in their desire for my words I find the most steadily convincing support that I have ever dared to dare to rely on. Without their eyes, which I feel peering over my shoulder when I sit at my computer, I am afraid that I would simply abandon this tryst with words, this constant refusal of writing. At the same time, my encouragers cannot fathom the enormity of the crime I commit with this writing, this forbidden articulation. And this crime is not writing itself, but the presence and the nature of my desire to write, not to write, as exemplified by writing's wonderful and perpetual inconsummation. Desire arises from denial, and it was out of denial, the carefully delineated territory of the artist, forbidden ground, that my cowardly heart discovered it would have to learn how to grapple with this impossibility.

The fact is, when I was small, we were poor. Immigrant families eke out their improvements as best they can, and we were a family without much money for anything extra. I do not believe that I was ever seriously hungry or cold, but I certainly had only one pair of shoes and my winter coats were supposed to last a number of years. But writing has nothing to do with money. It has everything to do with desire. My father had brought with him from Holland a gold fountain pen. It lay ceremoniously, emanating a certain impervious promise, within its original box in the top right hand drawer of a highly carved and encrusted piece of oak furniture that had been crated and shipped and emigrated from Holland along with my family. We called that furnishing a buffet, but to my recollection it contained very few dishes and had instead become the reliquary of things that were not to be touched or used or handled: it was full of things being *saved*.

These objects included photograph albums and the onion-skinned

and gothically scriptured Dutch Bible, as well as other less portentous items obviously only safe if kept out of the grubby and curious hands of children. My father's fountain pen was never used, and although the flyleaf of the Dutch Bible contained the names, birthdates, and baptismal dates of my three siblings who were born in Holland, to my knowledge it never came to contain either my name or the name of my younger brother, born in Canada. I am still not certain of the reason for this absence or omission, our implied erasure. Could it be that only children born in Holland were properly baptized? Could it be that my father had to write these things into the Bible (and I imagine it was certainly his writing) with his Dutch fountain pen, and the fountain pen had ceased to function? Could it be that emigration/immigration to Canada meant that recordings of this nature were ascribed a different configuration or importance, and verification was vested differently?

I pretend that I cannot remember my father reading from that cumbrous Dutch Bible, but the truth is, if I concentrate very hard, I can clearly remember his voice weaving the heavy aspirations of Dutch, the language he was daily having to replace with a brash Canadian English that spoke in mouth much more than tongue, and did not hesitate to proclaim that it should take primacy over other speech. It was the tradition in our family—no, not the tradition, the rule—that after every meal, the entire family would remain in their chairs around the table, sitting perfectly still with eyes downcast, listening while my father read aloud a section of a chapter from the Bible.

When I was very small, and my father read from the Dutch Bible, which I pretend I cannot remember, we were allowed to sit on my mother's lap. To keep us quiet, she would gently stroke our backs. And I pretend that I cannot remember when my father changed from reading the Dutch version to the sonorous rhythms of the English King James version. I only pretend to know that I felt, as listener, the terrible imposition of having to sit still (how I longed for the casual behaviours of my Canadian friends who merely said, "Excuse me," and darted from their supper tables to their play). But worse than pretending to sit still was the weight of the heavily Calvinist Christianity that my parents had been raised within and that they now practised on us. I had already—when? when? has escaped me completely—decided that I was not Christian but heathen and that religion was more than an opiate of the masses: it was dull and constrictive. And worse than both sitting still and religion was the terrible disjunction of my father's reading, his voice trapped in a language not his own and struggling through the elegantly impossible phrases of King James, determined despite his accent and his mispronunciation to offer the proper words to his children so that

they would grow up to be God-fearing people in a kingdom and a morality far from that place he still called home. In the face of those arrested words, it was impossible to approach words. And so I could not become a writer.

There is, of course, another possible side to this story. If I were a different kind of writer and a different reader, I would pretend that the persistent erosion of Bible stories in my daily life made me a fetishist of narrative, especially the inconclusively suggestive narratives presented as lessons within scriptural context. I was taught to appreciate the cadence of story and its undoing, but I relied on my own imaginative interpretations; the Biblical insistence on genealogy is easy to annex to the passionate recountings of sex and violence that are the index of Christian mythology. Even more striking, of course, was the extent to which enforced listening, every day for an hour or more, to stories of disobedience as object lessons for obedience was clearly a reverse inscription. I came to desire, to want passionately to practise disobedience. My whole life and its writing has been a quest to seize that opportunity.

And perhaps those repeated listenings accomplished more than I can account for. For in a recalcitrant way, I refused to learn to read. At least, I cannot remember learning to read. I merely, and this sounds like a lie, always could. There was never any doubt, never any question, that when I picked up a book and opened it, I would understand what was printed on its pages. I looked at the black letters and they meant something. How could they not? Once again, it was clear that I would refuse to become a writer simply because I would write.

It is easy to guess that at some point I would steal my father's gold fountain pen and try to write with it (as if it were a pencil), thereby wrecking the fountain pen forever, although it was kept, I believe, after I split the nib, in the same box in the same drawer in the same buffet. Keeping, saving, were more important to my family than utilization. Understandable for immigrants, of course, and I cannot fault my parents for their particular desire to maintain some aspects of their lives intact, despite Canadian dust, despite Canadian agnosticism, despite Canadian callousness and Canadian English. But I was impatient with their desire to *save*, and wanted instead to participate, use up. Everything they suggested underscored the importance of waiting, of postponing desire. Experience or actual usage, I wanted everything immediately. And, impatiently, I did not want to become a writer.

But another malfeasance. My friend and I crouched under the dropleaf table with the Crayolas we had stuffed in the pockets of our

pedal-pushers—red and green, the primary colours—and drew letters on the ceiling of the table above us. **D**, we carved, with large bold strokes. **A** and **R**, we were inspired to add. We were showing off how much we knew to each other, that we could write. We were not yet in school—no school would take children so early, not in those days. The drop leaves of the table sheltered us magnificently, and the scratching of our crayons on the wood underside was hugely assertive. It was Heather's table, a dropleaf, her mother's table, that we were under. We were inscribing a surface we knew was probably as forbidden as the white-painted walls, but less likely to be read.

Heather became a nurse's aide. I did not become a writer. But when her family left their farm, they held the traditional farm sale, where everything that has accumulated over the last fifty years is arranged on the grass and sold by an auctioneer with a twangy voice and a portable mike. The dropleaf table was up for auction. Heather's mother had tried to sand the surface smooth so it would look a little more appealing, but it had served as an egg table for years and the top was scratched and marred. I was in Edmonton trying not to become a writer. My mother was at the auction. She bought the dropleaf table for two dollars. Or maybe it was six. I can never be certain about the numbers in stories. She brought it up to me and said, "I thought you needed a table for your new apartment." That table was in rough shape. I didn't dare to look underneath, or maybe at that moment I didn't quite remember that I'd written in crayons on its underside. Maybe I didn't want to. Anyway, I was grateful. I needed a table. And my father-in-law, who was an insurance adjuster but who had a wood-working shop in his basement, came over and ran his hand over the surface of the table and said, "Do you want me to refinish this for you?" Which I instantly accepted for the generous gift it was, and the next time I saw the oak table it was taken apart down in his shop and the top leaf was lying upside down while he refinished the spindle legs, and he said, "Kids wrote all over underneath here. But that doesn't matter, the top's in good shape." And I saw my large **D** and **A** and **R**; as a matter of fact, there were my initials, **RvH**, plain as plain, although to this day I'd never admit that I had a nickname, the name that I was always called because, although I have this exotic name (suitable enough for a writer), my parents, who were Dutch immigrants and who gave me this personal handle, complete with its exotic spelling, were unable to pronounce it—were, as most Dutch immigrants are, incapable of pronouncing in any way "th"—and so were reduced to calling me "Arita," which was rapidly shortened to Rita, which I learned very quickly to hate and determined to change the moment that I left home in order not to become a writer. Which name

reversal I have denied into existence, and never since regretted. And the sanded and beautifully refinished oak dropleaf table now rests its quiet spindled legs in my house, with those secret letters, which my father-in-law did not bother to sand away since they were on the bottom and no one was likely to see them, glowing secretly underneath. Except that when I find myself awake at three o'clock in the morning with some sensation that I am convinced is not being a writer's insomnia, although I have never managed to become a writer, I creep out of bed and down the stairs and I raise one side of the dropleaf in order to crawl under the table (in bare feet and the torn old T-shirt that I sleep in) and with the cold floor under my bare thighs I read again those glowing letters, announcements of writing. Nocturnally then, I am convinced that Heather, who became a nurse's aide, is lucky; and that Rita van Herk, who erased herself so successfully, knew more than I do now.

About not becoming a writer. Which has much to do with the compromises of desire. In such a religious and carefully controlled family, sexuality was something that, despite my impatience, I had no opportunity to test. I was discouraged from growing up, from attaining certain kinds of adult knowledge too quickly, from testing what I imagined to be my own fabulous capacity for orgasmic experience. Maybe it was all that Bible reading, but I turned out to be a smart kid. Too smart, too full of both curiosity and answers, as well as all eyes for things that I wasn't supposed to be interested in seeing. Despite the restrictions on desire, I fell in love repeatedly, in serial expectancy, with Doug and Roger and Johnny and David, with Larry and Brian, and even with Bob. Not to mention Donnie, who was the closest thing to a juvenile delinquent that we were lucky enough to encounter in our rural community. Note how I date myself here: in my adolescence there were no Shawns or Elijahs, no trendy Christophers. We fell in love every-where—in and out of the darkroom, the filmroom, behind the gym, and in the curling rink. Falling in love was mostly a matter of stealthy groping that was certain to leave both pairs of hands slithering, but unresolved. Closure was impossible, even with access to a car (a warm, dry space with windows and doors, and dear God, seats as wide as legs and arms could manage) because a car was instantly commandeered by at least six couples, and completion is much more difficult to accomplish when there is an elbow in your eye while you are trying to discover the passionate intricacies of French kissing.

The whole serial list of my adolescent loves were singularly and collectively trying to achieve the single outcome of making it with a girl and then being perfectly happy about marrying her if the result was a knock-up. They were a tremendous inspiration to anyone not wanting

to become a writer. Until the one (I think he was called Dwayne) who was determined to corner me beyond a mere quickie or my raging hormones: he tried to convince me that in order to become a writer I had to marry him. This was tempting but scary stuff. Such an equation: become a writer; marry me. I fled, and having fled as far as was possible on my limited means and with my limited imagination, I recognized that truly, truly, I did not want to become writer. I would avoid that temptation forever.

I settled on dreaming of flight, in one version or another. Airline pilots, ballerinas, balloonists. Anything to escape being a writer, which I suspected of imperatives that I was already having to negotiate. Away from home I was relieved at last (I thought) to be free from the tempestuous language, full of vernacularity and error, passionate mis-use and Calvinist forbiddances, of my immigrant family. At last I felt I had a chance to achieve elegance, perhaps even glamour. Every Dutch immigrant daughter knows that she cannot possibly become a writer— she hasn't got the required capacity for irony, the sense of being able to toss away desire and longing. Which I had steadily worked at in all my early refusals, refusing and refusing every expectation that offered itself.

Greater malfeasance, although earlier. When it came time for me to walk, I refused. Did I know that walking would mean that I was carried less? I was three before I walked, and my mother was so worried she took me to every leg and foot doctor around, thinking there was something wrong with my ambulatory and motor capability. It was not illness, my father insists, but pure laziness. It was, I know, and continue to know, a justifiable fear, a prefiguration of the denials that walking would discover. Once I set foot on the ground I would be responsible for where those feet at the ends of my legs would lead me, and I wasn't certain that I wanted to be. So I sat and I crawled, but I wouldn't walk. Until my father gave me a willow stick, just my height. "Here," he said. "Hang onto this." Magic. I held onto the stick and somehow, walking became addictive.

Perhaps out of the same instinct for survival, I have never learned to swim, and I drown repeatedly when I enter water. The first time I drowned was in that magnificent Alberta hieroglyphic known as Buffalo Lake (named by the Cree—how could they know that the lake is shaped exactly like a Buffalo from the air when they could only walk around its edges?), a dramatic loss of footing in a sudden great hole. That drowning I have never recovered from. The story that one's life flashes in front of one's eyes is not true, but while I drowned, there was a solemn parade of people watching, and asking why I did not want to

become a writer. I have never figured out if this is where the image of the revisioned life comes from or if those figures are supposed to encapsulate an unlived life. But drowning was and still is a way for me to avoid being a writer, afraid of water, afraid of words, unable to keep afloat in a great sea of singing as the cold element rushes my ears.

Yes, I am beginning to arrive at the admission that I write out of fear, and that I will never dare to call myself a writer; but also to recognize that the conjunction of my fears, my terrified escapes, my inability to escape, have led me to writing. I am reminded perpetually of the strokes and steps I should have taken, of the men I might have married and the children I might have had, of the intricate fishing net that binds us all to our initial inscribements, of the writer I have not become.

Believe me when I confess that I was greedy for knowledge. I hid all my terror behind a smart-ass intelligence, knew everything there was to know in a wise-guy way that must have made my parents and teachers want to kill me. They played a trick on me instead. They decided that everything was too easy for me and I didn't have enough to do, so I should skip grade seven. Sadistic reasoning, although logical enough. I was bored, I didn't have enough to do, despite my efforts to avoid becoming a writer; I drowned again and again in grade six out of sheer boredom and sheer revenge for the meagre scholastic problems I was dealt. So the teacher conferred with my parents who too were at their wits' end, and they skipped me. The system doesn't do this anymore because it results in maladjusted children. But there I was, all of twelve years old and slam, bang, in grade eight. Not a problem for my studies, I could handle the mathematics and social studies. No, a social problem. I was a fiction that did not believe itself. It is a crime to brand a child as smart—other children tend to experience hate and to make that child's life uncomfortable. But even social outcasting was manageable, an opportunity to refuse to be a writer.

What was unmanageable was the size of my breasts. I had breasts, good breasts, very pleasing breasts, even to my own shy and jaundiced eye. And the fact of the matter is that when a girl is twelve years old and she is in a class with fourteen-year-olds, and her breasts are not only more obvious but definitely more breasty than theirs, she is in serious trouble. She has issued a physical challenge that will never be forgiven. Remember, this was 1967 when people still approved of breasts, before desire for adolescent flatness overran the beauty experts of the world. So, I suffered from the reverse of all possible problems. Most teenage girls of my era longed for breasts and did not have them; I had good breasts and longed for less than what I had. Another reason why I could not possibly become a writer: I was without discretion. Which meant

there was nothing to do but become, then, that same writer. There is no surprise in possession, only in absence. And I became the same writer that I did not become.

These small reversals might seem over-portentous, listed this way, as the miniature malfeasances they were, as the points of friction where I encountered my own resistance and denial. But they gesture toward the irrevocable refusals of the woman as artist: the imperatives that she knows will need to be negotiated again and again, the double negatives of what she does compared to what she doesn't. Of what she dares and dares not dare. The thin air beyond the edge of the precipice.

She must, the female artist, reconcile herself to a perennial refusal; she will be reminded again and again that she is not an artist, but a fraud of sorts, an imposter trying to slide between the thin cracks of the artistic fences built by the male model. In those marginal places, acknowledgement and praise are scant, and she will need to remind herself, again and again, that she will never become an artist. She does not dare to imagine that she will succeed. And she will be reminded by others that she fails and fails and fails, that she cannot live up to the world's standards. Again and again, she will refuse to become a writer. She will be told that her book is not the kind of book she should have written; she will be chided for not writing something else (when she wrote what she wrote, and what she might have written is another matter). She will be told that she is too visceral: nobody wants to read about the interior organs of women. She will be told that she is too cerebral: women aren't supposed to meddle with theoretical and philosophical ideas. She will be told that she is too feminist: the men in her books don't look like heroes. She will be told she is not feminist enough: the men in her books get off too lightly. Her own premise, the step that she takes, that moment when she alone, without parachute or rope, steps from the edge and dares to fall, to fly the currents of the winds of the imagination—her own premise is seldom even accorded the courtesy of recognition.

The female artist must refuse, again and again, to become an artist, because she is not an unfettered agent in the arena of creativity. She is buffeted by the intransigence of a world that regards with surprise and affront (as if she were a dog walking on its hind legs) her attempts to make public what she imagines. She will be rulered beside some "universal" measurement of achievement and inevitably found wanting. But somehow, despite the huge claustrophobia of what she is not permitted, she must refuse, resist, defy. She must break old European fountain pens and scribble under dropleaf tables; she must flee from the loving tyranny of encouraging lovers; she must take pleasure in her

breasts; she must drown and drown and drown; she must erase all testaments with her reading; she must, finally, refuse to walk, and instead, choose to take that one magnificent step, off the edge of the precipice.

Aritha van Herk is a novelist, critic, and professor. She has published work throughout North America and Europe. Her novels include *Judith* (1978), *The Tent Peg* (1981), *No Fixed Address* (1986), and *Places Far From Ellesmere* (1990). Her critical books include *In Visible Ink* (1991) and *A Frozen Tongue* (1993). Her work focuses on the unexplored geographies of landscape and language; she is particularly interested in the recovery of women's myths in contemporary time and place. She is Professor of English, teaching creative writing and Canadian literature at the University of Calgary, where she and Marsha Hanen were colleagues.

Afterword

ELIANE LESLAU SILVERMAN

Happy expectation. Here I find nouns, statements of where we are and what we feel, what we paint, dance, or write alone or collectively, how we teach and learn. Fragmentation. Organization. Contradiction. And interruption, not only of the words, images, and bodily experiences that the artists here hear, enforced on them or gently persuaded, but of each other. Conversation. Inclusion and exclusion. Some depression; a lot of transgression. All in the face of restriction.

Out of all this emerge other traditions, born out of tension between this time and place and the creation of new meanings. Redefinition out of sensation, perception and intuition, craft and skill. Exaltation.

Make room in your heart and body and head for it; more composition, narration, exclamation. Premonition, collaboration, and concentration. Deformation. Reformulation. Where does it take you?

This is not the moment for definition. It is instead time for the conviction born of knowing every day the perpetual presences: dancing, writing, painting, photographing, teaching, acting, living. For creation. Illumination.

Eliane Leslau Silverman treasures feminist scholarship and feminist activism equally—to her they are inseparable. She has been involved in the women's movement since 1970, at the local and national levels through NAC, LEAF, and as Director of Research at the Canadian Advisory Council on the Status of Women, and has written books on frontier women's construction of their own lives and on adolescent women's understandings of their worlds. As coordinator of the women's studies programme at the University of Calgary, she is daily affirmed in her knowledge that women will continue to re-create worlds that feel like better places to be. She and Marsha Hanen were colleagues at the University of Calgary for many years.

Postscript

It seems appropriate to conclude by reflecting on some of the recurring themes that give unity to this collection. Most of these themes are projected in the life and career of Marsha Hanen herself, as described by Margaret Osler. One of the most important of them, however, is implied rather than explicitly stated. Though it is not the central theme in any one essay, implicit in nearly all is the story of the support and encouragement that women offer to one another—the sympathy, the suffering alongside, above all the respect.

One element in this solidarity is directly addressed, however. This is, as we have seen, the figure of the mentrix, a good definition of whom is given by Margaret Osler in her description of Marsha Hanen's administrative style: "She listens carefully to the individual's desires or needs or complaints and helps them think of ways in which to make a constructive outcome possible" (15). This theme, developed in detail by Diana Relke in her discussion of the mentrix figure in novels written by Canadian women, is important in many of the other essays too. We find it, for example, in Kathleen Martindale's account of Gail Scott's deliberate choice of francophone "fictional mothers," and again in Tamara Seiler's reference to "the maternal drive to nurture those perceived to be weak or in need" (56). Sometimes the theme is played in a minor key: Diana Relke laments that there are so few mentrix figures in novels by Canadian women, and Alice Mansell and Marcia Epstein point out the problems that arise for the woman painter or composer as a result of the lack of the female model or mentrix. On the other hand, Marilyn Engle and Anne Flynn bear witness to the enormous creative power of the mentrix when she is to be found.

This nurturance that women are able to provide for one another is especially important in view of the particular constraint under which the woman artist has to work: the world of male theories and paradigms. Aritha van Herk's eloquent account of the terror and pain

of the woman artist allows those of us who are not artists to understand something of what those who are have to endure: "Daring to intrude on, to insert herself into this canonized context is daunting even for the bravest woman artist. For those of us who are not brave, it is an act closely akin to suicide, an act closely akin to enacting a perpetual denial" (211). The particular ways in which this constraint affects the development of the woman artist are most directly addressed by Alice Mansell, who asks, "Could critical theories be operating to reinforce the values that postmodern artists and scholars thought were at least being questioned, if not subverted" (145)? But the theme comes back again and again throughout the collection. Marcia Epstein presents the point of view that music was effectively "removed from the realm of the female (emotional ecstasy, frenzy, sensuality, dancing) by means of rationalizing principles" (164–5). Some feminists, she tells us, perceive traditional art music as embodying metaphors of conquest, often over the feminine, or "other," or "deviant." Kathleen Martindale, drawing upon the work of Luce Irigaray, asks: "Is 'normalcy' ever possible for those gendered female in Western culture" (72)? Melancholy and femininity are, she claims, nearly identical. Susan Stone-Blackburn believes that women dramatists have been silenced by patriarchal expectations: "The ways in which dramatic expression of women's experience departs from the male norm that established critical standards remain a constant impediment from Aphra Behn's day to our own" (104). Beverly Rasporich, like Marcia Epstein, believes that the feminine aspects of painting, like those of music, have been discredited by the rationalizing masculine tradition: "It is the Italian Renaissance tradition which has prevailed, while its elevation of an abstracting and generalized mode of expression has been interpreted as superior 'masculine' art" (128). Even in dance, according to Anne Flynn, though women have had far more opportunities than in most of the other arts, it is men who have most commonly been the directors and choreographers. Typically, therefore, the woman artist finds herself at a disadvantage, operating in what all too often she perceives as an alien environment. She is a stranger in a strange land.

It is not surprising, therefore, that many women artists feel a strong kinship with those who are literally strangers in a strange land: immigrants, especially those who come from cultures other than the Anglo-Saxon. The theme of the ethnic "other" is introduced by Margaret Osler in her account of Marsha Hanen's parents, themselves immigrants, who assisted refugees from the Nazi regime to establish themselves in Canada. Ethnicity is, of course, central in Tamara Seiler's essay, and it is she who most tellingly puts into words the

connection that many other contributors also perceive: "While it would be difficult, if not impossible to argue conclusively that this profound 'othering' of the female is related to the othering of the immigrant, it seems clear that the processes involved are similar and that language and storytelling and their power to create the worlds in which we move as individuals and as groups, is central to both" (46–7). The connection is movingly confirmed by Aritha van Herk: "Every Dutch immigrant daughter knows that she cannot possibly become a writer" (218). Another contributor who makes the connection between the immigrant and the female is Pamela McCallum. To illustrate what is meant by "marked subjectivities" she uses, as we have seen, a figure created by the Montreal writer Yeshim Ternar: Saliha Samson. Saliha sees and interprets her world from her particular perspective as both woman and immigrant. Epistemologies of marked subjectivities, Pamela McCallum believes, "offer an empowering ground not only for feminist theories but also for those groups with which feminism may wish to build alliances" (117). Obviously, one such group may be immigrants.

Another theme that emerges in Pamela McCallum's essay is the propensity of women artists to use the experience of being female, with all that it entails, as artistic material. Yeshim Ternar's created figure Saliha is not only a woman and an immigrant: she is also a *cleaning* woman. Saliha's experience as a cleaner is central to Ternar's story, and in fact provides its title, "Ajax Là-Bas." It is Saliha's position as a cleaning woman that gives her her own distinctive point of view on Canadian culture: "Canadians are funny, thinks Saliha.... Old heroes live on as detergents in Canada" (112). The creative use of the feminine experience—housework, food, clothes, the home as centre of nurturance—is most thoroughly discussed in Beverly Rasporich's essay on Alice Munro and Mary Pratt. Though recognizing, like Alice Mansell and Marcia Epstein, that "being feminine inhibits and limits the woman as artist and contributes to the female as victim," she nonetheless sees femininity also as "a source of beauty and artistic authority" for Pratt and Munro. "It positively informs their choice of subject matter, their techniques and even their method of photographic realism. The female as feminine and domestic artist preoccupied with food, fashions, and furnishings has an alluring presence in their art" (121). The importance of what is specifically feminine as artistic material is recognized too in Diana Relke's discussion of the mentrix in fiction. Morag, in Margaret Laurence's *The Diviners*, needs and values as mentrix not only her composition teacher, Miss Melrose, but also Millie, the senior clerk at Simlow's Ladies' Wear, who teaches her "Good Taste." But if what is feminine can thus be used artistically

by the woman painter and novelist, the woman playwright is less fortunate, according to Susan Stone-Blackburn: "It is not that men go out of their way to keep women's plays out of the theatres ... but those who hold the decision-making power in theatres do not often find women's dramatized experience interesting or important enough to warrant production.... Whether the barrier is fear or disinterest, it seems likely to be there when the playwright's voice is distinctly female" (100).

It is different, however, with the woman teacher. Both Anne Flynn and Marilyn Engle draw attention to the feminine in the teaching styles of the women whose careers they describe. As Flynn puts it, "These three women were childhood dancers who all began their training in the living rooms of three other women, who likely began their training in the living rooms of three other women" (209). Similarly, Marilyn Engle testifies to the significance of Mrs. Egbert's house: "She seemed to take power from that house, or the house from her. The combined *gestalt* of Mrs. Egbert plus house exerted a magnetic attraction for all who visited and spent time there" (188). And Tamara Seiler perceives in the fiction of Winnipeg's North End a difference between the practice of male writers and female writers that has to do with the feminine experience of home-making: "female writers to varying degrees, shape [Winnipeg's North End] into a warm, nurturant, ultimately powerful syncretic space wherein limiting and repressive dualities can be creatively shattered thereby making spaces that include rather than exclude those 'othered' by rigid concepts of ethnicity and/or gender" (41).

It is noteworthy that both Marilyn Engle and Tamara Seiler believe the feminine to be a source of power. So do Pamela McCallum and Beverly Rasporich. Indeed, it is hard to find even one essay that does not acknowledge the fundamental strength of women, despite the forces of tradition that inhibit their progress, despite setbacks and disappointments, despite even their apparent powerlessness. Paradoxically, it is often the very femininity which implies powerlessness that in fact generates strength: women are like those "who going through the Vale of Misery use it for a well" (Psalm 84:6).

That is why, as Eliane Silverman reminds us in her Afterword, the overwhelmingly dominant theme of this collection of essays is celebration: celebration, in the first place, of Marsha Hanen, but also of women as artists, of ourselves as women scholars and teachers, of the female and the feminine. And beyond that we celebrate the communities in which we have been encouraged to grow, and beyond that again, all those who have contributed to the empowerment of women, who have released them into a world where they can find the joy of creativity.

Christine Mason Sutherland
Calgary, 1993

Index